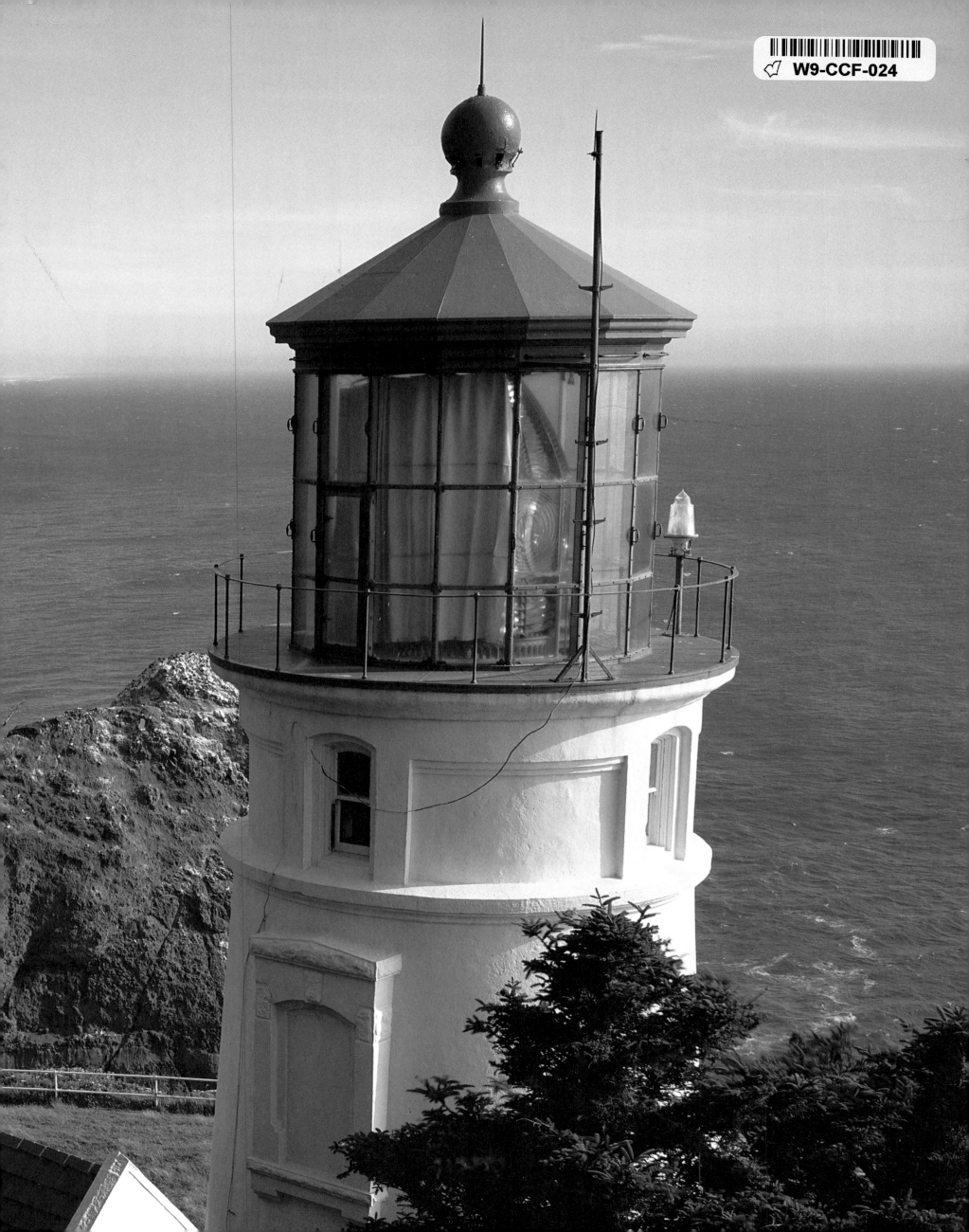

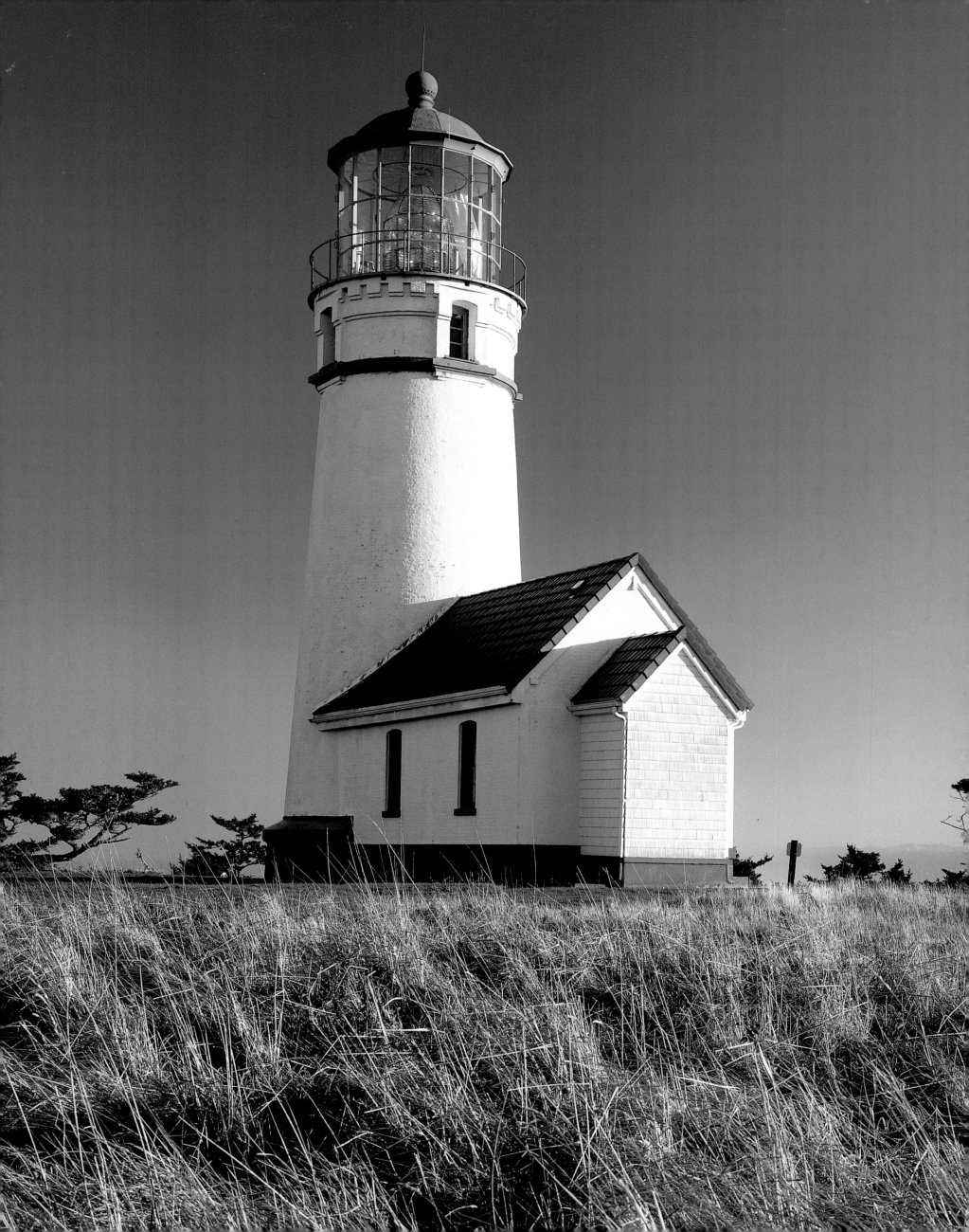

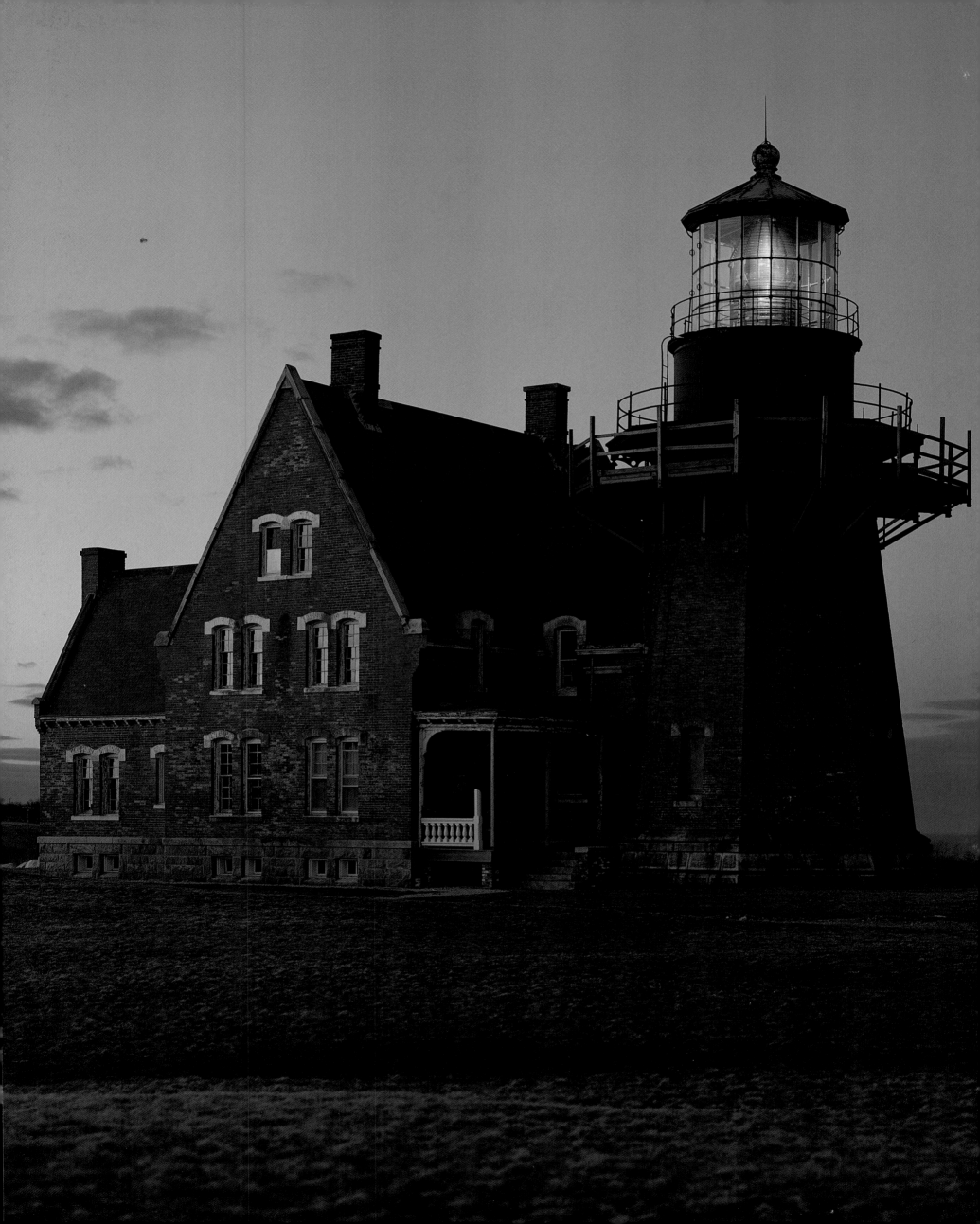

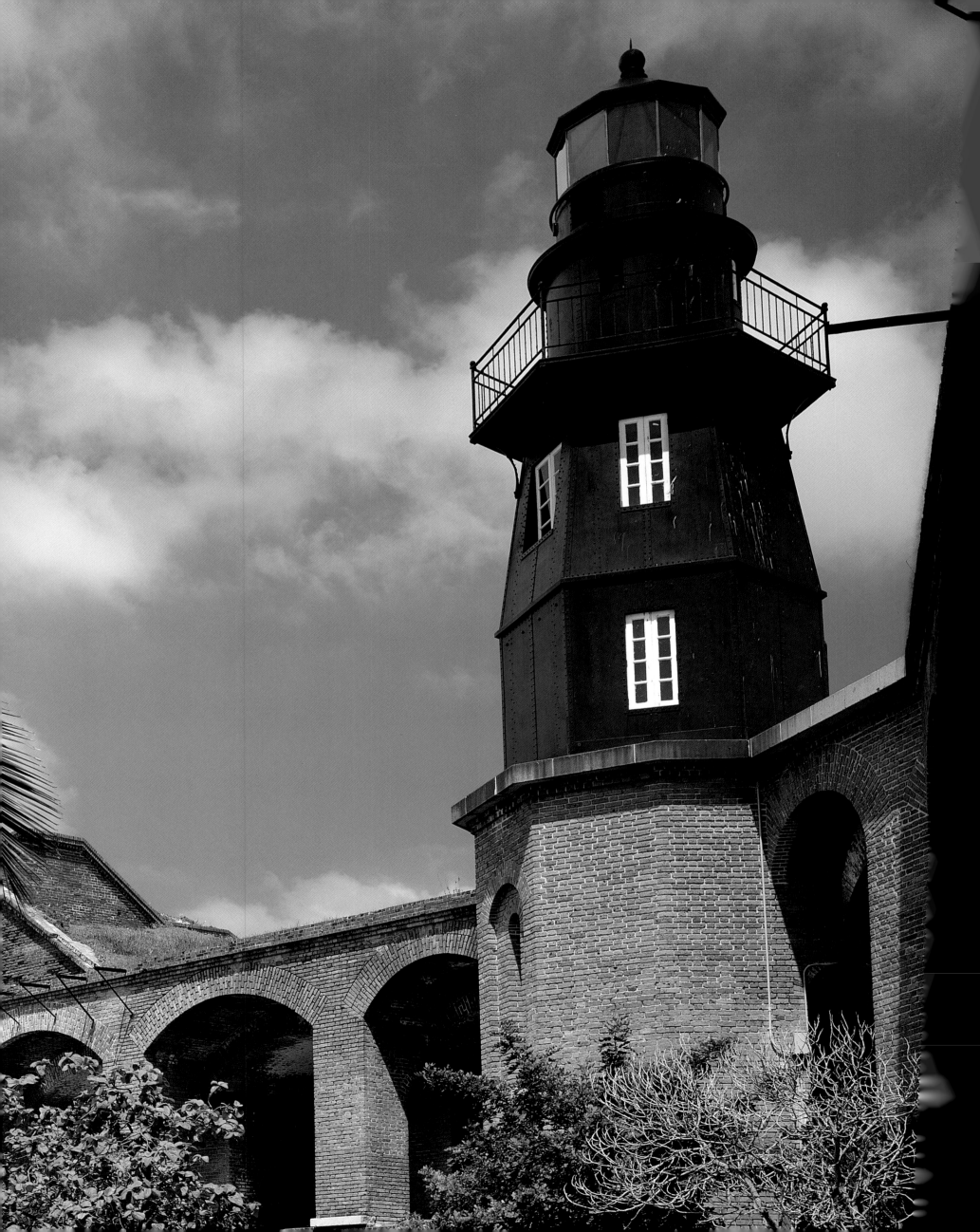

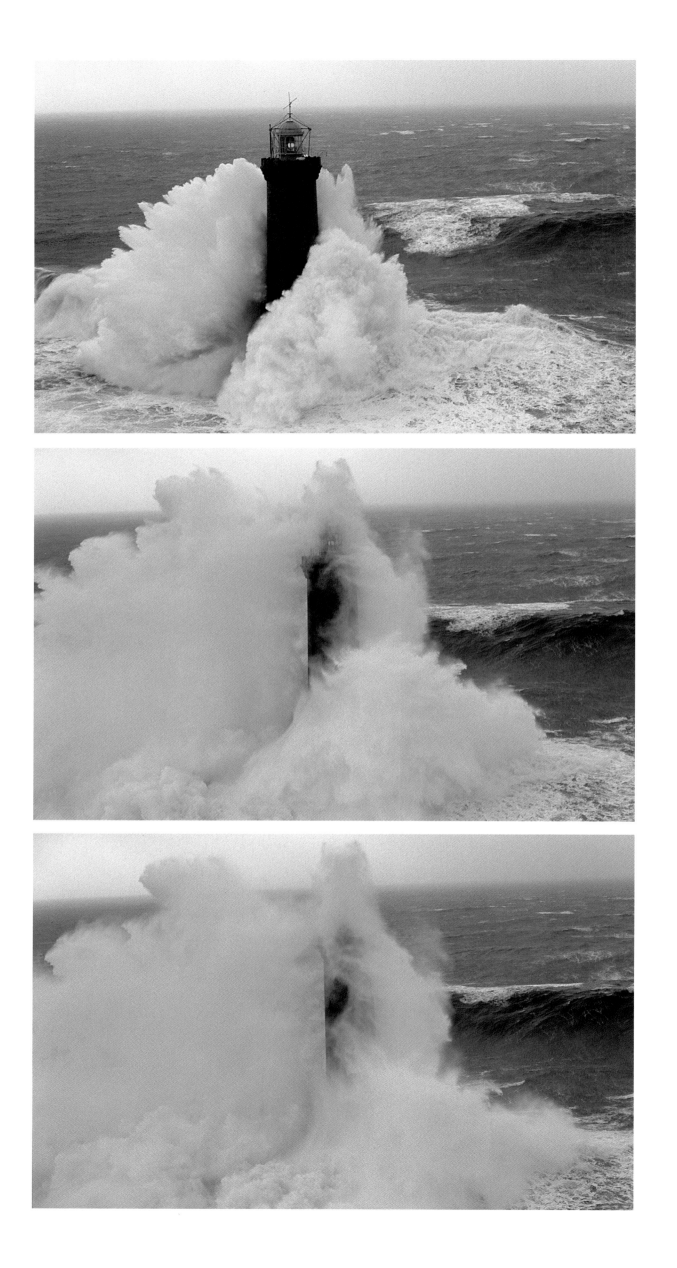

LIGHTHOUSES

Introduction by Michael Vogel

BARNES
&NOBLE
BOOKS
NEW YORK

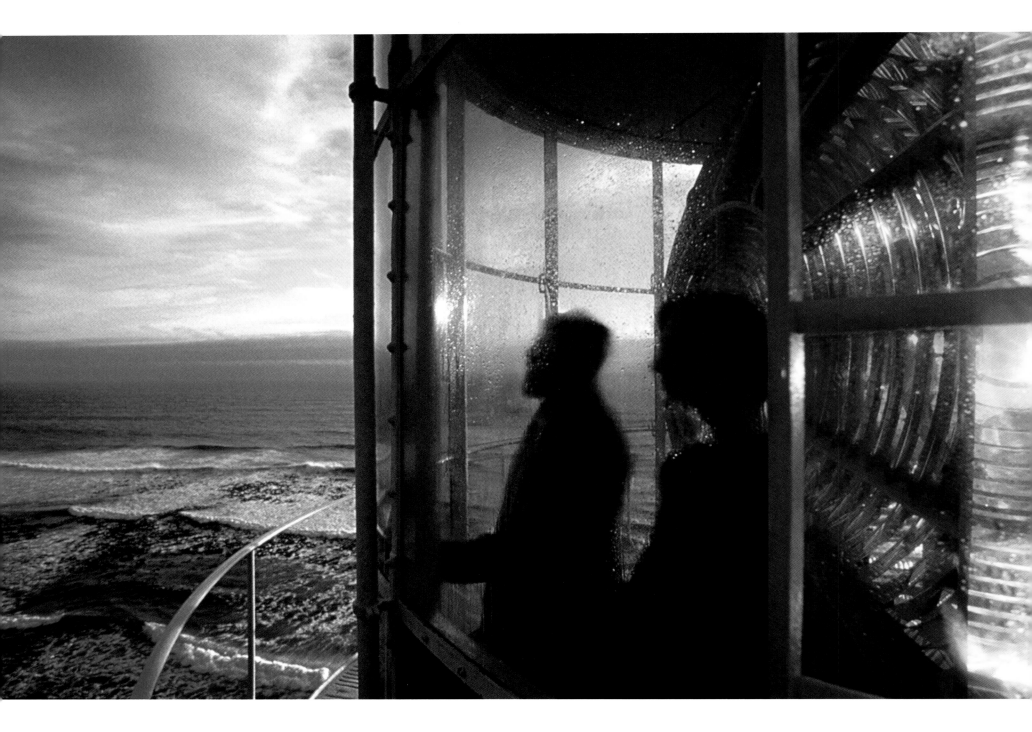

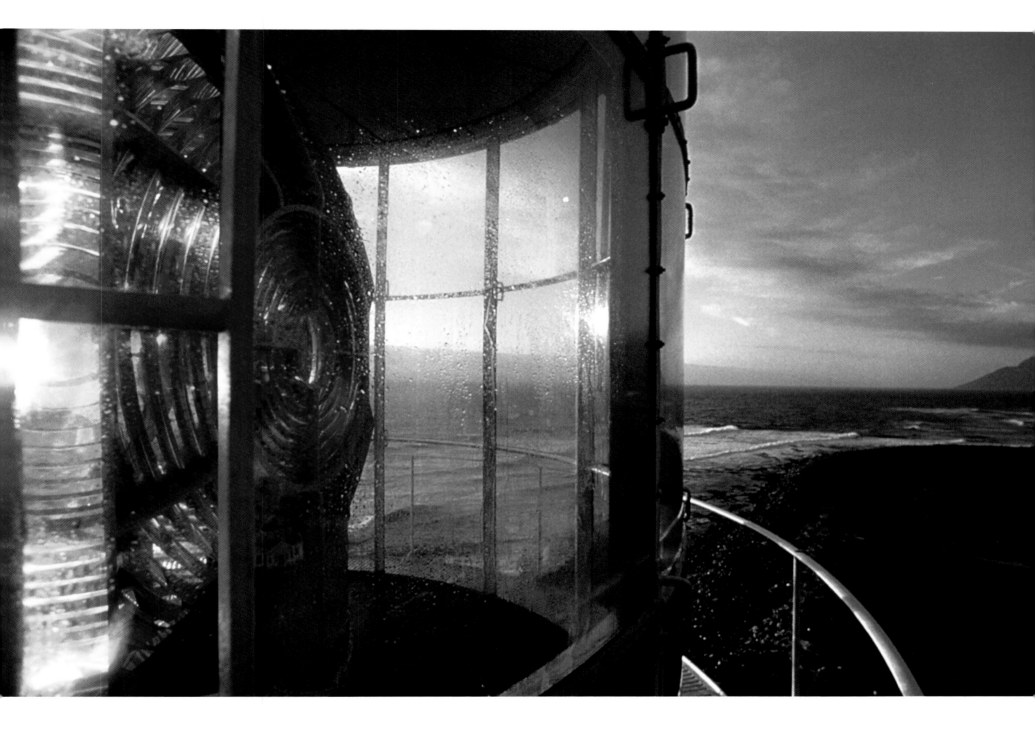

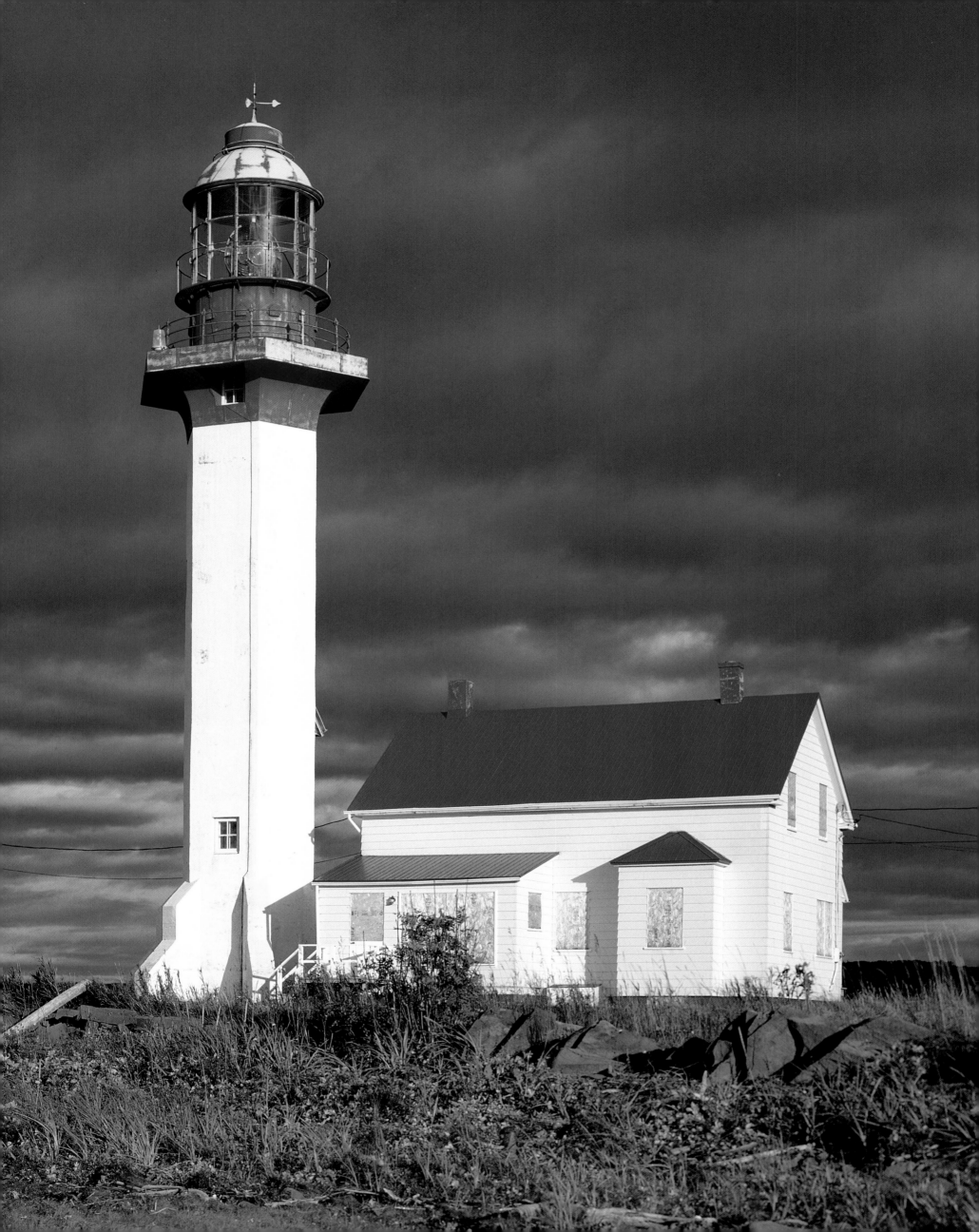

INTRODUCTION

NEAR THE ENTRANCE TO THE BUFFALO COAST GUARD BASE, just a few feet from one of the oldest light stations on the Great Lakes, there is a quotation cast in bronze. The words, written long ago by a man who served a quarter of a century as U.S. Commissioner of Lighthouses, earned their place of honor by capturing the spirit embodied in the nation's myriad shoreline sentinels by those who built them and kept their lights faithfully shining. "The lighthouse and lightship appeal to the interest and better instinct of man because they are symbolic of never-ceasing watchfulness, of steadfast endurance in every exposure, of widespread helpfulness," wrote George R. Putnam, who tended the lights from 1910 until 1935. "The building and the keeping of the lights is a picturesque and humanitarian work of the nation."

The lure of the lighthouse still tugs at us today, although the optical technology that once awed the world has been eclipsed by radar and satellite-based navigation systems. Lighthouses are America's castles, reminders of a romantic past and mantled in mystery. For all their utilitarian purpose, they still call to the heart as strongly as they flash warning or welcome to sailors at sea. "If there is magic on this planet, it is contained in water," Loren Eiseley wrote. But that's only partly true. Magic concentrates at the edges of things, at the boundaries where the world is awash in change. Lighthouses stand at those boundaries; they mark the edge of the familiar and the start of the unknown, and they speak simultaneously of danger and adventure and the comforts of home.

Like diamonds on a continental necklace, lighthouses encircle North America, and shine as well from the shores of American islands in the world's seas. They stand watch in remote places of incredible beauty and amid the bustle of urban harbors. Each has its own personality—both in the daymark characteristics that identify them to mariners and in the twists of time that make up their histories. These towering structures have been celebrated in film and in print, burned and shelled in warfare, destroyed by the fury of storms and tidal waves, and loved by generations of coastal residents and seasonal visitors. Some, in recent years, have even gone on journeys of their own—moved by engineers back from the brink of eroding shores, so their watchfulness may continue for decades yet to come.

For all that, lighthouse would not exist at all if they didn't serve a compelling practical purpose. They are signals, landmarks by day and beacons by night, that keep ships safe. America is a maritime nation, built and preserved by waterborne trade routes that link the heartlands by lake and river to the sea, and the coastal ports to markets throughout the world. Lighthouses enabled that trade, by making those routes safe.

America's first permanent lighthouse was built on Little Brewster Island in Boston Harbor, in 1716. About a dozen lighthouses were in existence when the thirteen original colonies became the United States, and in 1789—in only its ninth official act—a new Congress established federal control of lighthouses in a

measure signed by President Washington. The number of American lighthouses grew rapidly, matching both the needs of maritime commerce and the growth of a nation; in all, between 1,200 and 1,300 beacons would be built as part of the world's most complex system of navigational aids. Today, despite the inroads of time and automation, 631 historic towers still survive on 611 light station sites.

Lighthouses come in an array of shapes and sizes. Differences are essential because they allow mariners to identify the tower or the light at which they are looking, and that identification helps pinpoint a ship's location on navigational charts that mark surface and submerged hazards as well as harbor entrances. Shapes, colors, and patterns help identify lighthouses by day; at night, beacons may show steady white, red, or green lights, or they may flash in identifiable sequences. Some clear lights add a red sector—a shift in color warns sailors that they are entering dangerous waters.

Before the advent of electronic aids, navigation at night was far more hazardous than daytime sailing. Shoreline signal fires gave way in antiquity to towers that could elevate the flames and make them visible much farther out to sea; the Pharos of Alexandria was one of the seven wonders of the ancient world, and the science of lighthouses is still known as pharology today. But wood and coal fires, and the candles and then lamps that replaced them, were relatively poor lights even when backed by reflectors. It wasn't until 1821 that a French engineer named Augustin Fresnel perfected the complex arrangement of lens and prisms that glows at the heart of a classical lighthouse; by the Civil War, the shining jewels of crystal and brass known as Fresnel lenses had been installed throughout the American lighthouse system.

The shape and height of lighthouses is dictated mainly by geography and the distances at which the light should be visible. But the role played by the different types of lighthouses usually dictated the size of the lens and of the "lantern" that housed it. One super-lens, the hyperradiant at Makapu'u Point on the island of Oahu, was installed to mark the Hawaiian landfall. First-order lenses, standing more than eight feet tall and weighing more than six tons, were used in the largest seacoast lights. Second-order lenses shone from coastal islands, sounds, and major Great Lakes lighthouses. Third-order lenses commonly marked harbor entrances, and fourth, fifth, and sixth-order lenses generally were use in towers marking breakwaters, rivers, shoals and reefs, or piers. Occasionally, towers and their lenses would be paired as "range" lights: when the towers or lights appeared directly in line, the mariner's vessel was in the middle of a navigational channel.

Today, many of the high-maintenance classical lamps and lenses have been replaced by modern optics. About four hundred such lenses survive, some in use but many in museum displays. The technology has reversed—Fresnel was forced to develop a powerful lens because there were only weak light sources to work with, while today's powerful lights are encased in a one-piece lens that is more protective cover than magnifier.

Fresnel's lenses could be rotated by clockwork mechanisms, floating over beds of mercury or rolling almost effortlessly on bearings or "chariot wheels." By installing bull's-eye lenses amid the prisms that bent relatively weak lights into powerful, focused planes of illumination, Fresnel made his rotating lenses seem to flash. Looked at from above, a rotating Fresnel lens resembles a spinning wagon wheel of light with a spoke blazing from each bull's-eye. On ships at sea, the light "flashes" each time the spoke passes by. This technological advance allowed the government to abandon older and more expensive ways to distinguish between light stations, including twin, and even triple, arrays of towers.

Each of America's coasts also contributed architectural distinctions to the nation's lighthouses. Towers on low-lying Atlantic coasts are often tall and thin, like the nationally recognized Cape Hatteras Lighthouse, designed to raise the light high and make it visible for greater distances. Pacific highlands provided natural height and led to a style of short towers, often through the roofs of the lightkeepers' quarters, although in some places headlands rose invisibly above thick fog banks and the towers had to be relocated closer to sea level. The Chesapeake, Florida's waters, and parts of the Gulf Coast added spidery screwpile-anchored lighthouses and skeleton towers to the list, and the Great Lakes contributed a densely packed array of styles with Victorian and Italianate flair. And, of course, the Statue of Liberty was once a lighthouse.

The styles, the technology, and the history, though, don't fully explain the allure of lighthouses or the passion with which local and national volunteer groups have worked in recent decades to save them. "Lighthouses have long had a strong appeal to Americans, an attraction that becomes more intense as time passes, fueled no doubt by the fact that our historic lights are being automated and in many cases replaced," notes lighthouse historian F. Ross Holland Jr. "Only someone with a closed mind or a cold heart will not be at least momentarily drawn to a lighthouse, for its attraction is at once visual, emotional, and intellectual."

What worlds await, beyond the lighthouse? That depends on where you're standing—on familiar slopes of land, gazing out toward the boundless wave-swept stretch of the sea, or aboard a ship gazing toward a journey's end and the solid comforts of home and destination. That's the magic of edges, of the boundaries symbolized by and embodied in lighthouses. There are landscapes and seascapes of the mind and emotions as well, and upon the journey we all take through each of them the symbolic steadfastness and guidance of the lighthouse sheds its light.

Humanity has always been drawn to the edges and beyond. The need to explore is strong within us, yet we yearn for home. Lighthouses stand, physically and symbolically, at the places where both are equally possible, and the call is equally strong. They speak to us of going out and coming in, of voyages begun and voyages ended and voyages yet to come. They stand unchanging, amid seas of change. Lighthouses encourage us on our outward journeys, and welcome us to return. And when we become a race of spacefarers, chances are there will be beacons beyond the Sun to guide us ever outward, and welcome us ever home.

Every night in the year, when darkness has fallen on the Cape and the sombre thunder of ocean is heard in the pitch pines and the moors, lights are to be seen moving along these fifty miles of sand, some going north, some south, twinkle and points of light solitary and mysterious.

Henry Beston, from *The Outermost House*

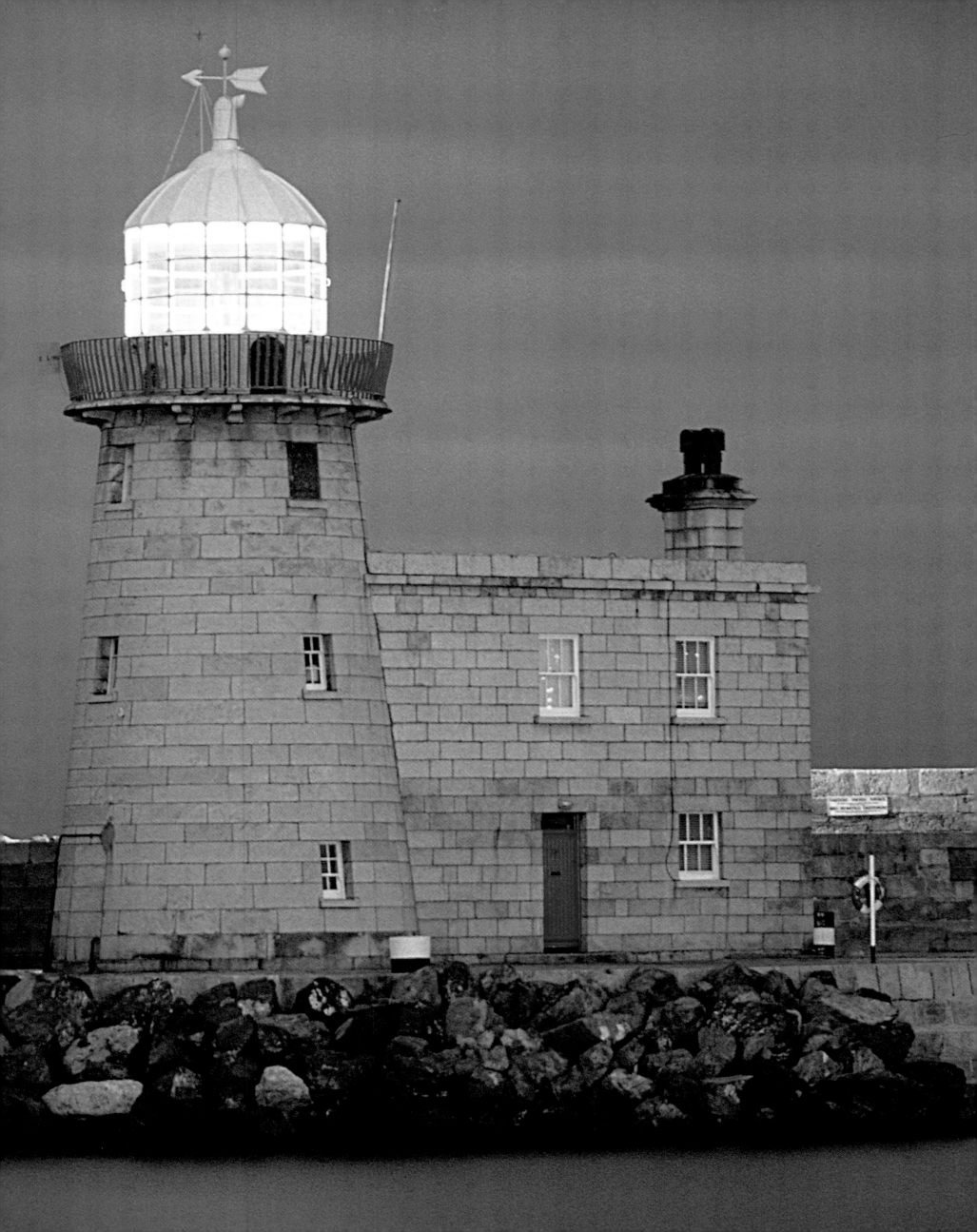

*M*ay I for my own self song's truth reckon,

Journey's jargon, now I in harsh days

Hardship endured oft.

Bitter breast-cares have I abided,

Known on my keel many a care's hold,

And dire sea-surge, and there I oft spent

Narrow nightwatch nigh the ship's head

While she tossed close to the cliffs.

From *The Seafarer*, tenth-century English poem

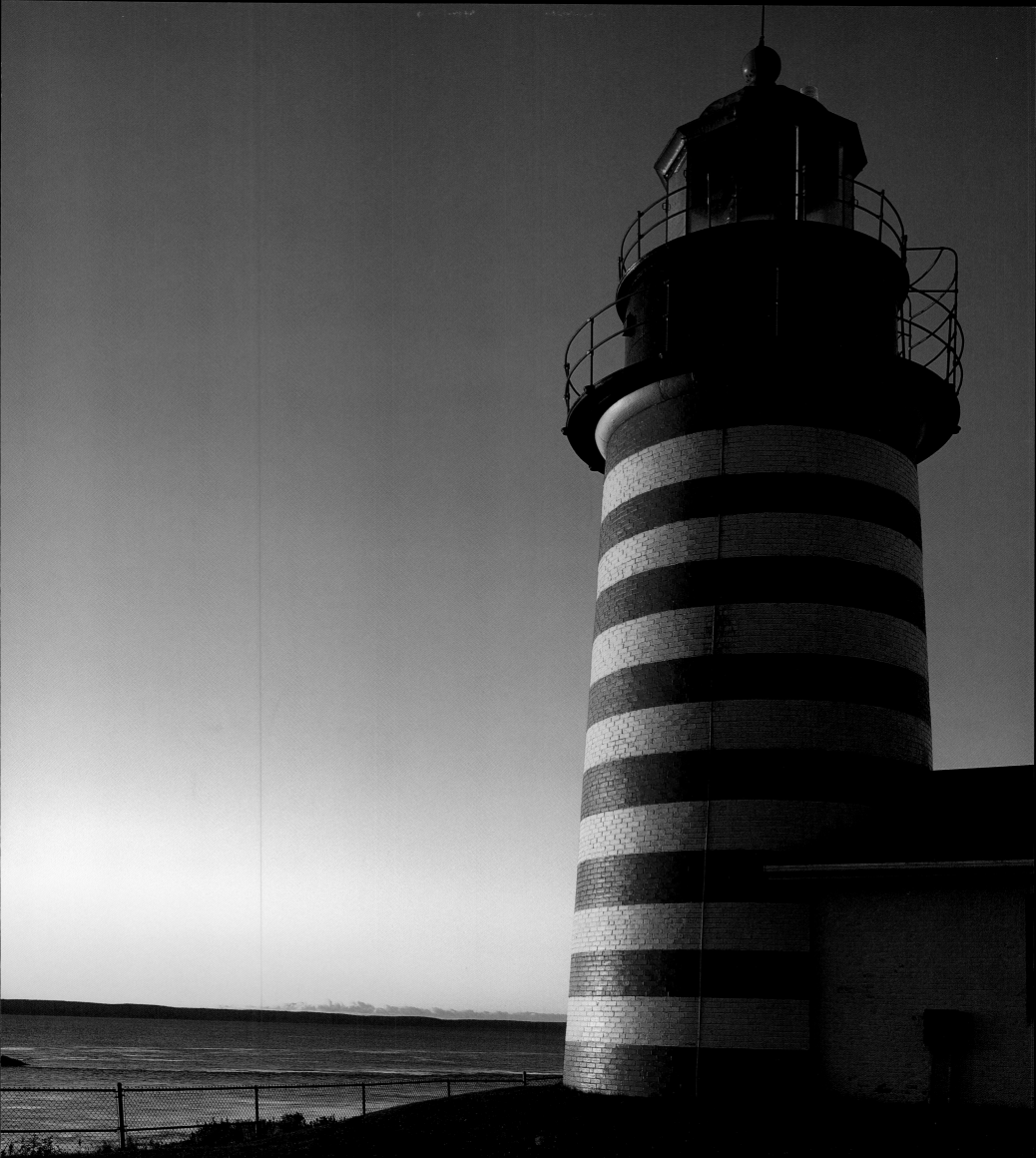

Alone upon the leaping billows, lo!

What fearful image works its way? A ship!

Shapeless and wild…

Her sails disheveled and her massy form

Disfigured, but tremendously sublime;

Prowless and helmless through the waves she rocks

And writhes as if in agony! Like her

Who to the last avail o'er starving foes,

Sinks with a bloody struggle into death,—

The vessel combats with the battling waves

Then finally dives below! The thunders toll

Her requiem, and whirlwinds howl for joy.

George Crabbe

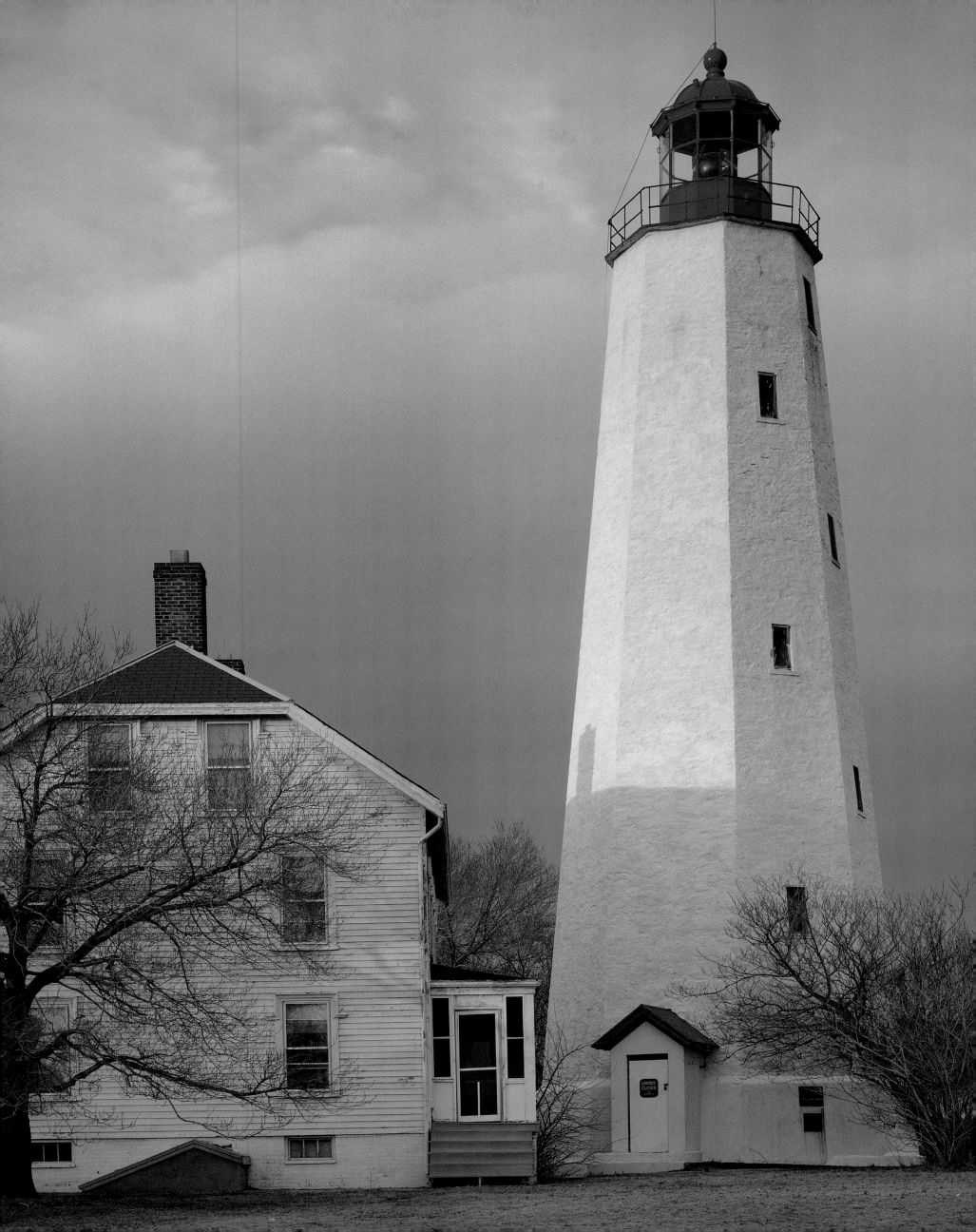

The light-house lamps were still burning, though now with a silvery lustre, when I rose to see the sun come out of the Ocean; for he still rose eastward of us; but I was convinced that he must have come out of a dry bed beyond that stream, though he seemed to come out of the water.

Henry David Thoreau, from *Cape Cod*, The Sea and the Desert

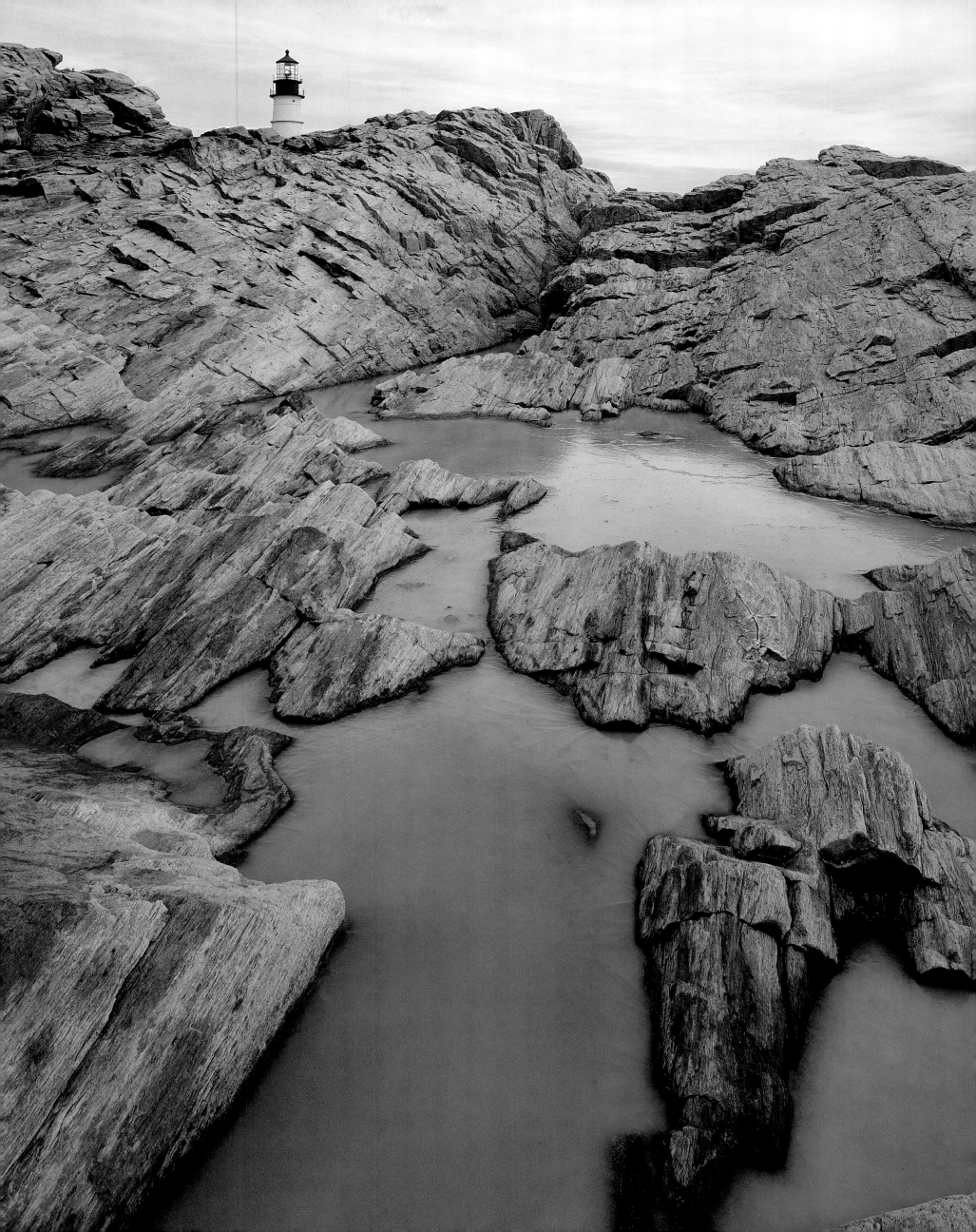

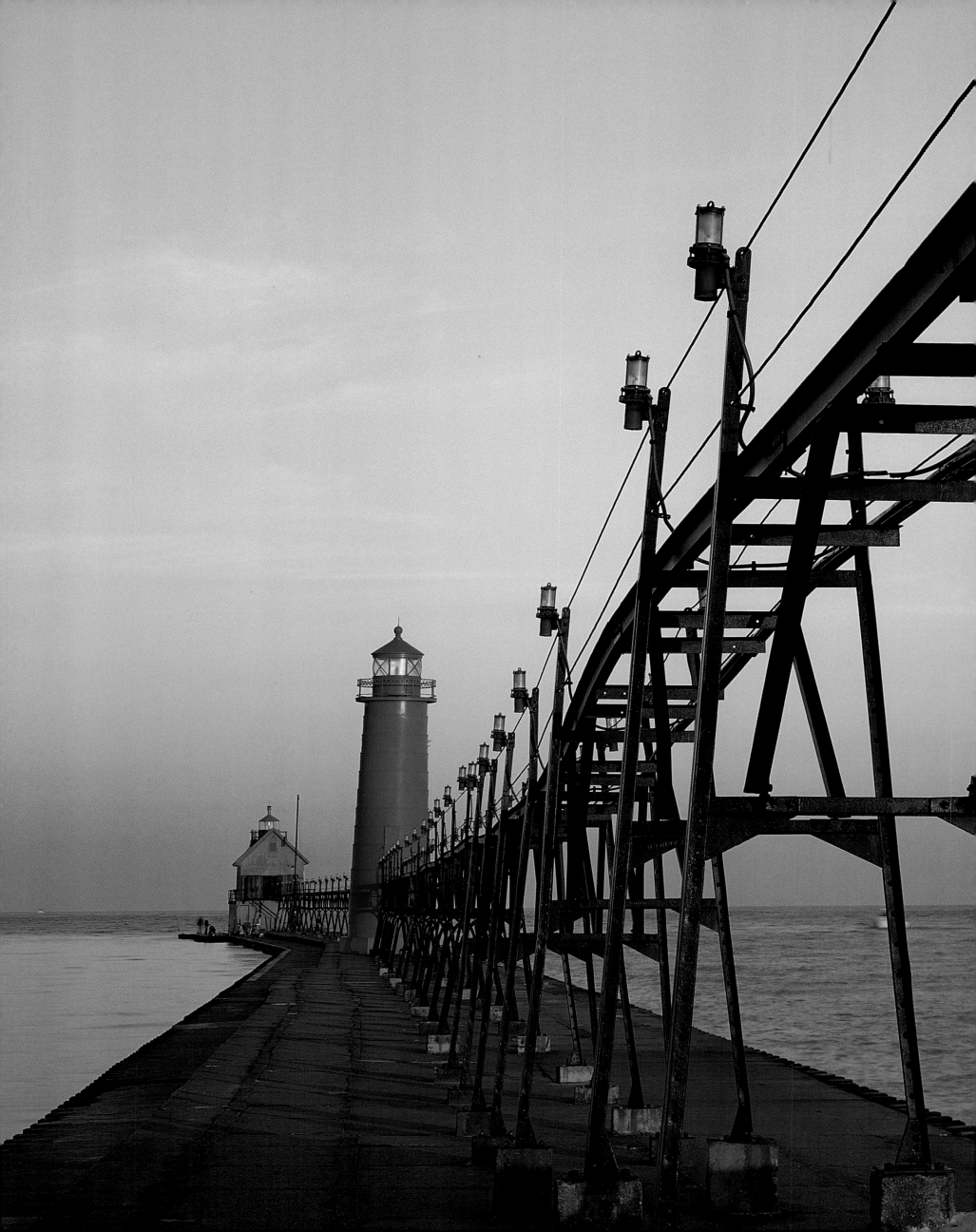

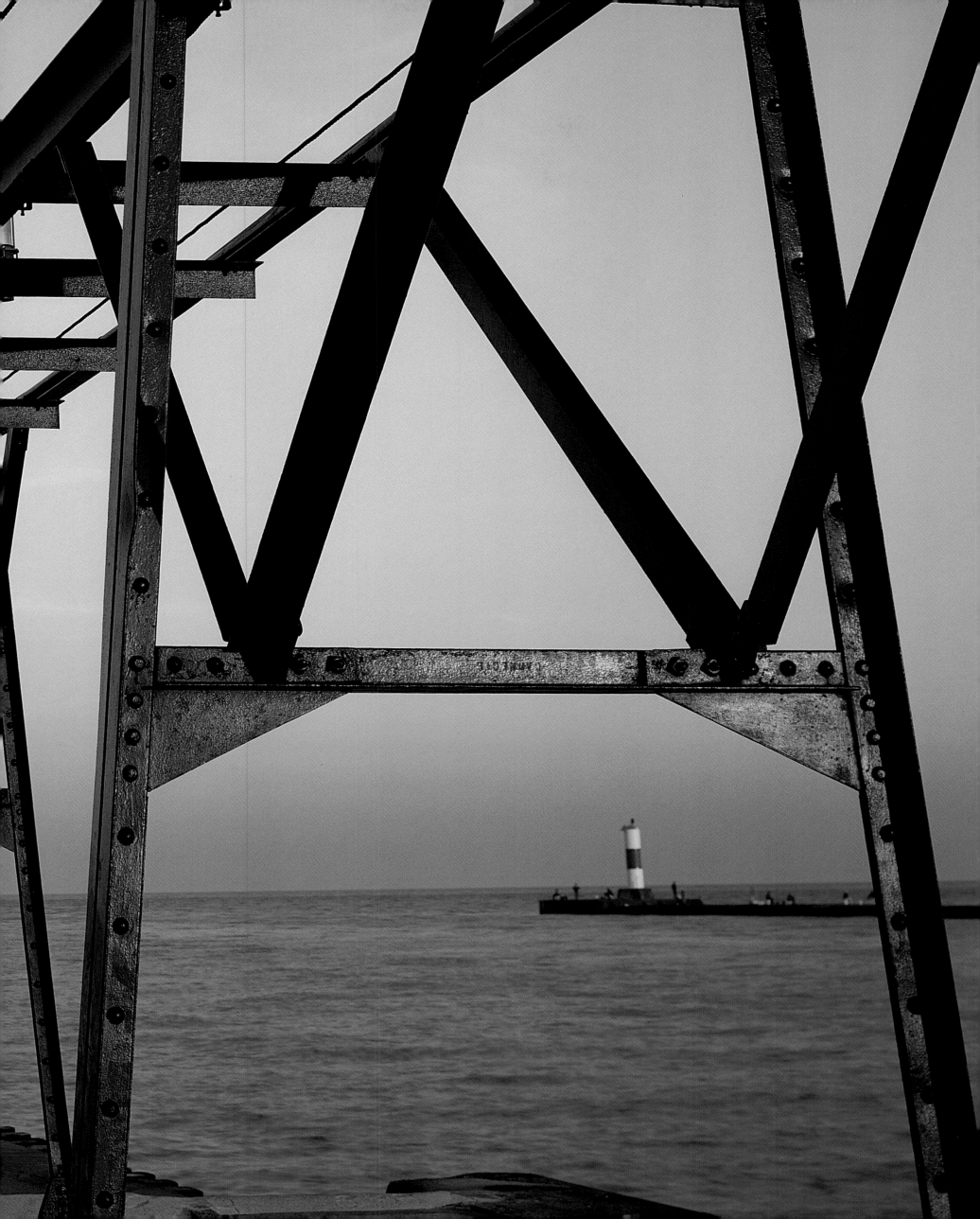

The work to build a lighthouse] …has been more changeable and trouble-some than I expected for the inhabitants near think they suffer in this erection. They affirm I take God's grace from them. Their English meaning is that now they shall receive no more benefit by shipwreck, for this will prevent it. They have been so long used to reap profit by the calamities of the ruin of shipping, that they claim it to be hereditary, and hourly complain to me but I hope they will now husband their land, which their former idle life has omitted in the assurance of their gain by shipwreck.

Sir Killegrew, of his application in 1619 to erect a beacon on Lizard Point

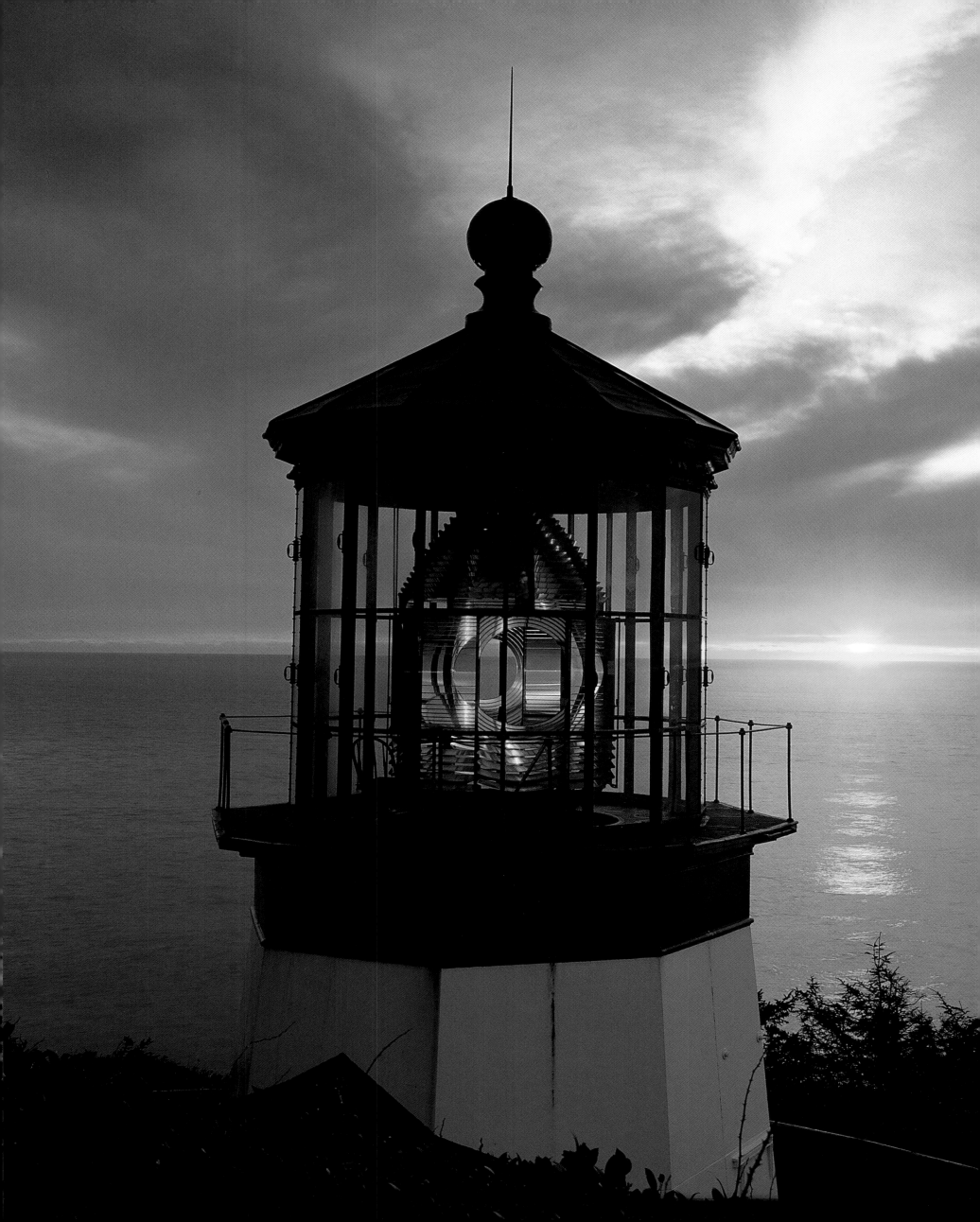

*O*ften I think of the beautiful town
That is seated by the sea;
Often in thought go up and down
The pleasant streets of that dear old town,
And my youth comes back to me.

I can see the shadowy lines of its trees,
And catch, in sudden gleams,
The sheen of the far-surrounding seas,
And islands that were the Hesperides
Of all my boyish dreams.

Henry Wadsworth Longfellow, from *My Lost Youth*

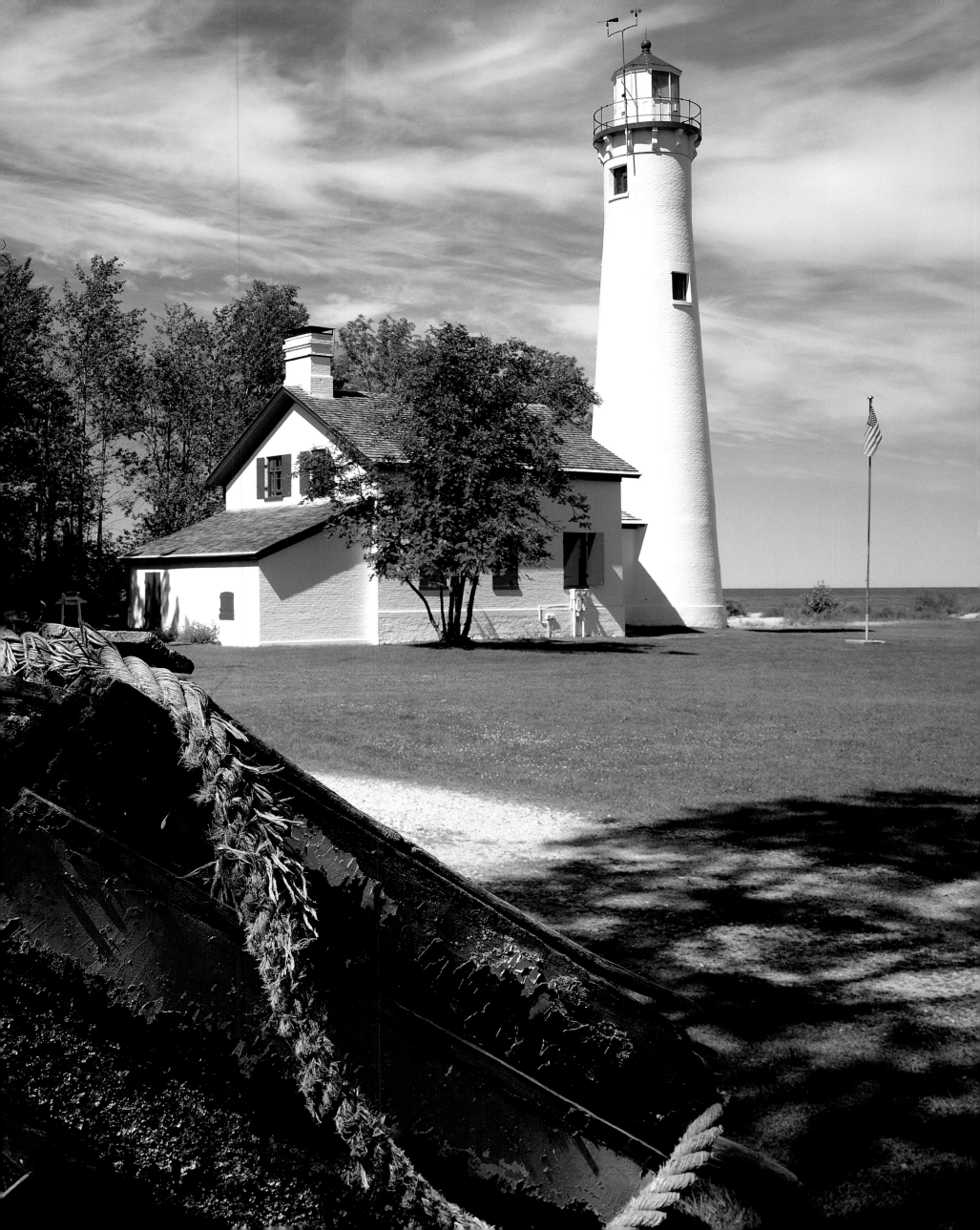

*T*he ship was cheered, the harbor cleared,
　　Merrily did we drop
　Below the kirk, below the hill,
　　Below the lighthouse top.

．．．．．．．．．．．．．．．．．．．．．．．．．．．．．．．．．

　The sun now rose upon the right:
　　Out of the sea came he,
　Still hid in mist, and on the left
　　Went down into the sea.

And the good south wind still blew behind,
　　But no sweet bird did follow,
　Nor any day for food or play
　　Came to the mariner's hollo!

Samuel Taylor Coleridge, from *The Rime of the Ancient Mariner*

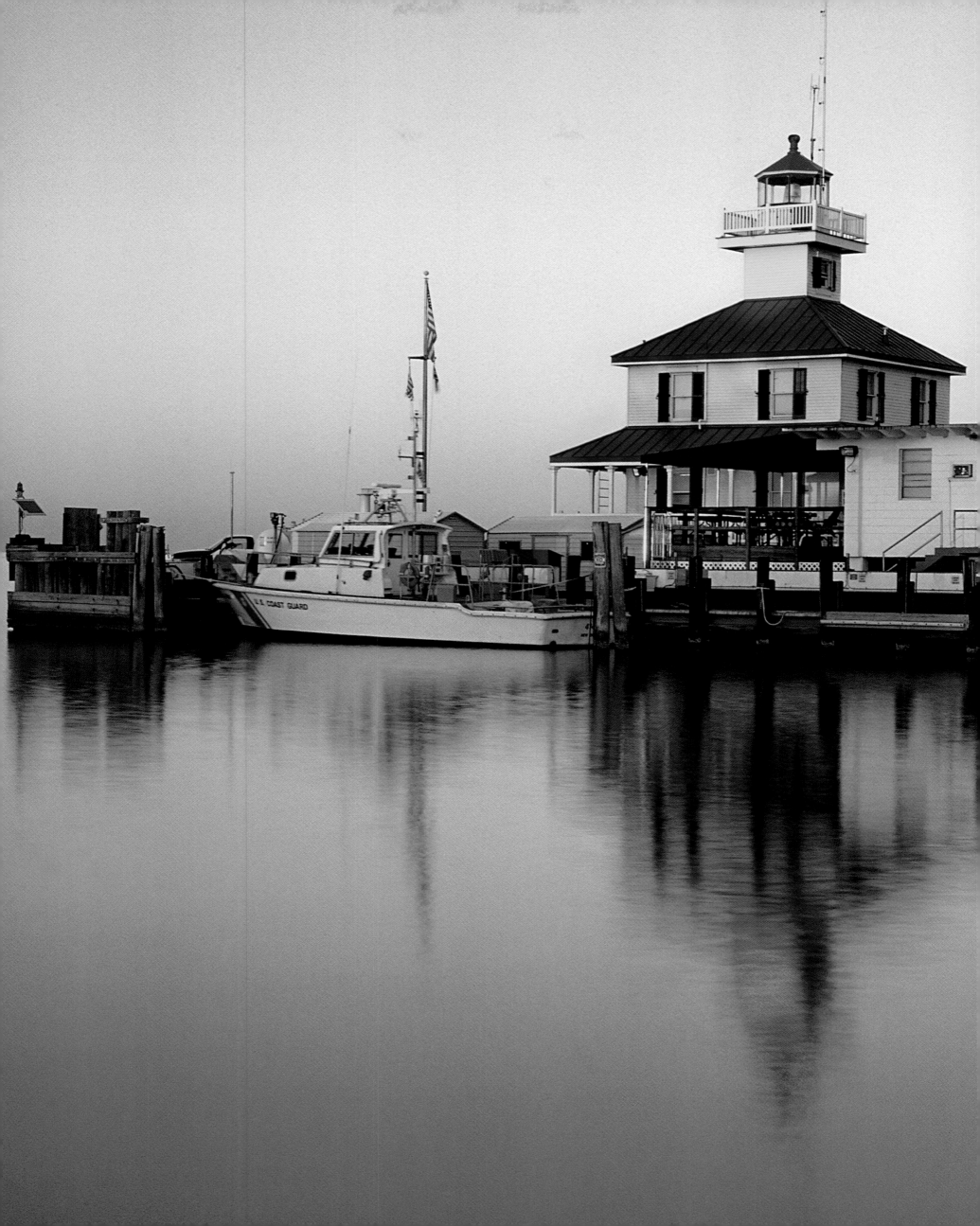

Yet, were I fein to remain

Watch in my tower to keep,

And tend my light in the stormiest night

That ever did move the deep.

And if I stood, why then 'twere good,

Amid their tremulous stirs,

To count each stroke when the wild waves broke

For cheers of mariners.

Jean Ingelow

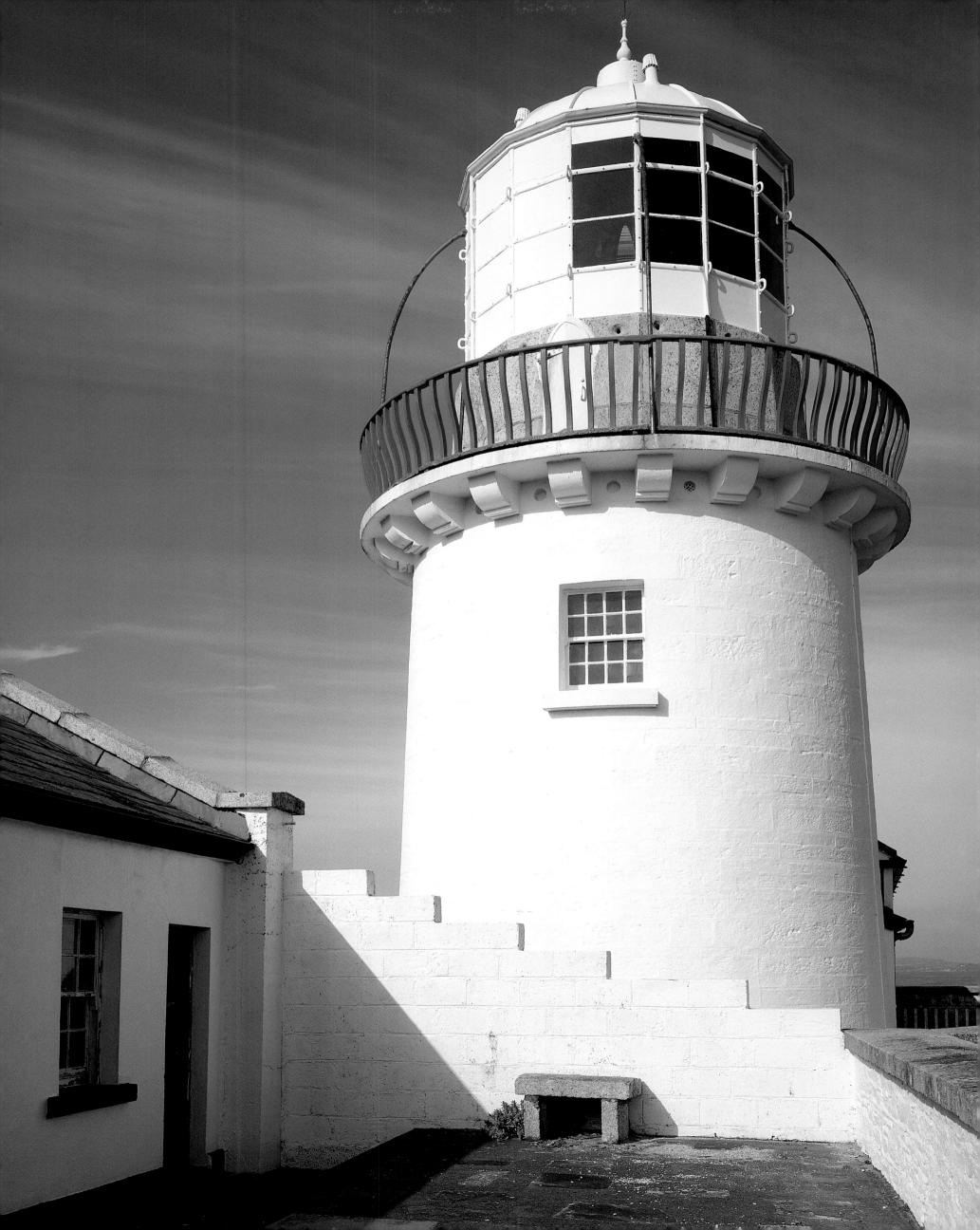

*S*oon the sharp prows were cleaving

The silver highway of the seas;

The light monsoon breezes blew

With their safe, persistent pressure;

The sailors talked of their perils

They had passed, for tension eases

Slowly from the mind when mere chance contrives

To bring us through great hazards with our lives.

Luis Vaz de Camões, from *The Lusiads*

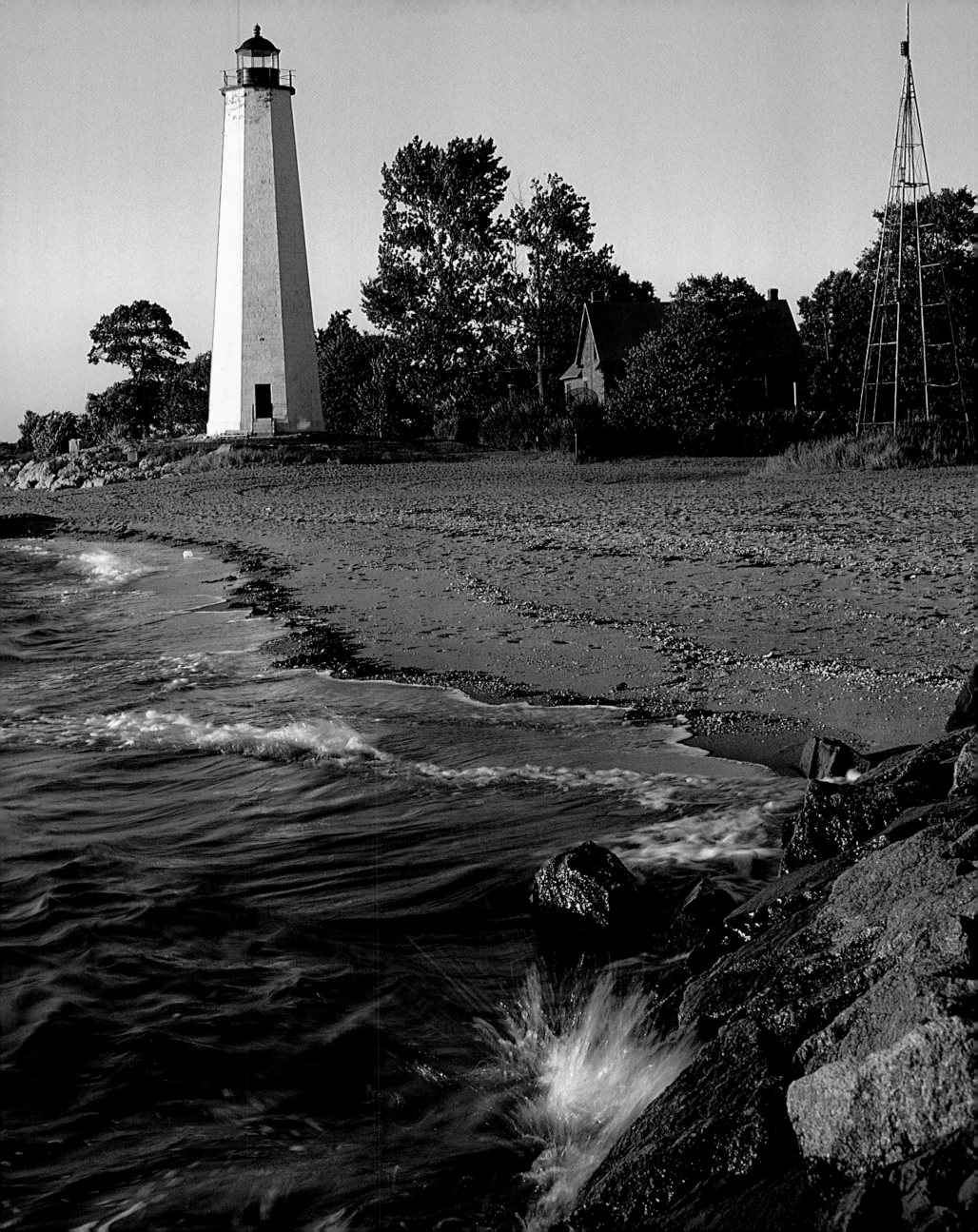

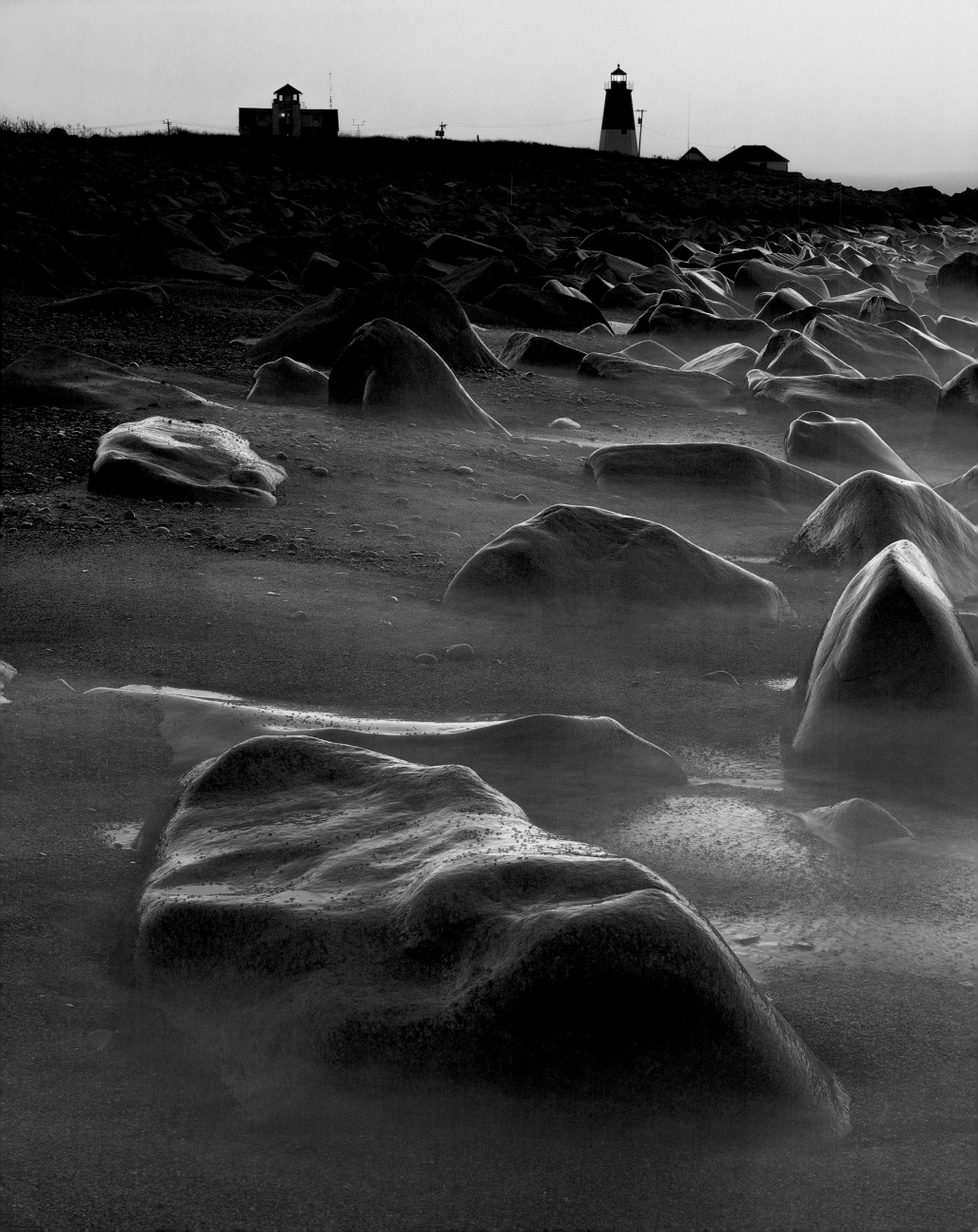

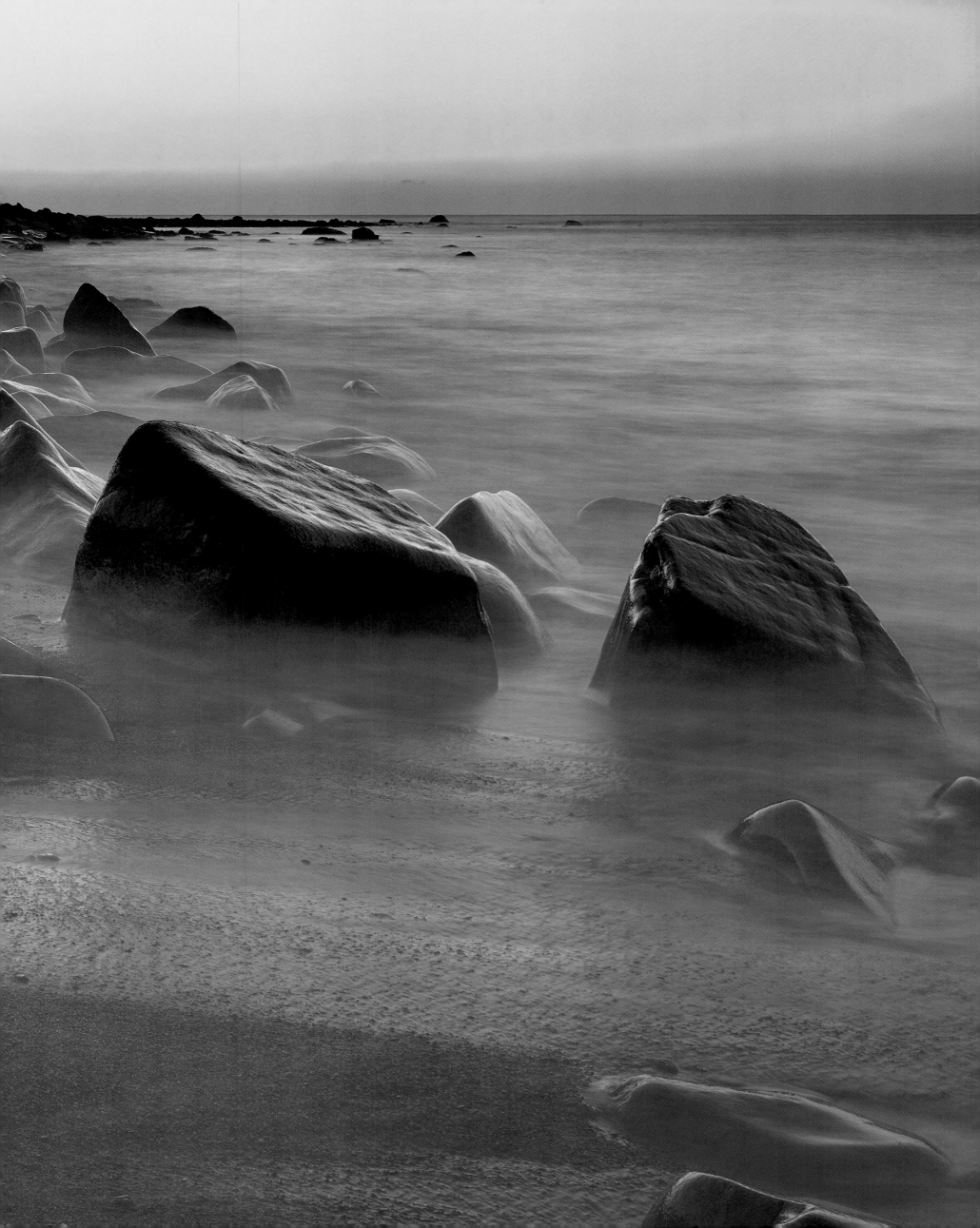

*I*t depresseth all vanities, dissolution, and lightness of manners, and, like as the beacon lighted in the night, directeth the mariner to the port intended, so the meditation of death maketh man to eschew the rocks and perils of damnation.

From *Pilgrimage of Perfection,* attributed to William Bonde

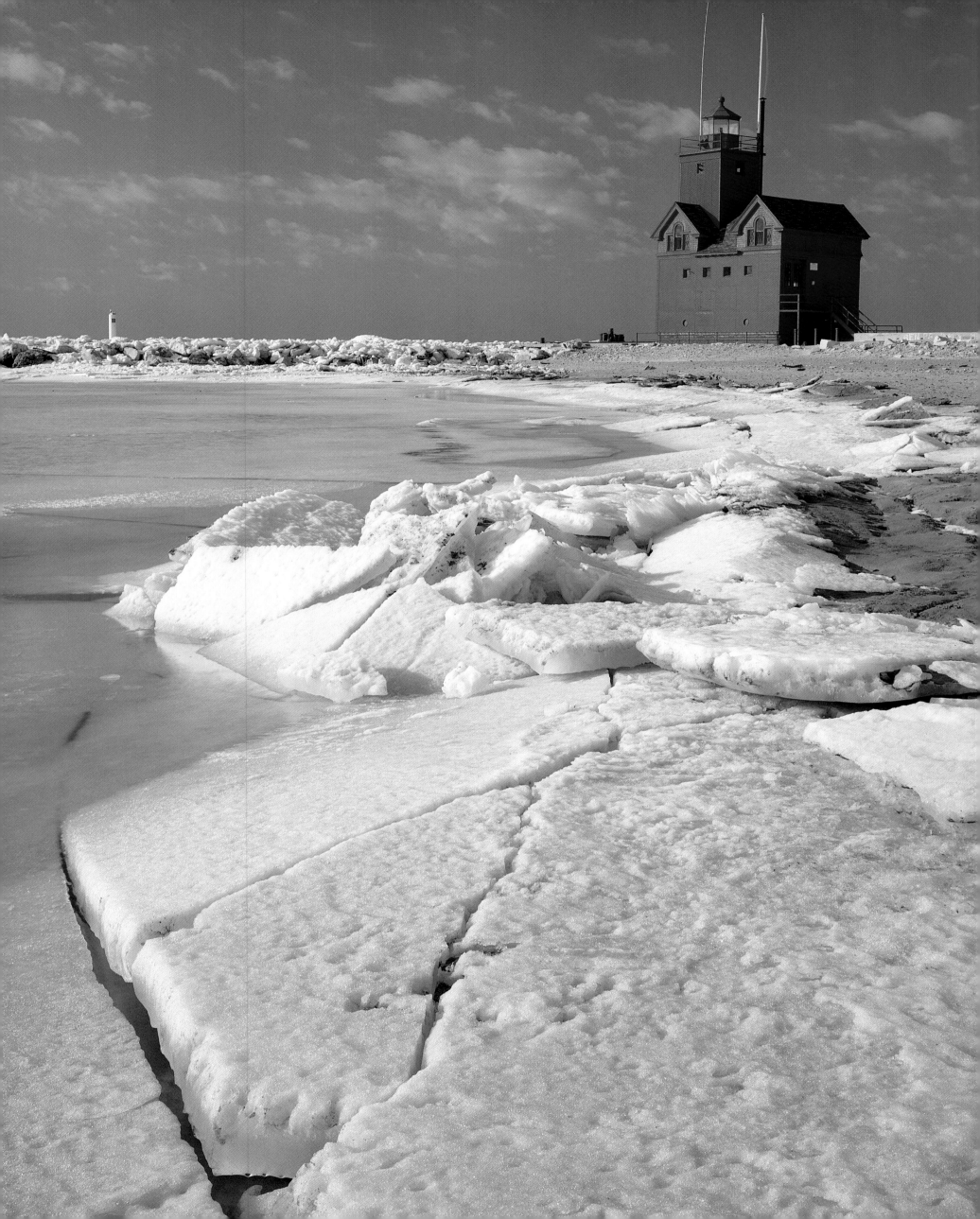

T lit the lamps in the lighthouse tower
For the sun dropped down and the day was dead.
They shone like a glorious clustered flower—
Ten golden and five red.

Celia Thaxter

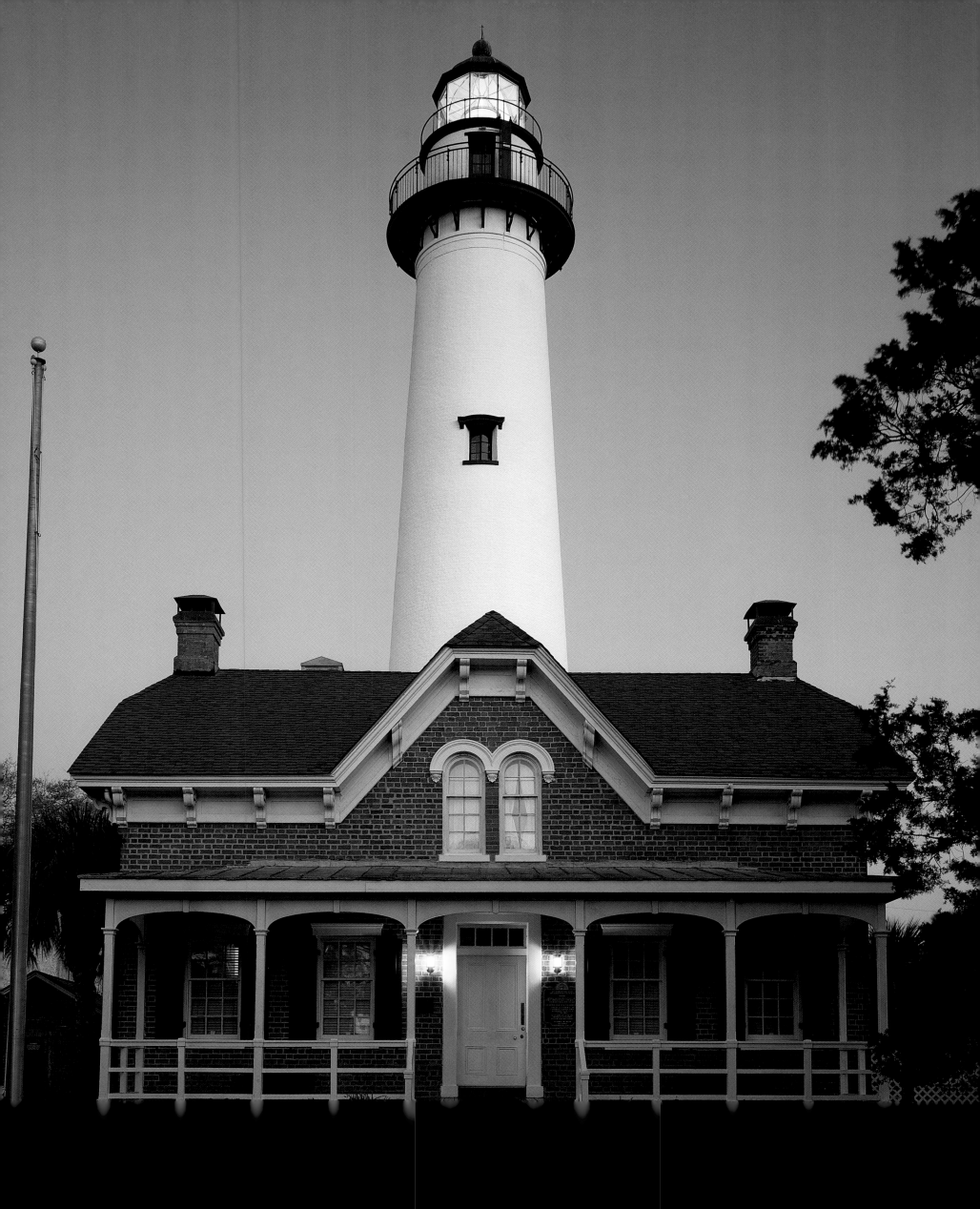

\mathcal{J}ames looked at the Lighthouse. He could see the white-washed rocks;
the tower, stark and straight; he could see that it was barred with black and white;
he could see the windows in it; he could even see washing spread
on the rocks to dry. So that was the Lighthouse, was it?

Virginia Woolf, from *To the Lighthouse*

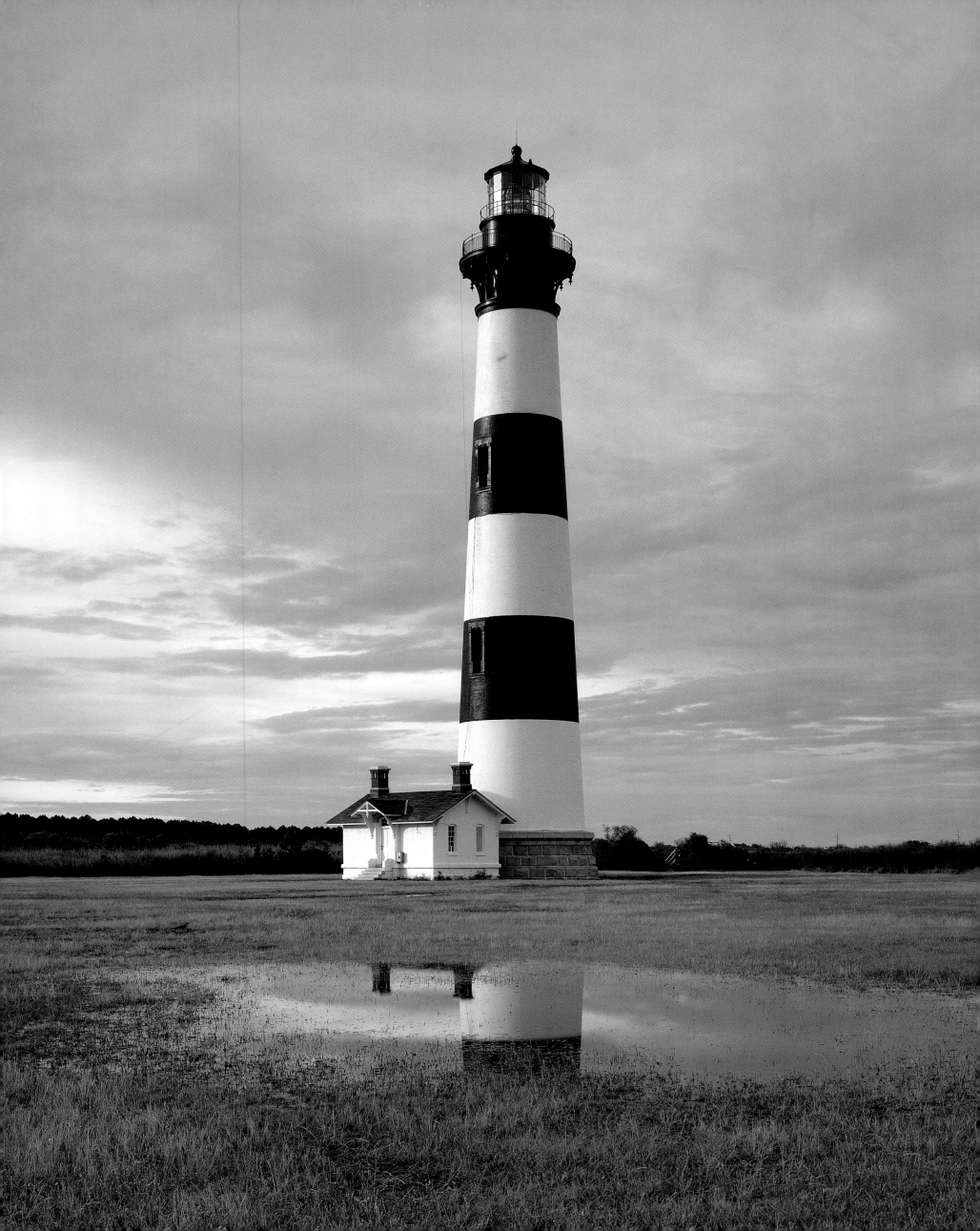

*F*ar in the bosom of the deep,

O'er these wild shelves my watch I keep,

A ruddy gem of changeful light,

Bound on the dusky brown of Night,

The seaman bids my lustre hail,

And scorns to strike his timorous sail.

Sir Walter Scott, *Pharos Loquitur*

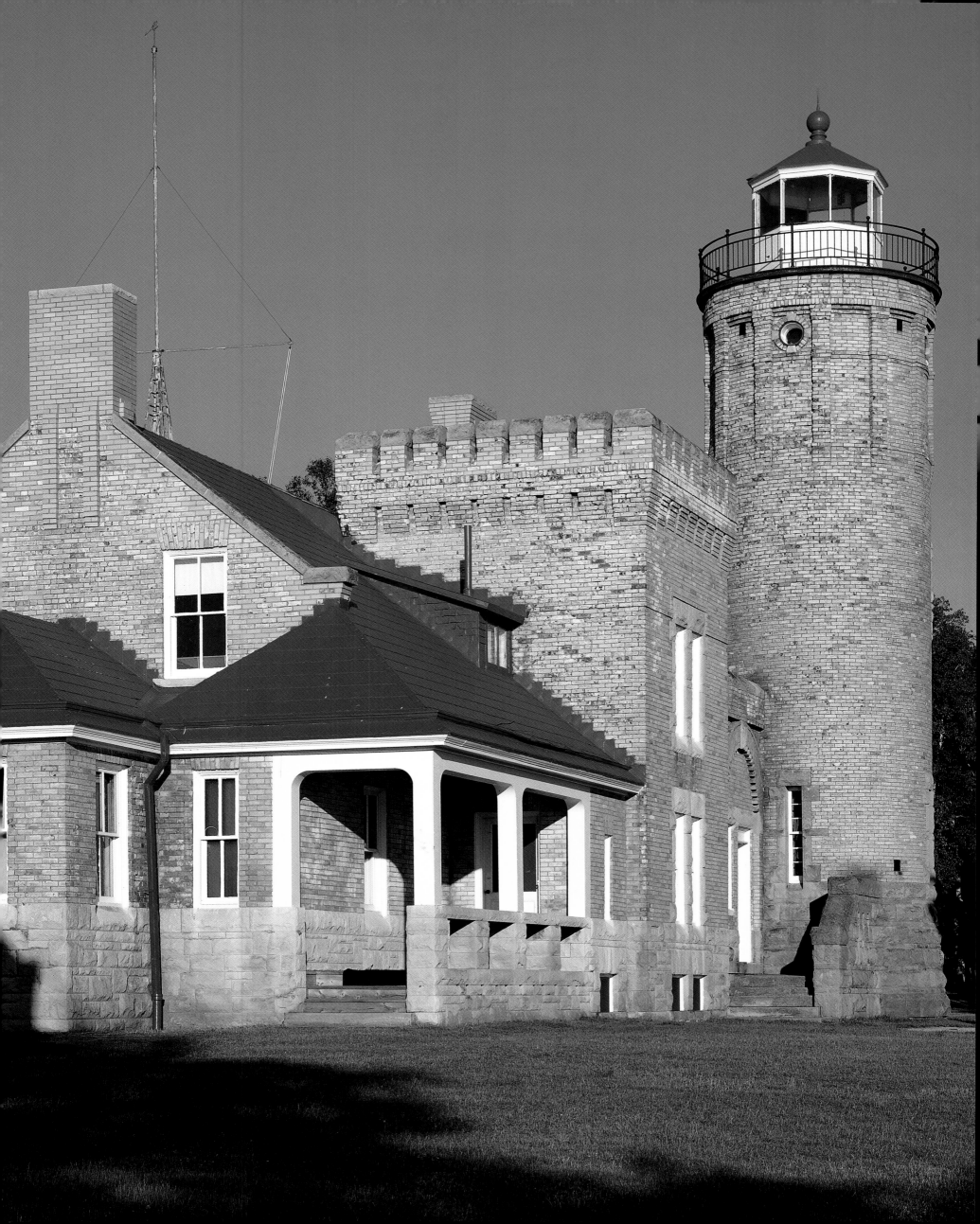

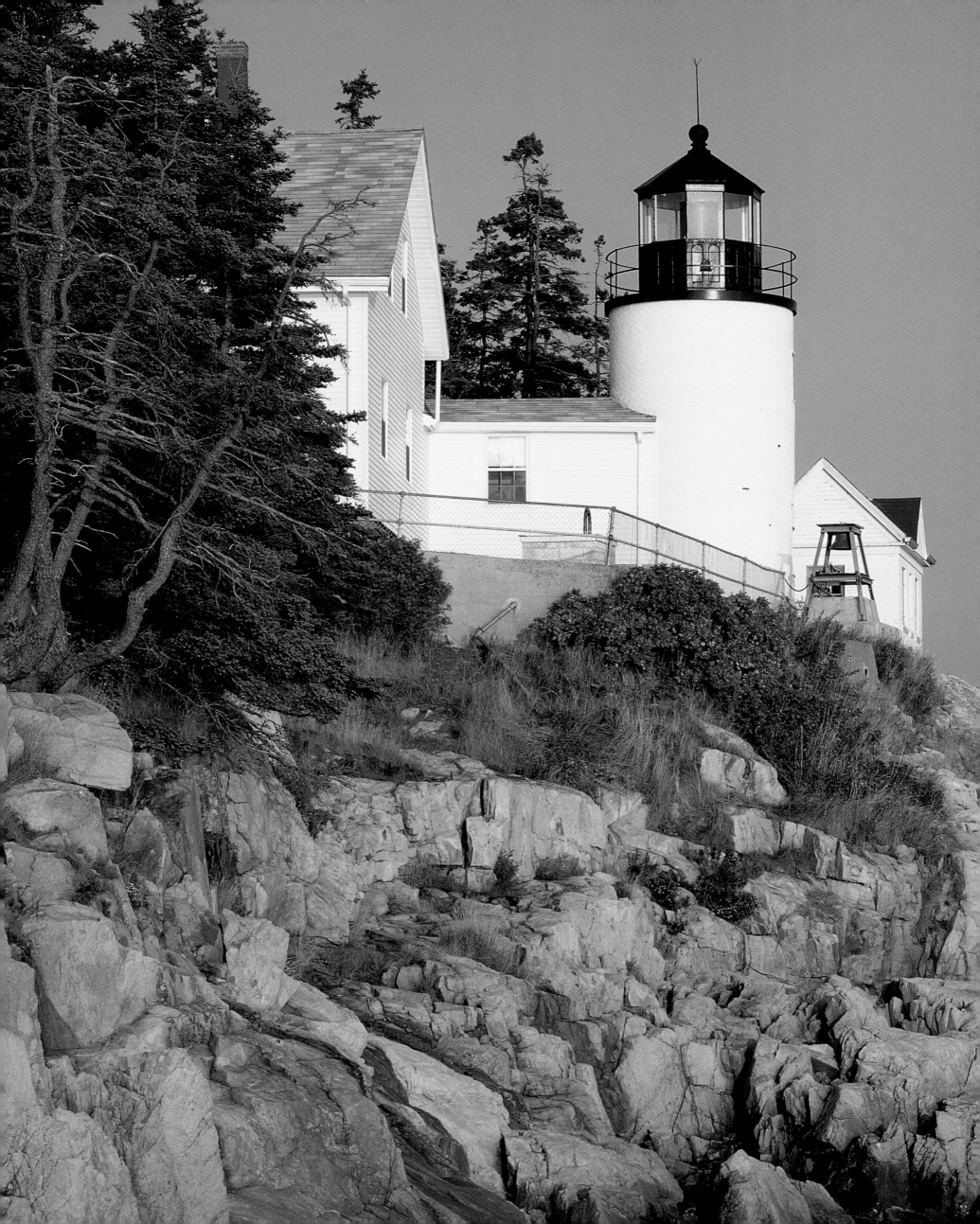

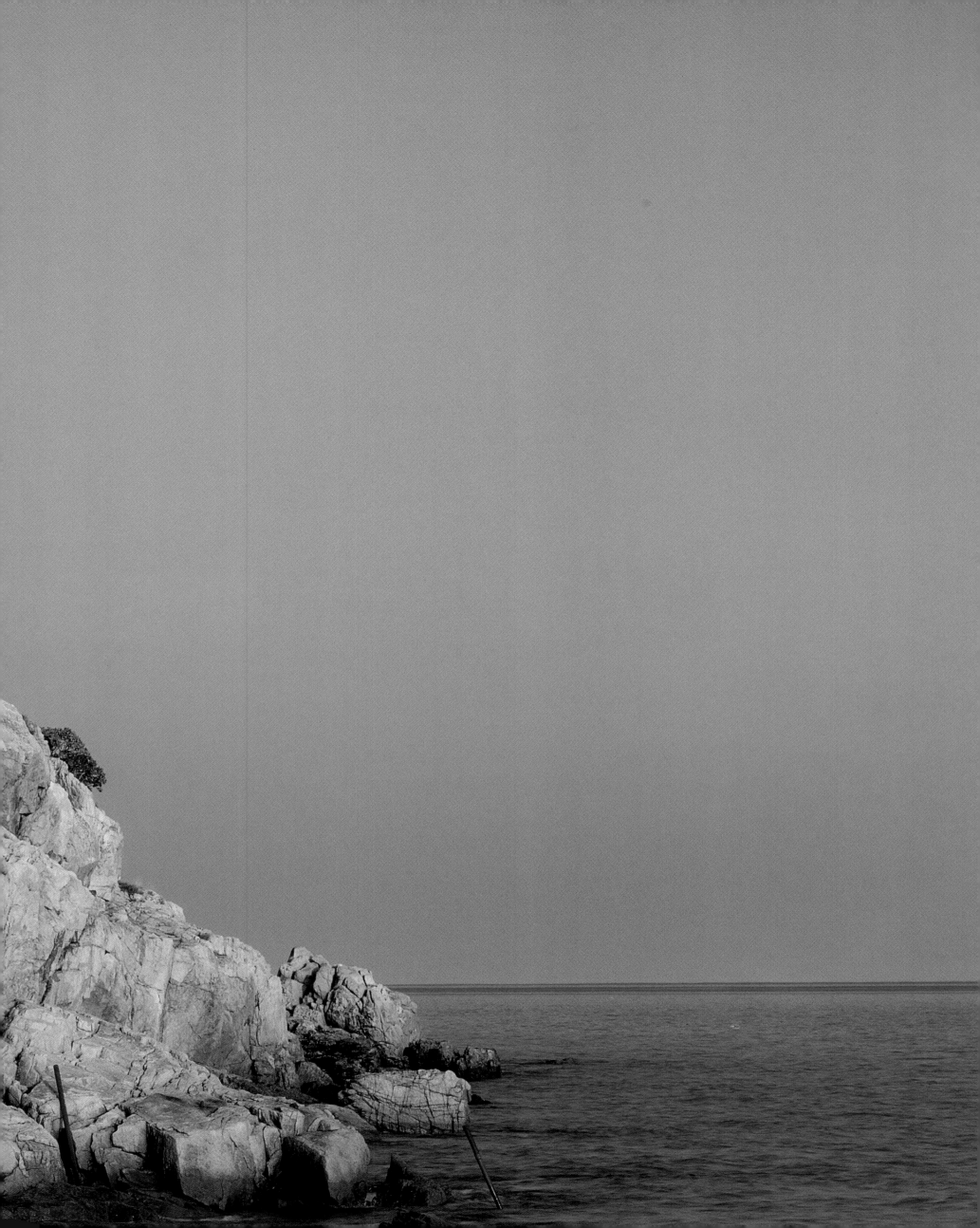

*G*ood night! Which put the candle out?

A jealous zephyr, not a doubt.

Ah! Friend, you little knew

How long at that celestial wick

The angels labored diligent;

Extinguished, now, for you!

It might have been the lighthouse spark

Some sailor, rowing in the dark,

Had importuned to see!

It might have been the waning lamp

That lit the drummer from the camp

To pure reveille!

Emily Dickinson, from Poem LXV, Part One: Life

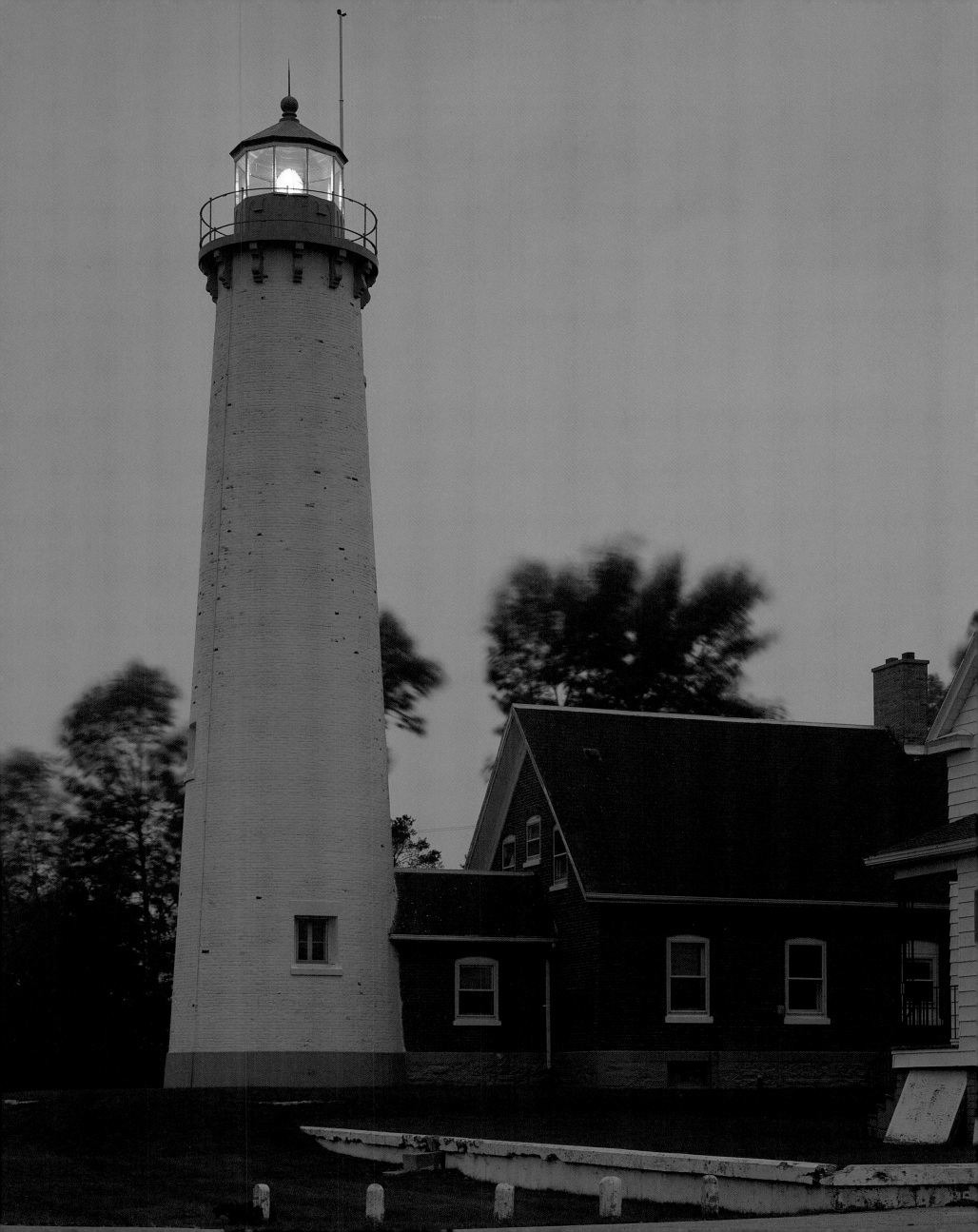

The use of this watch tower is to show light as a lanthorne and give direction in the night season to ships for to enter the haven and where they shall avoid bars and shelves; like to which there are many beacons burning to the same purpose, and namely at Puteoli and Ravenna.

Pliny the Elder, referring to the lighthouse at Alexandria

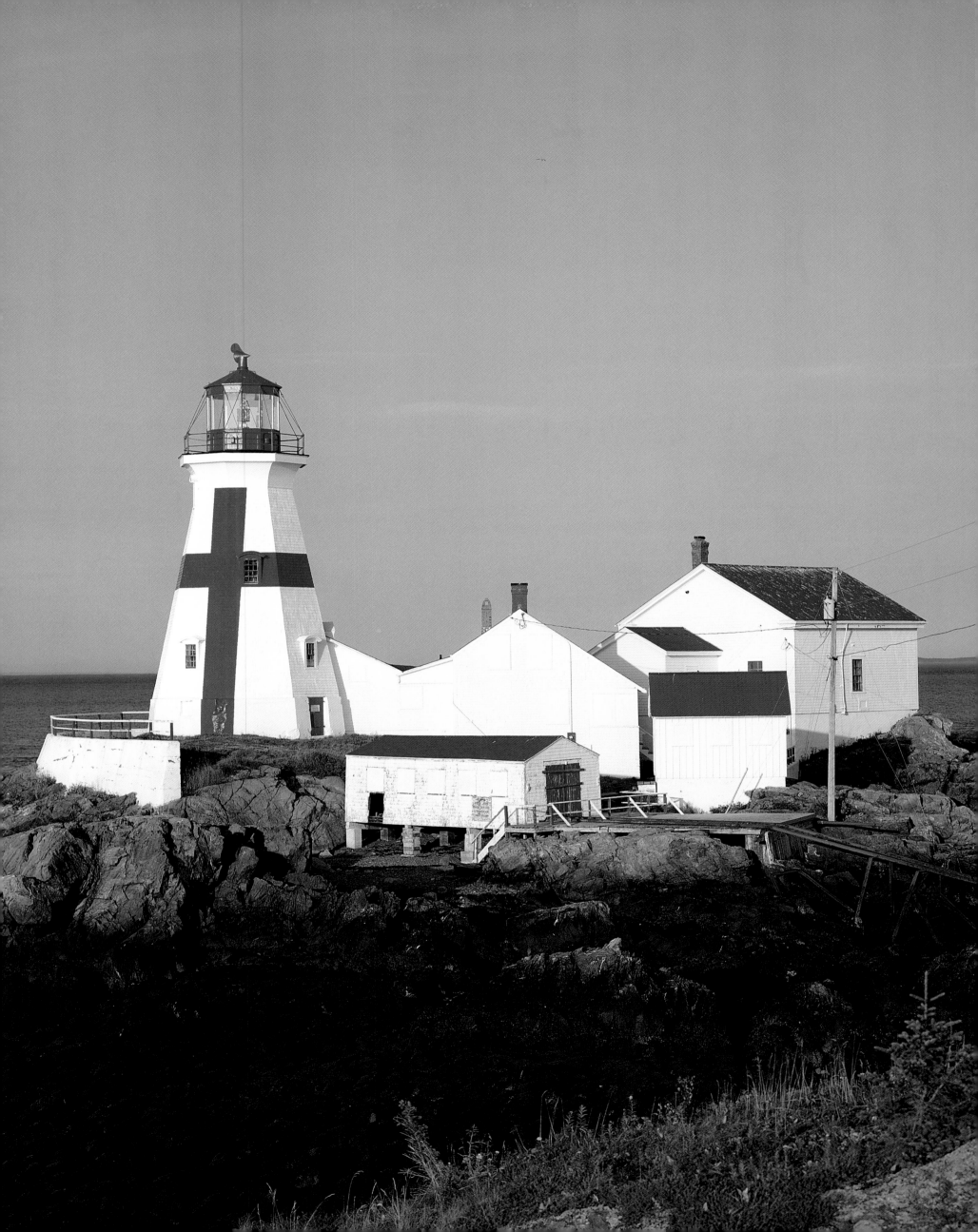

A stormy light of sunset glows and glares
Between two banks of cloud, and o'er the brine
Thy fair lamp on the sky's carnation line
Alone on the lone promontory flares:
Friend of the Fisher who at nightfall fares
Where lurk false reefs masked by the hyaline
Of dimpling waves, within whose smile divine
Death lies in wait behind Circean snares.

The evening knows thee ere the evening star;
Or sees that flame sole Regent of the bight,
When storm, hoarse rumoured by the hills afar,
Makes mariners steer landward by thy light,
Which shows through shock of hostile nature's war
How man keeps watch o'er man through deadliest night.

Mathilde Blind, *On the Lighthouse at Antibes*

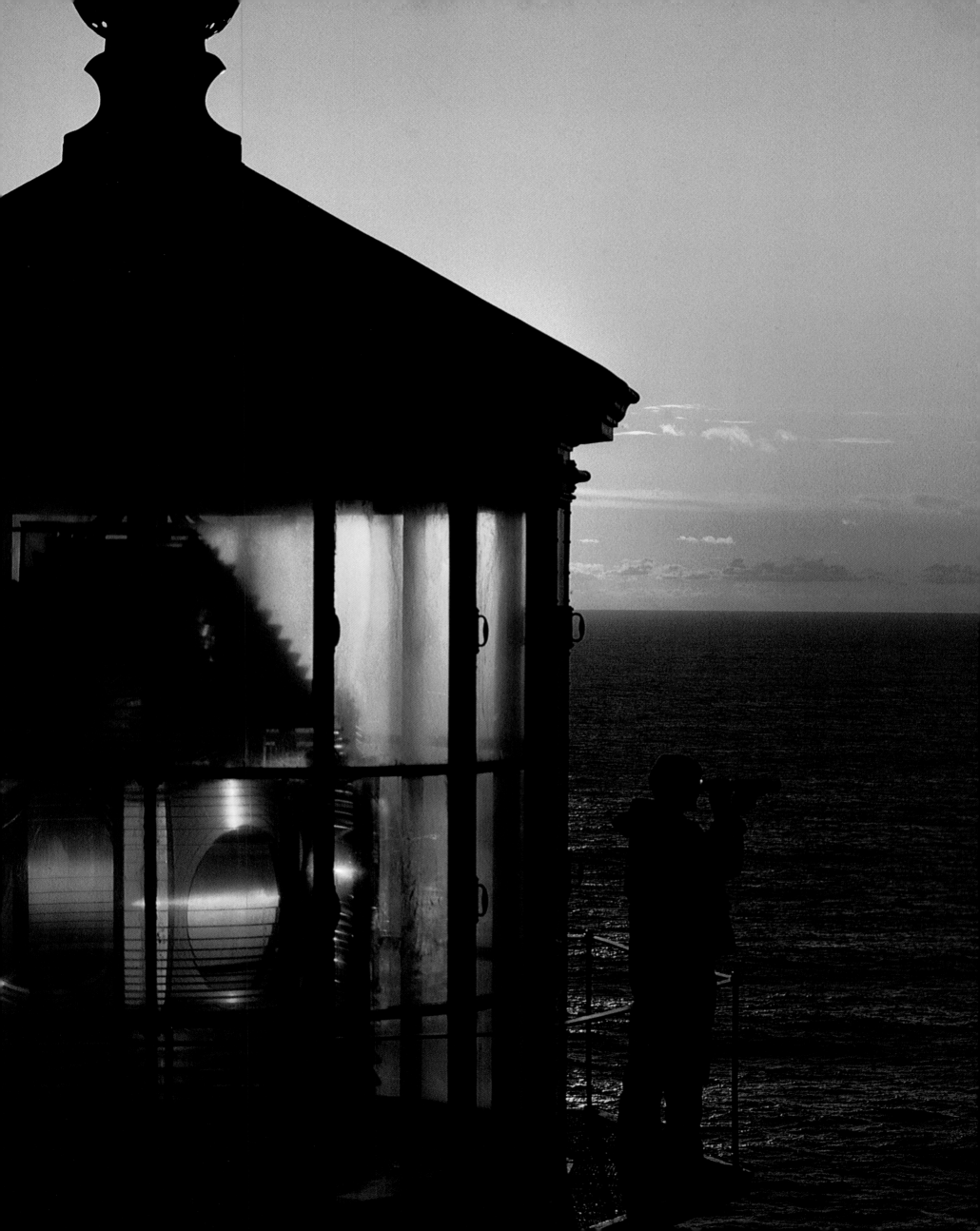

The sea is calm tonight.

The tide is full, the moon lies fair

Upon the straits; on the French coast the light

Gleams and is gone; the cliffs of England stand,

Glimmering and vast, out in the tranquil bay.

Come to the window, sweet is the night air!

Only, from the long line of spray

Where the sea meets the moon-blanched land,

Listen! You hear the grating roar

Of pebbles which the waves draw back, and fling,

At their return, up the high strand,

Begin, and cease, and then again begin,

With tremulous cadence slow, and bring

The eternal note of sadness in.

Matthew Arnold, from *Dover Beach*

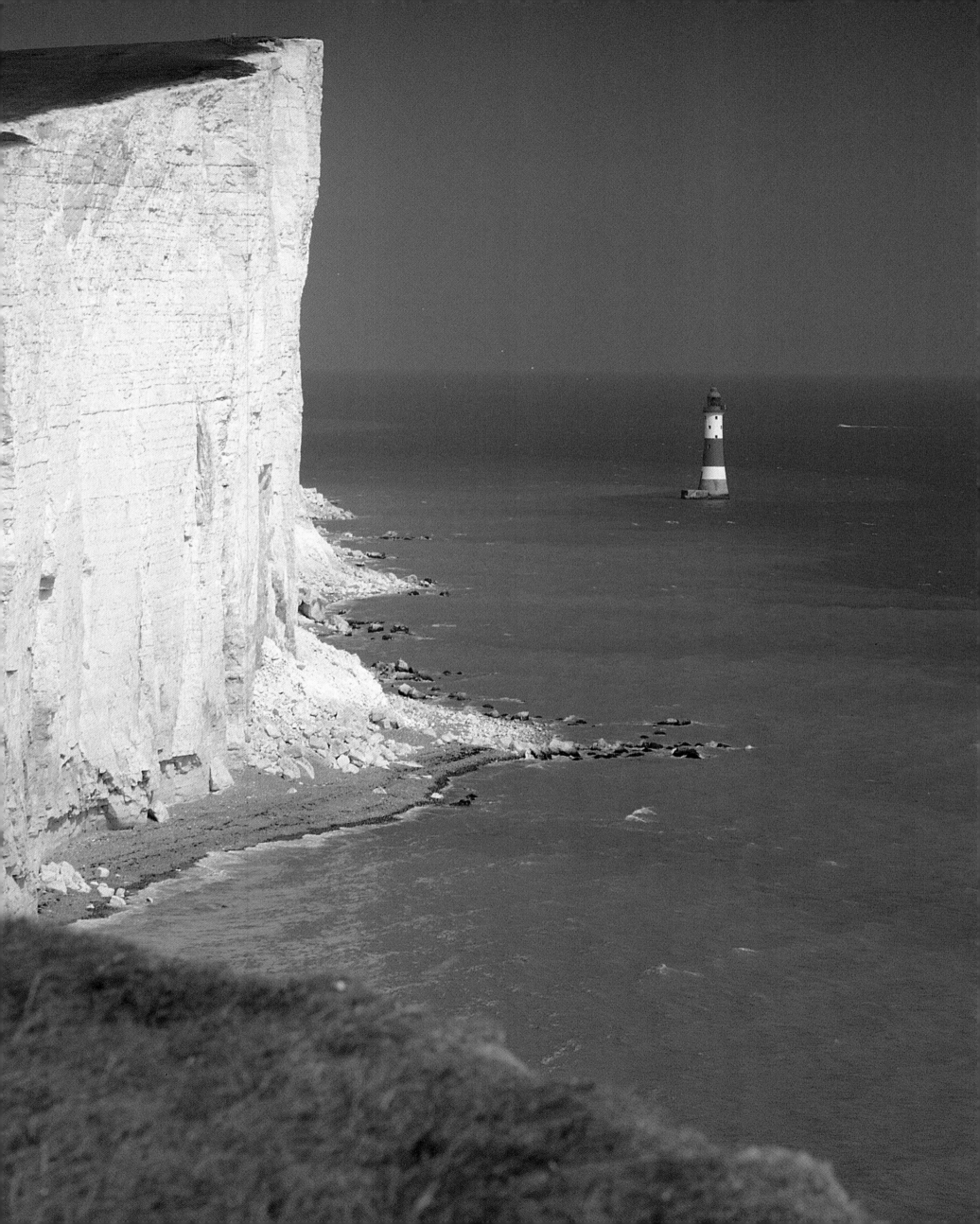

Every hazard faced

And difficulty mastered, with resolve

That no one breathing should be left to perish,

This last remainder of the crew are all

Placed in the little boat, then o'er the deep

Are safely borne, landed upon the beach,

And, in fulfillment of God's mercy, lodged

Within the sheltering Lighthouses.

William Wordsworth, from *Darling Grace*

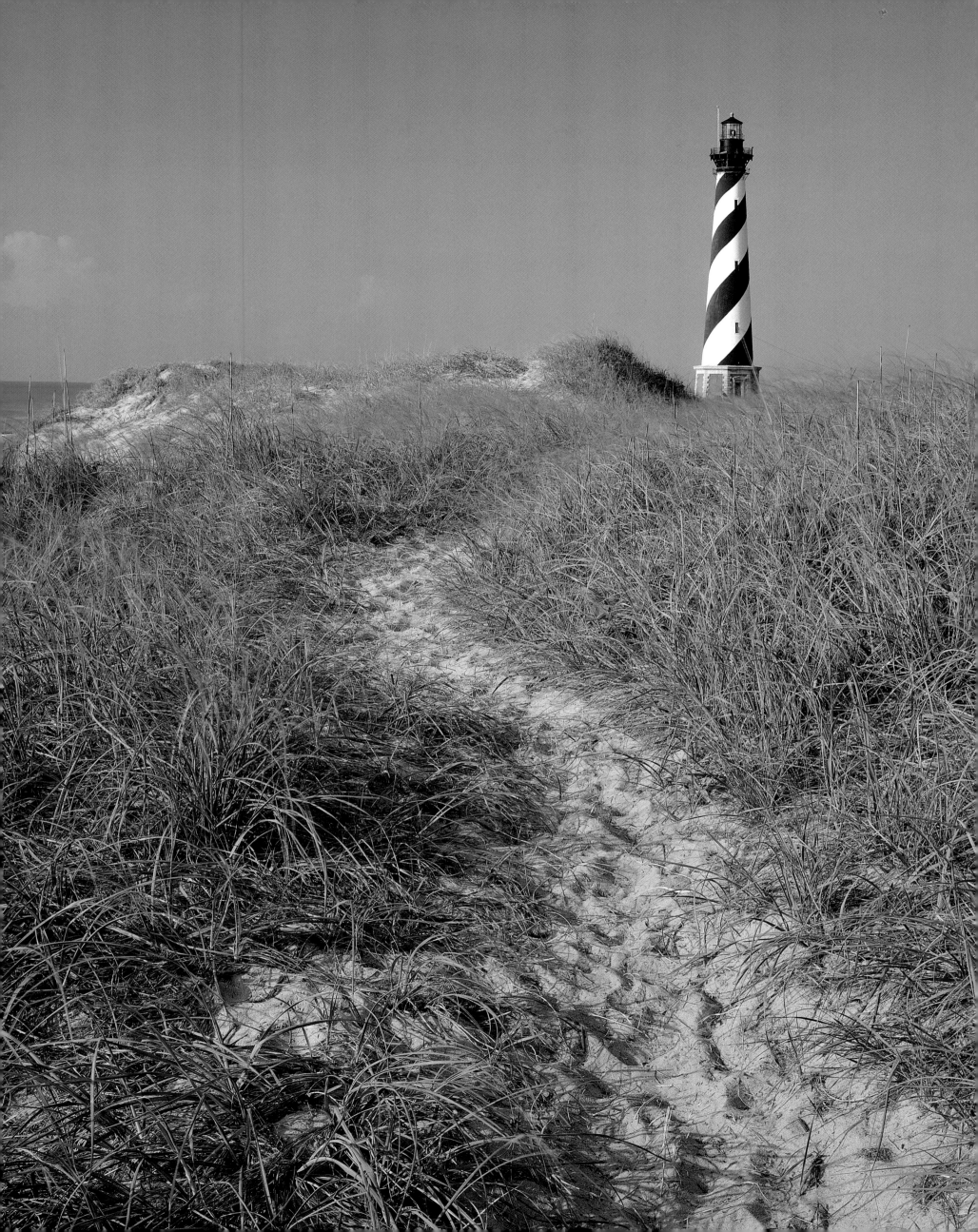

\mathcal{L}ighthouses are like grandchildren—all different but some more charming than others.

Anonymous

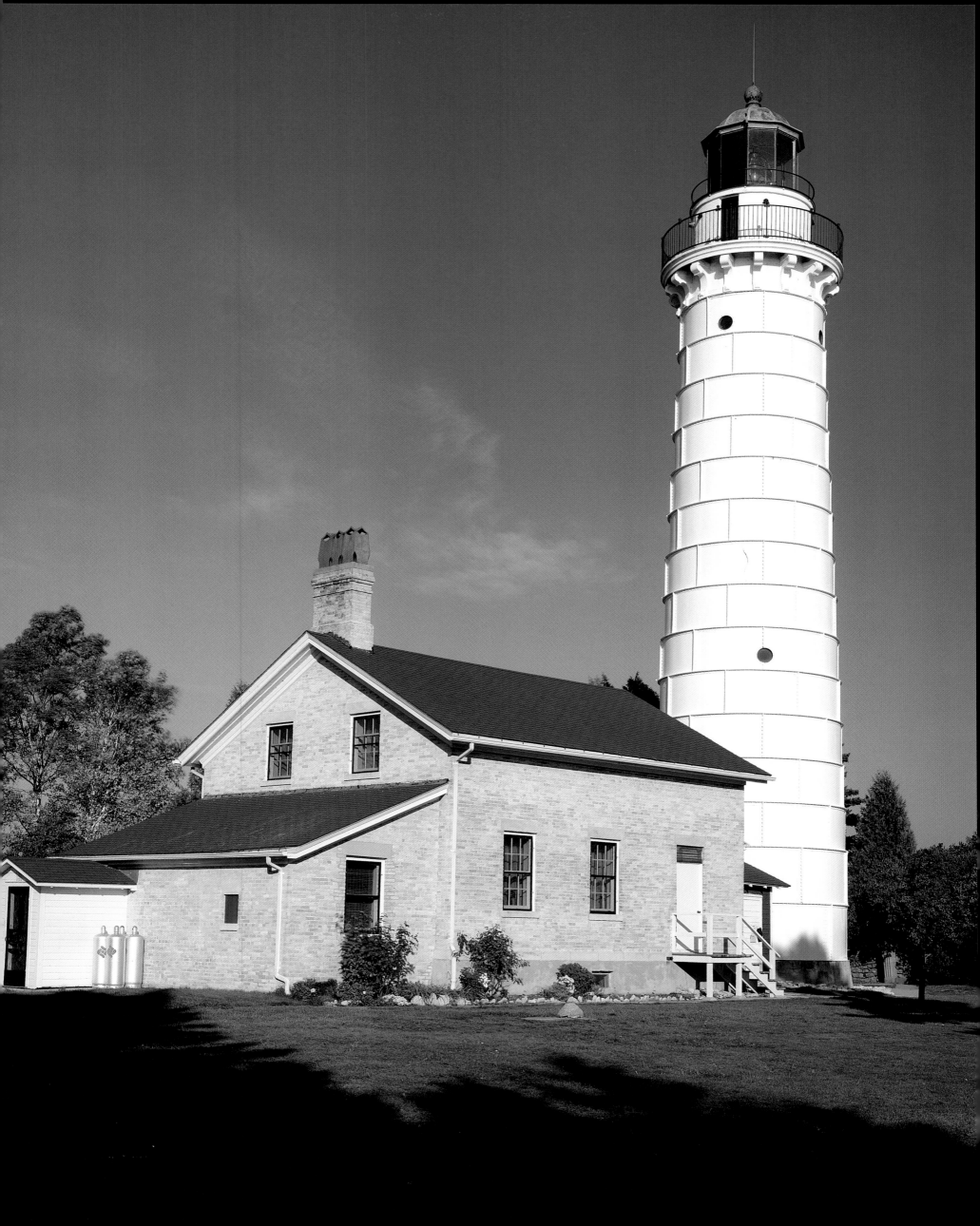

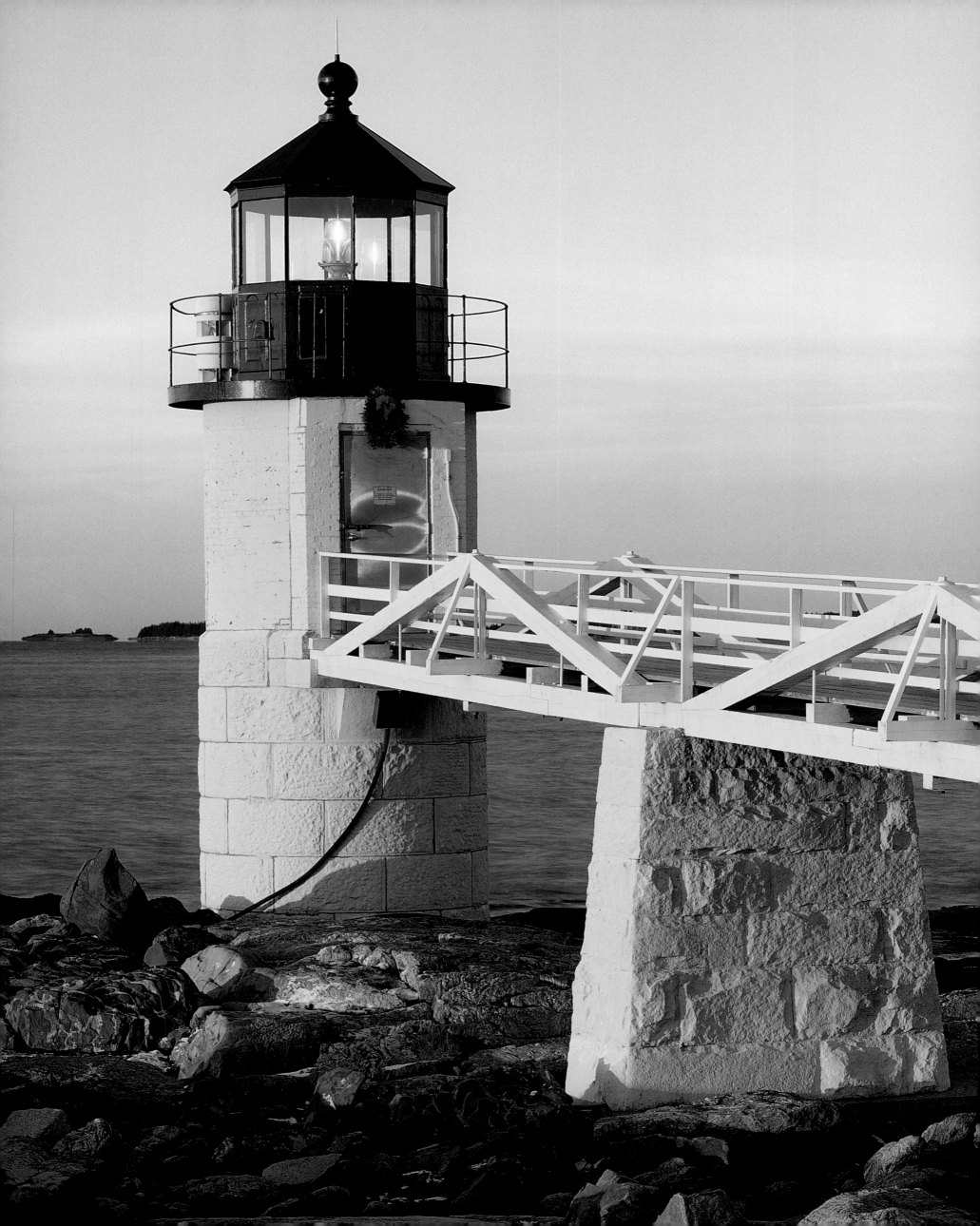

We are told to let our light shine, and if it does, we won't need to tell anybody it does. Lighthouses don't fire cannons to call attention to their shining—they just shine.

Dwight L. Moody

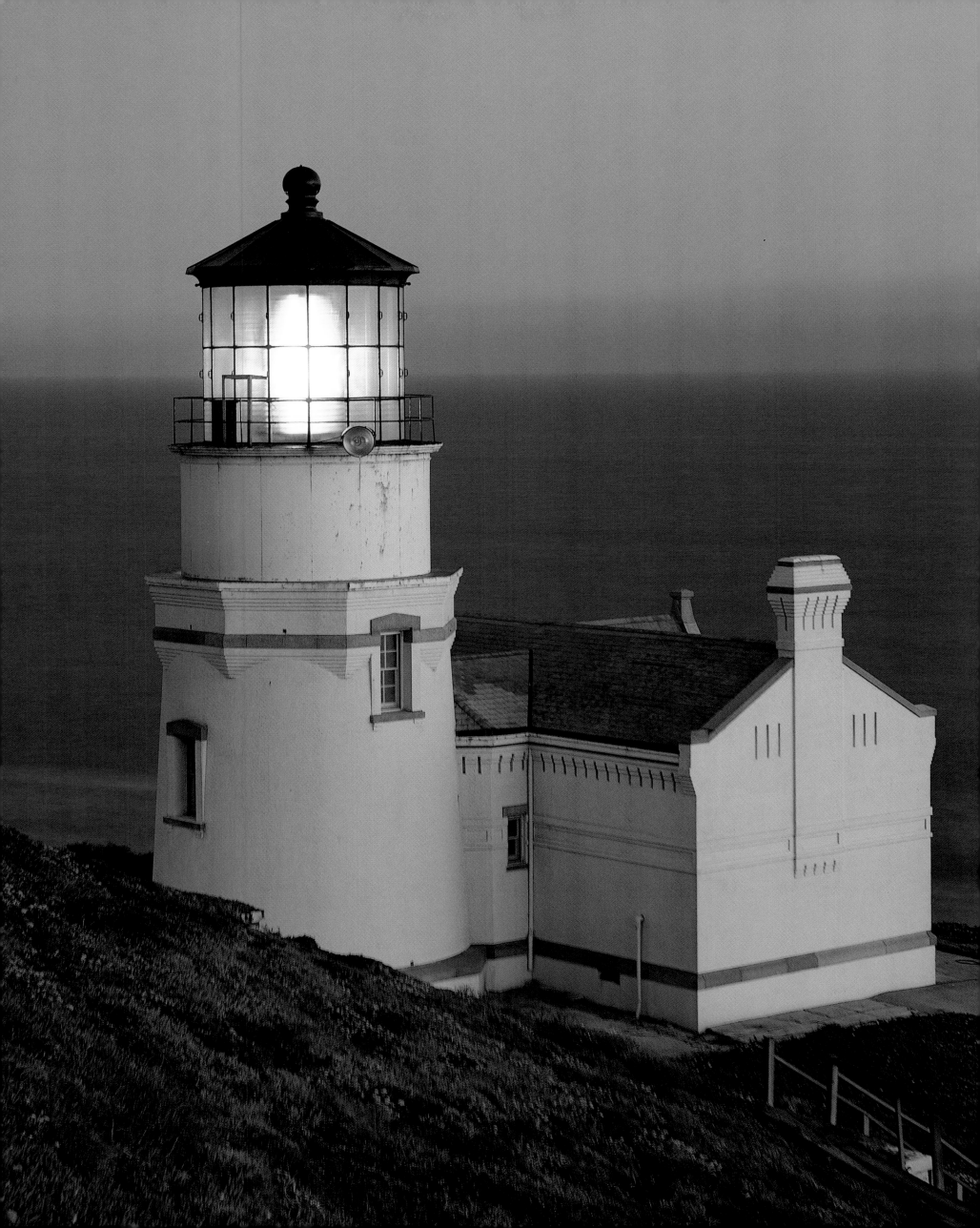

*T*t was a neat building, with everything in apple-pie order, and no danger of anything rusting there for want of oil. The light consisted of fifteen argand lamps, placed within smooth concave reflectors twenty-one inches in diameter, and arranged in two horizontal circles one above the other, facing every way excepting directly down the Cape. These were surrounded, at a distance of two or three feet, by large plate-glass windows, which defied the storms, with iron sashes, on which rested the iron cap. All the iron work, except the floor, was painted white. And thus the lighthouse was completed.

Henry David Thoreau, from *Cape Cod*, The Highland Light

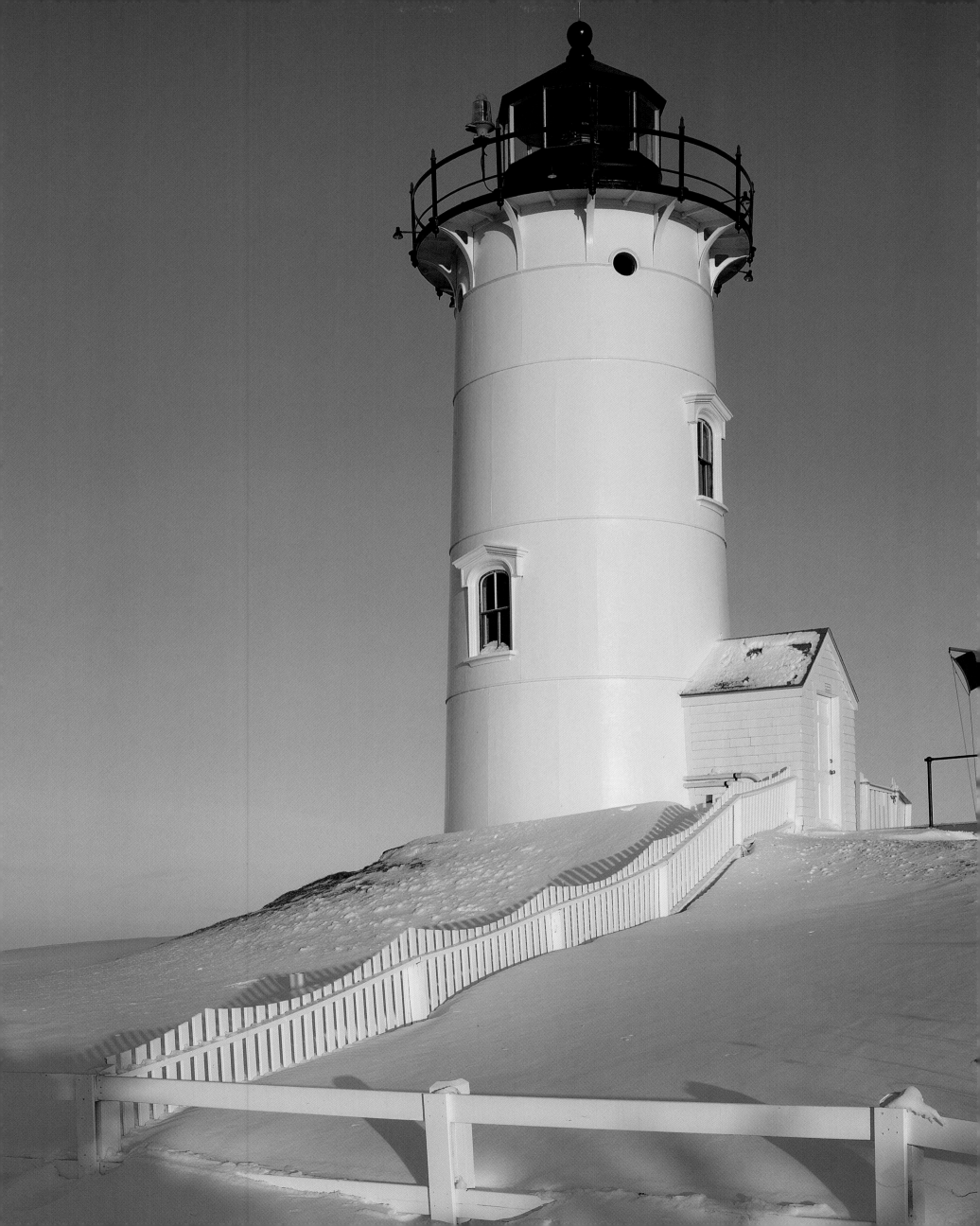

For so much as by destroying and taking away of certain steeples, woods, and other marks standing upon main shore adjoining to the sea coasts of this realm of England and Wales being as beacons and marks of ancient time accustomed for seafaring men…divers ships have by the lack of such marks of late years been miscarried, perished, and lost in the sea.

Act of Queen Elizabeth, passed in 1565

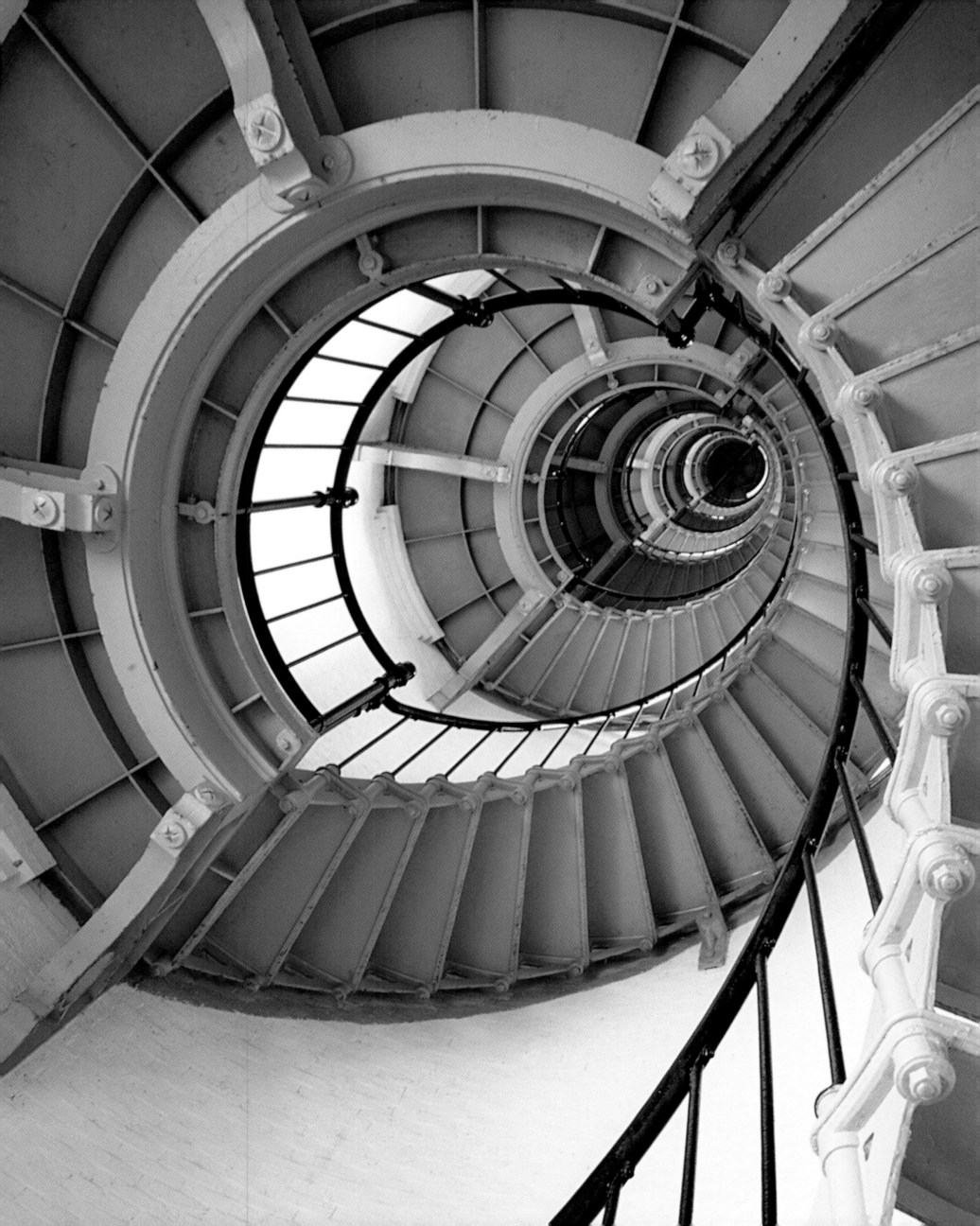

*A*nythin' for a quiet life, as the man said wen he took
the sitivation at the lighthouse.

Charles Dickens, from *Pickwick Papers*

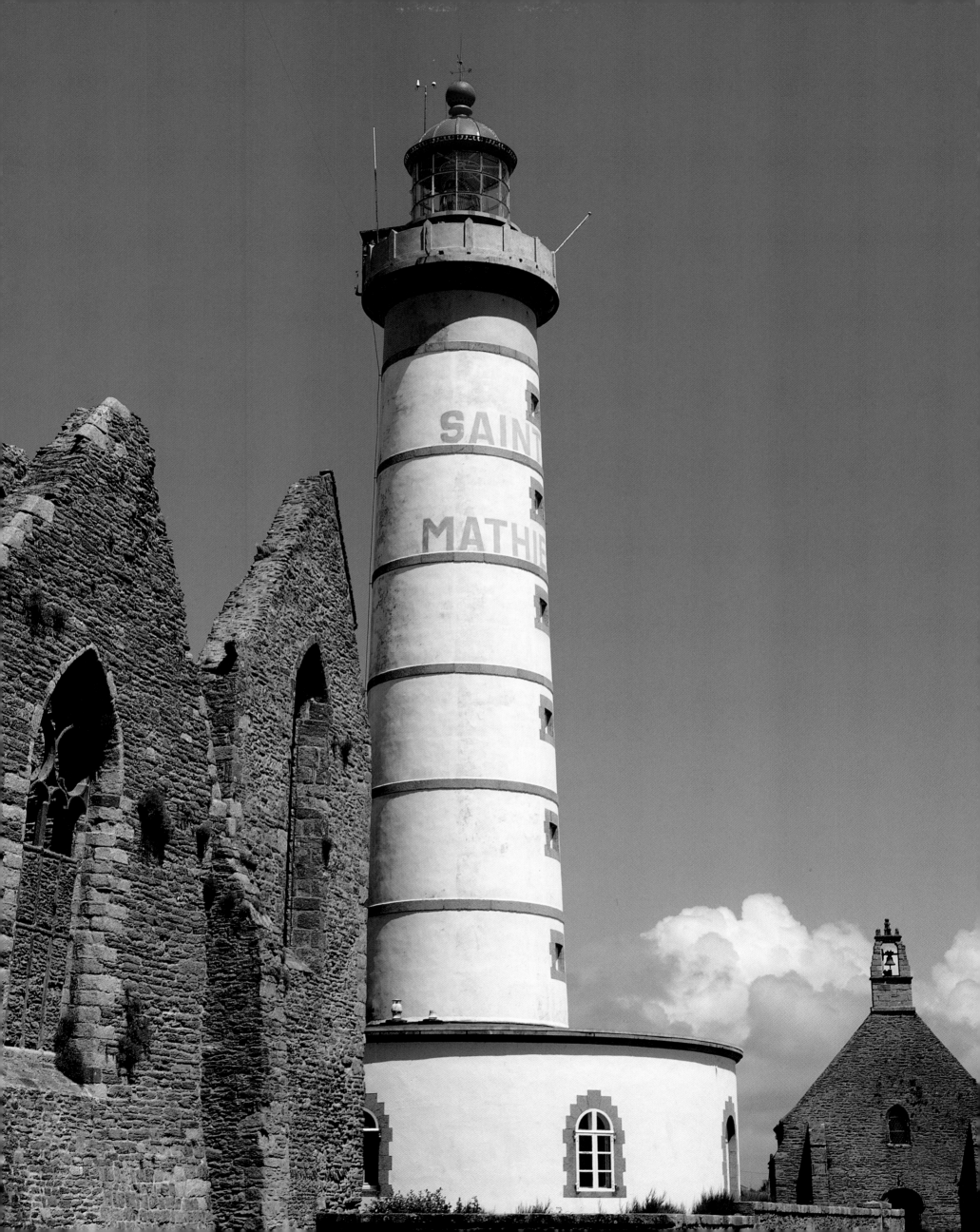

The sand bar of Eastham is the sea wall of the inlet. Its crest overhangs the beach, and from the high, wind-trampled rim, a long slope well overgrown with dune grass descends to the meadows on the west. Seen from the tower at Nauset, the land has an air of geographical simplicity, as a matter of fact, it is full of hollows, blind passages, and ampitheatres in which the roaring of the sea changes into the far roar of a cataract. I often wander into these curious pits.

Henry Beston, from *The Outermost House*

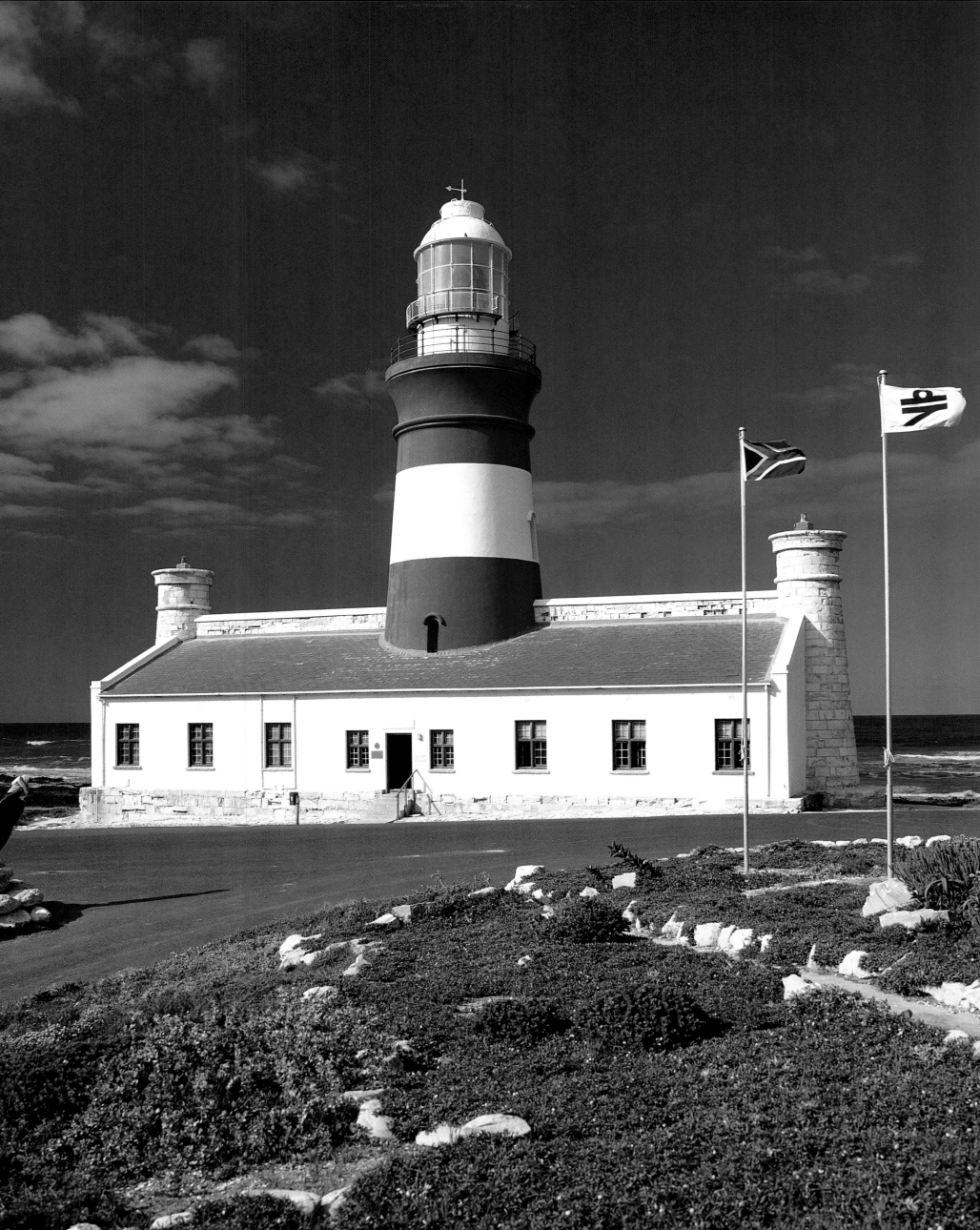

... *t*he first salt wind from the east, the first sight of a lighthouse set boldly on its outer rock, the flash of a gull, the waiting procession of seaward-bound firs on an island, made me feel solid and definite again, instead of a poor, incoherent being.

Sarah Orne Jewett, from *The Country of the Pointed Firs*

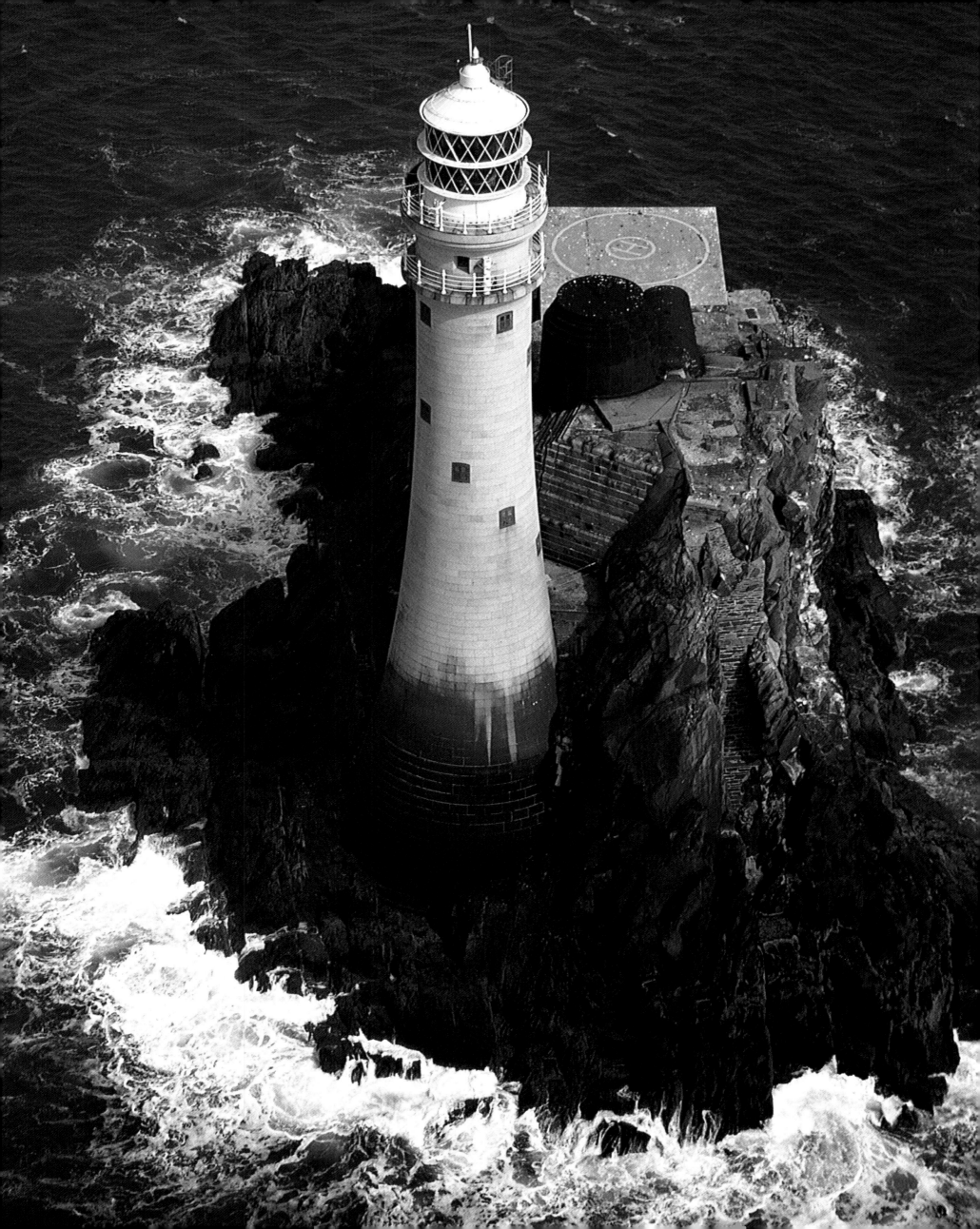

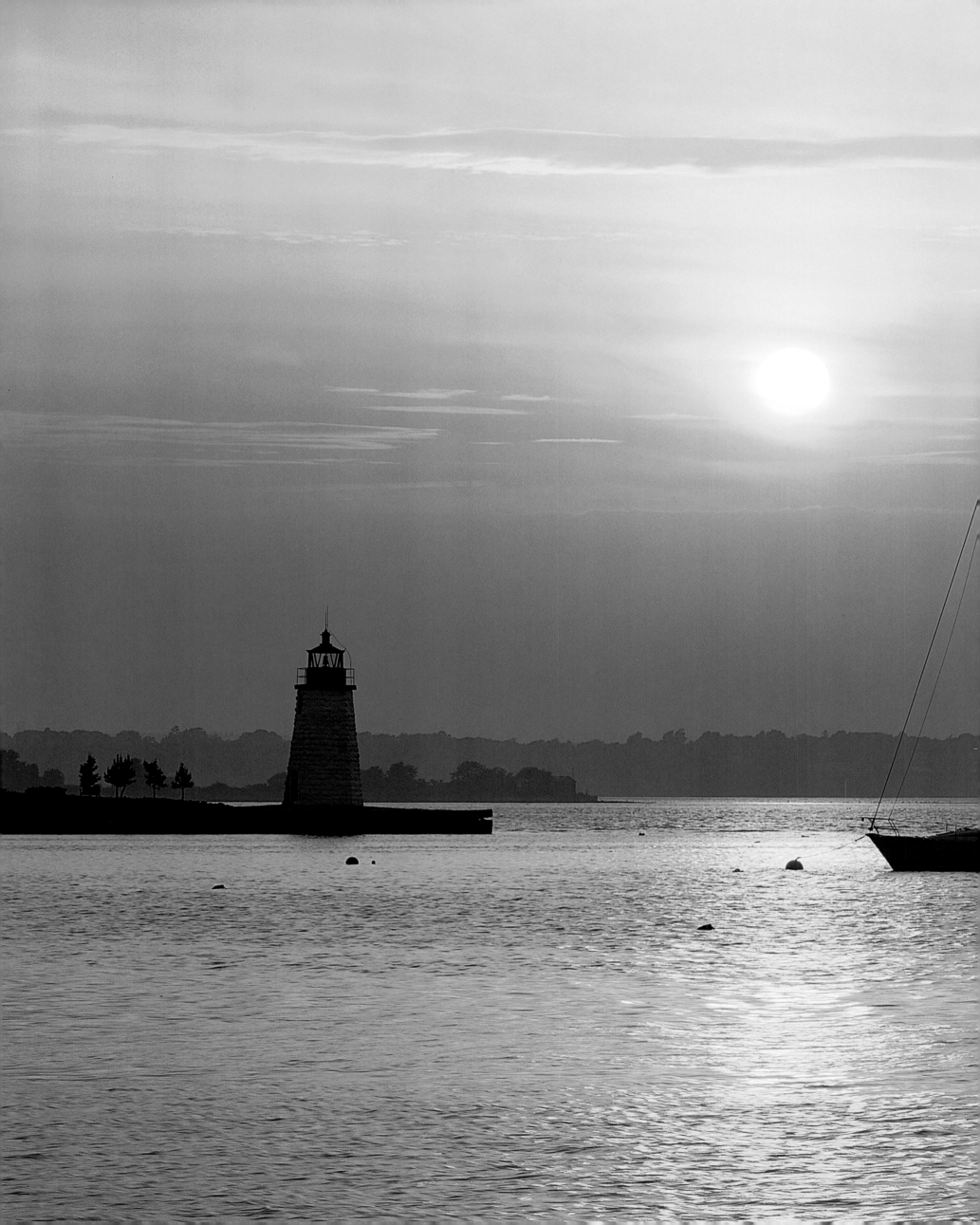

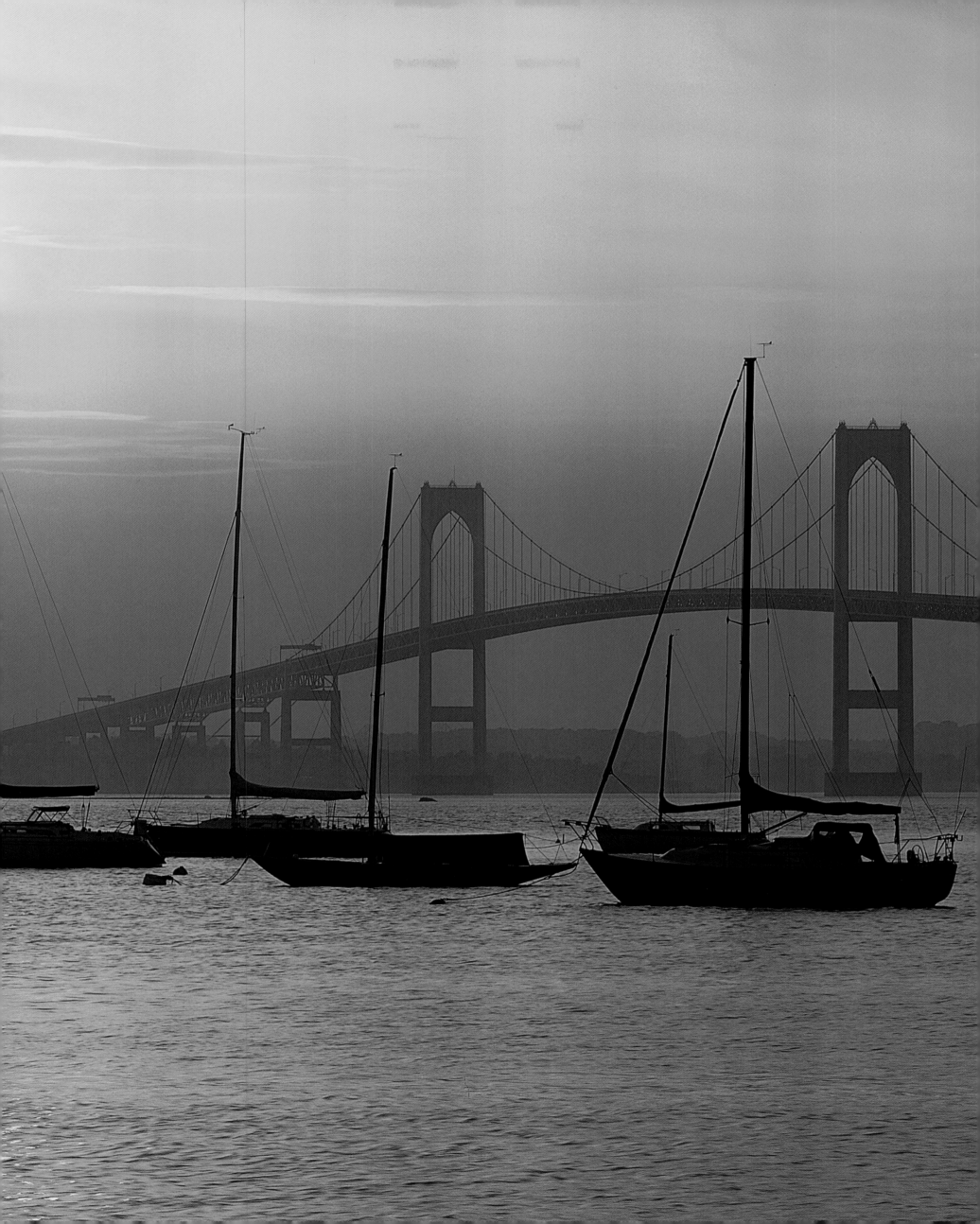

There lies the port; the vessel puffs her sail:
There gloom the dark broad seas. My mariners,
Souls that have toiled, and wrought, and thought with me—
That ever with a frolic welcome took
The thunder and the sunshine, and opposed
Free hearts, free foreheads—you and I are old…

. .

The lights begin to twinkle from the rocks;
The long day wanes; the slow moon climbs; the deep
Moans round with many voices. Come, my friends,
'Tis not too late to seek a newer world.
Push off, and sitting well in order smite
The sounding furrows; for my purpose holds
To sail beyond the sunset, and the baths
Of all the western stars, until I die.
It may be that the gulfs will wash us down;
It may be that we shall touch the Happy Isles.
We are not now that strength which in old days
Moved earth and heaven—that which are we, we are:
One equal temper of heroic hearts,
Made weak by time and fate, but strong in will
To strive, to seek, to find and not to yield.

Alfred, Lord Tennyson, from *Ulysses*

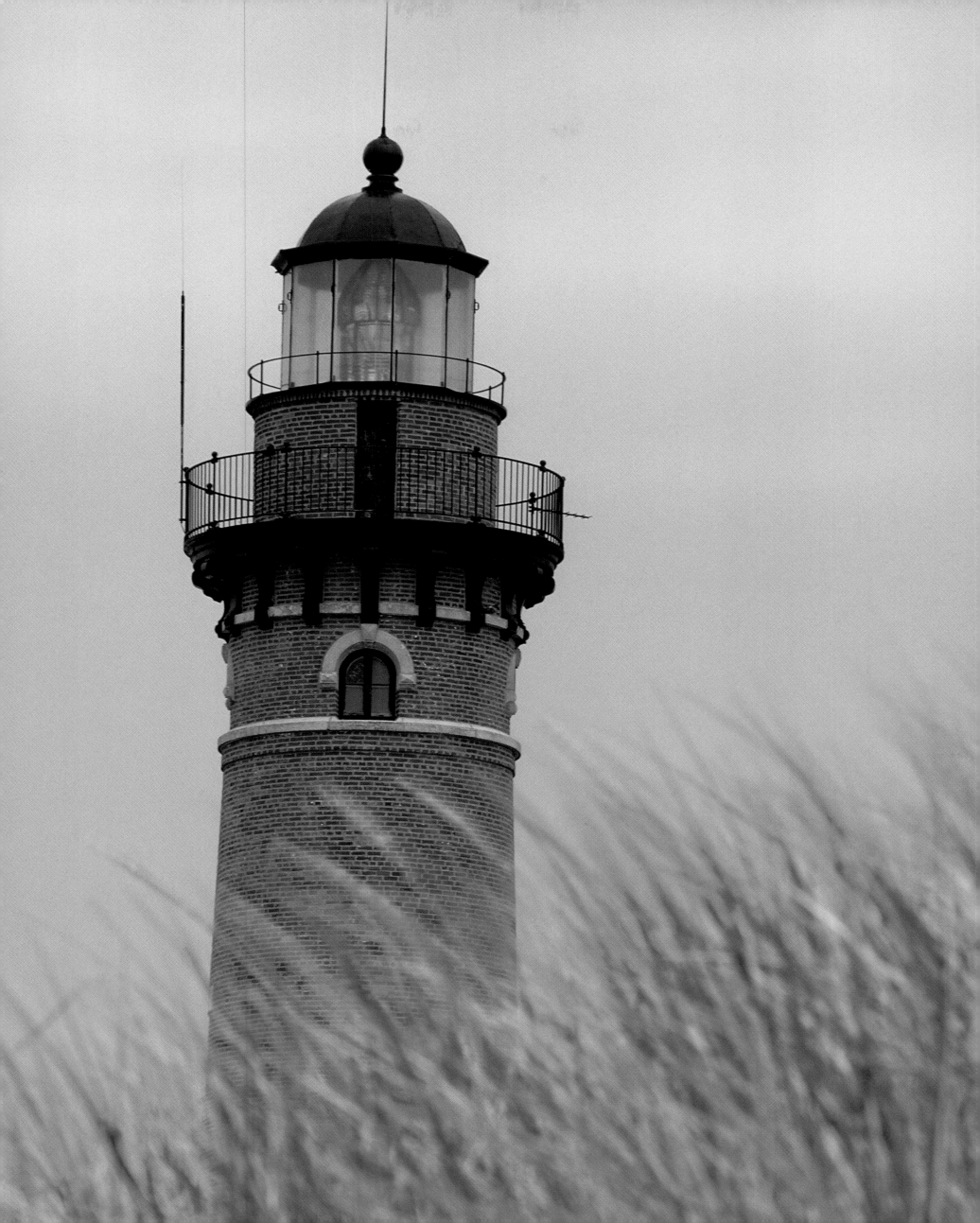

Fair shines the beacon from its lonely rock,
Stable and alone amid the unstable waves;
In vain the surge leaps with continual shock,
In vain around the wintry tempest raves,
And Ocean thunders in her sounding caves.

Lewis Morris

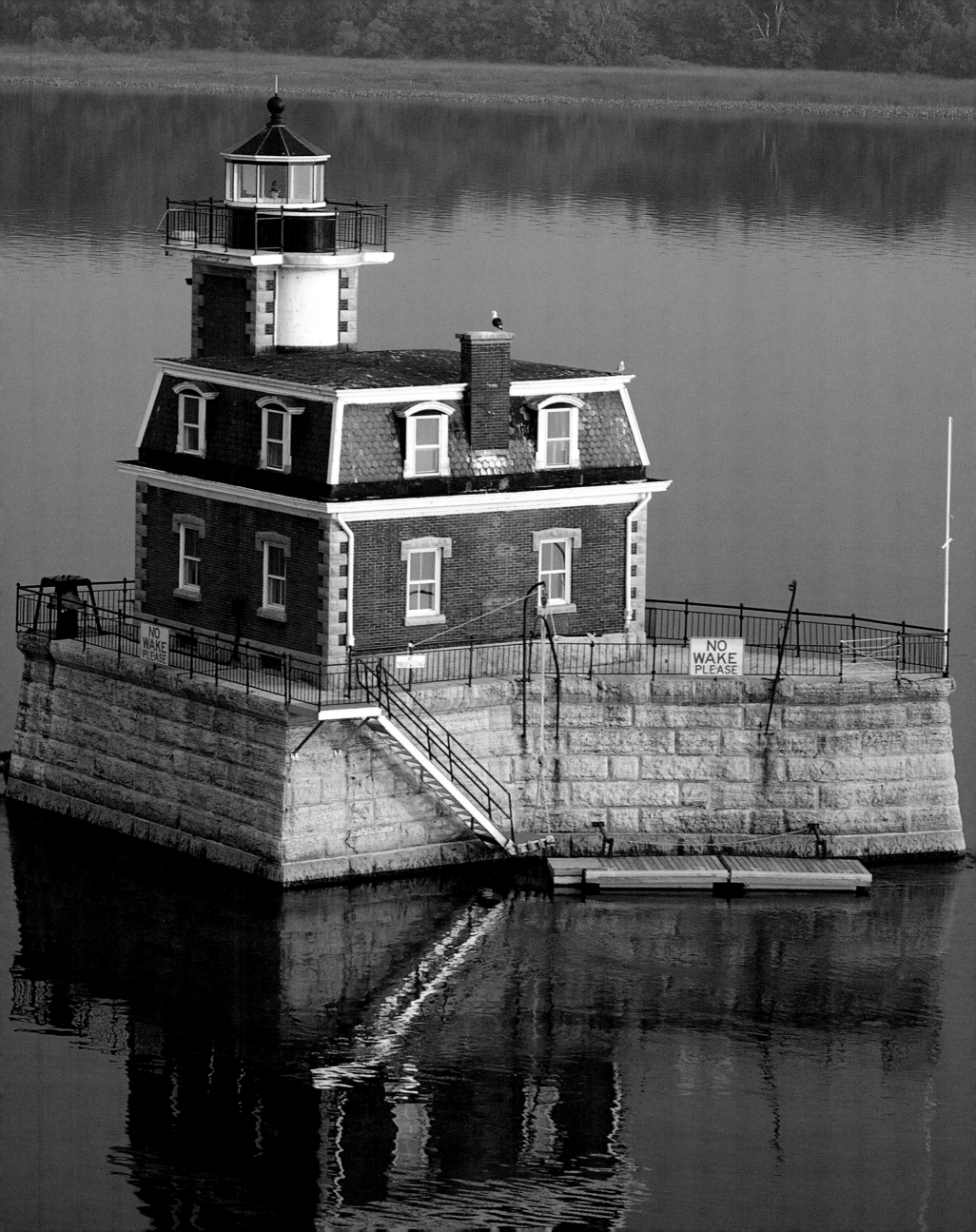

\mathcal{N}ow the little red lighthouse knew that it was needed. The bridge wanted it. The man wanted it. The ships must need it still. It sent a long, bright, flashing ray out into the night. One second on, two seconds off. Look out! Danger! Watch me! it called. Soon its bell was booming out too.

Hildegarde H. Swift and Lynd Ward, from *The Little Red Lighthouse and the Great Gray Bridge*

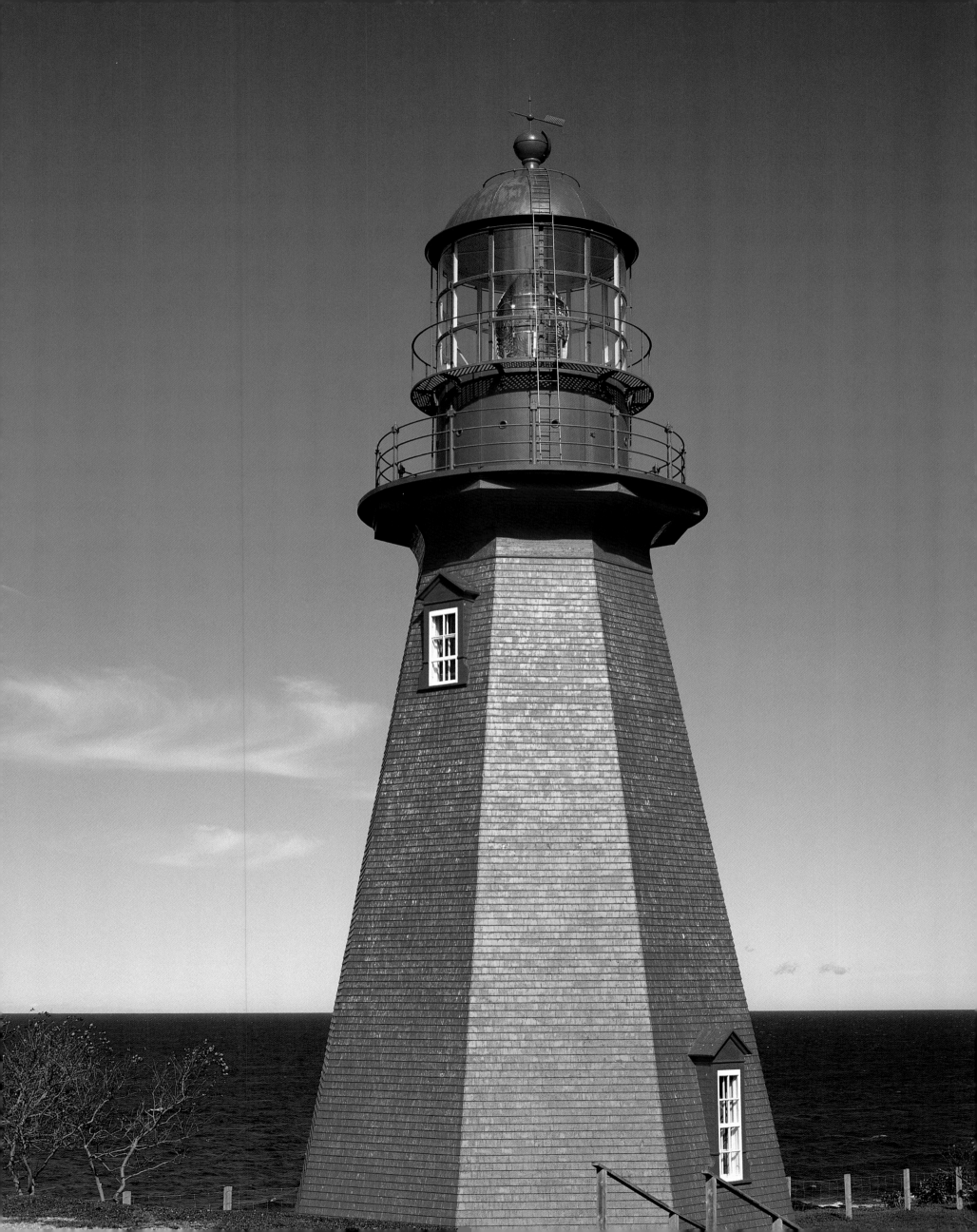

I can think of no other edifice constructed by man
as altruistic as a lighthouse. They were built only to serve.
They weren't built for any other purpose…

George Bernard Shaw

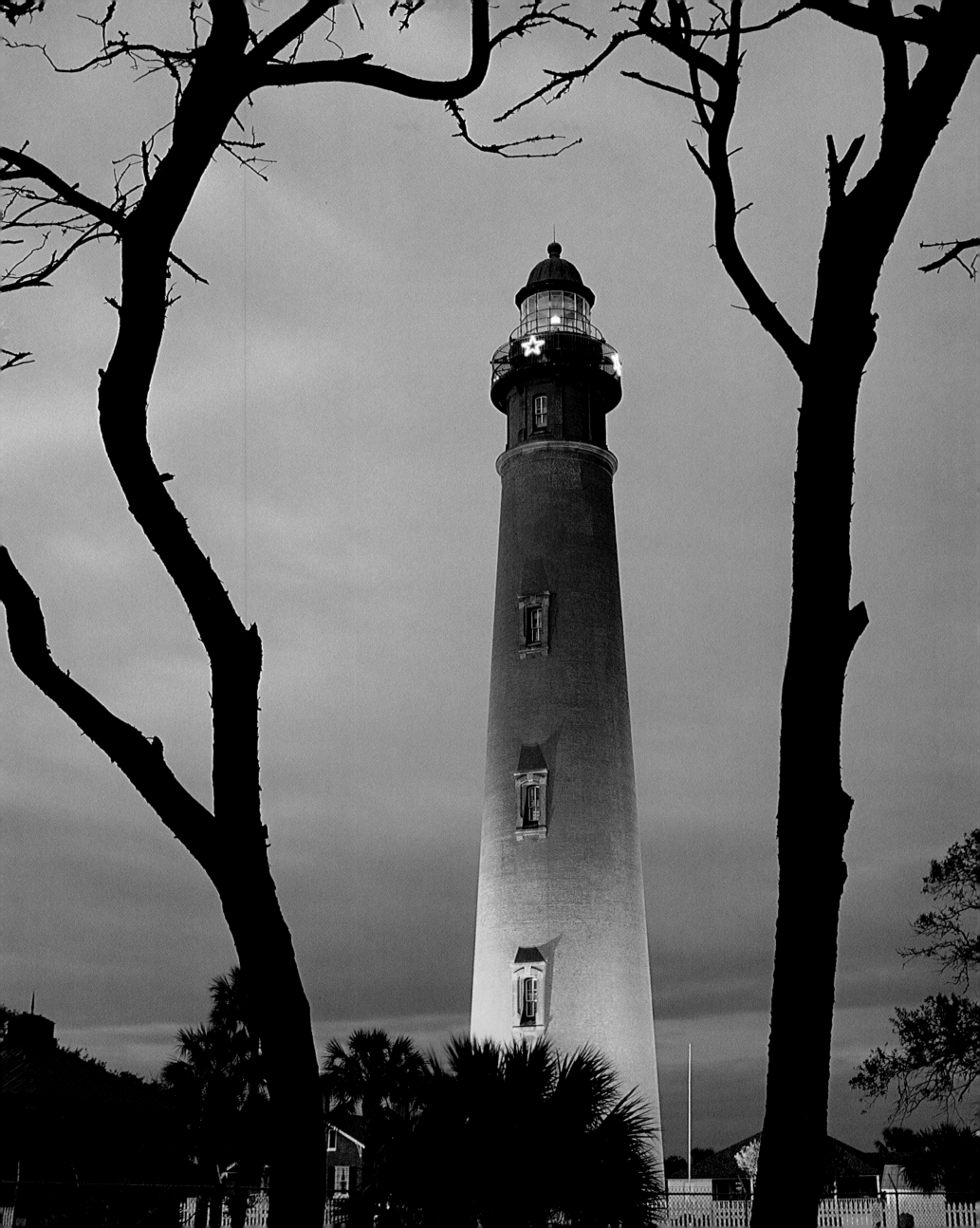

*T*he government pays many of its servants, usually those with rather easy jobs, too much; but the best men, who do the hardest work, the men in the life-saving and lighthouse service, the forest-rangers, and those who patrol and protect the reserves of wild life, are almost always underpaid.

Theodore Roosevelt, from *A Book-Lover's Holidays in the Open*

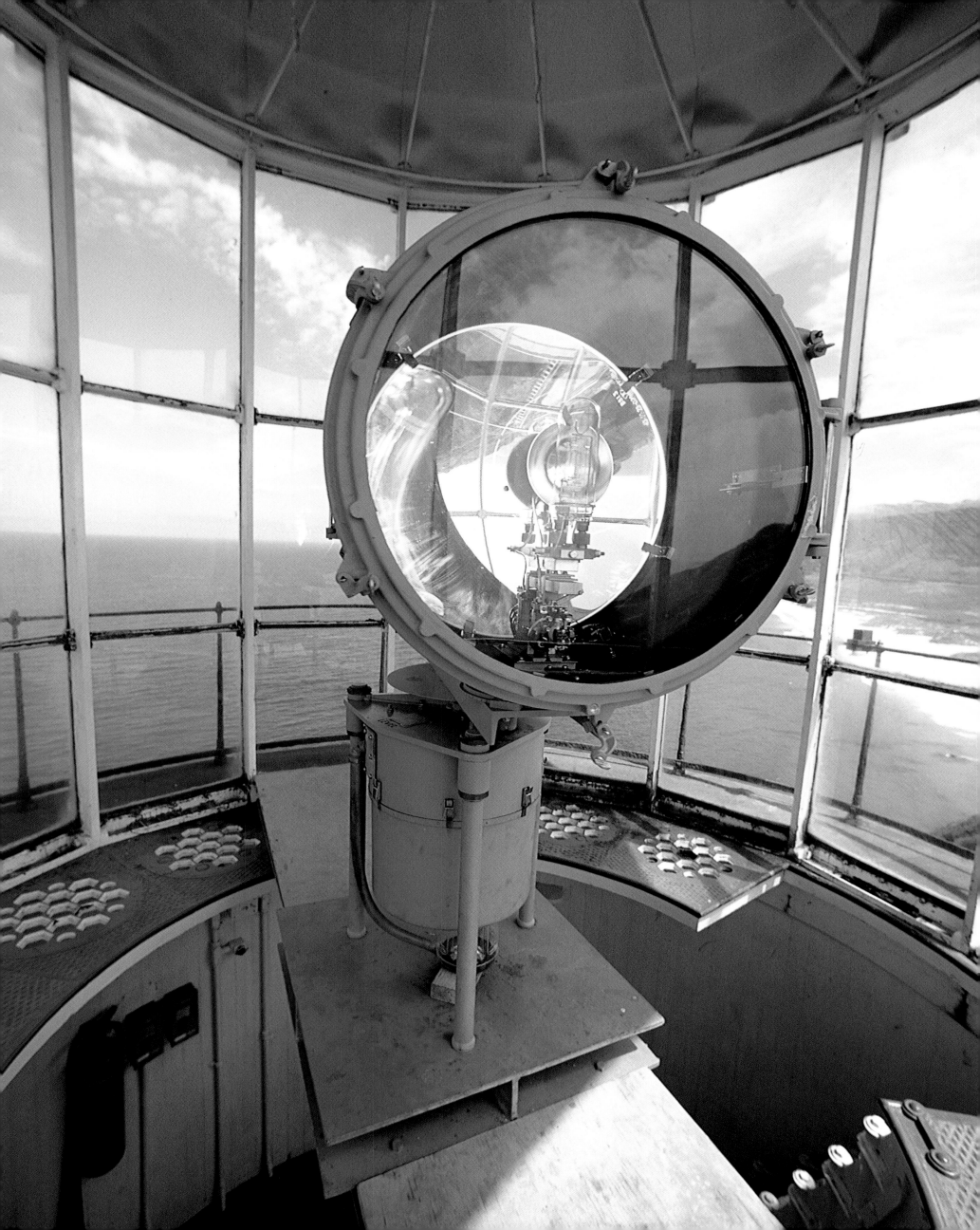

Inside my empty bottle I was constructing a lighthouse while all the others were making ships.

Theodore Roethke

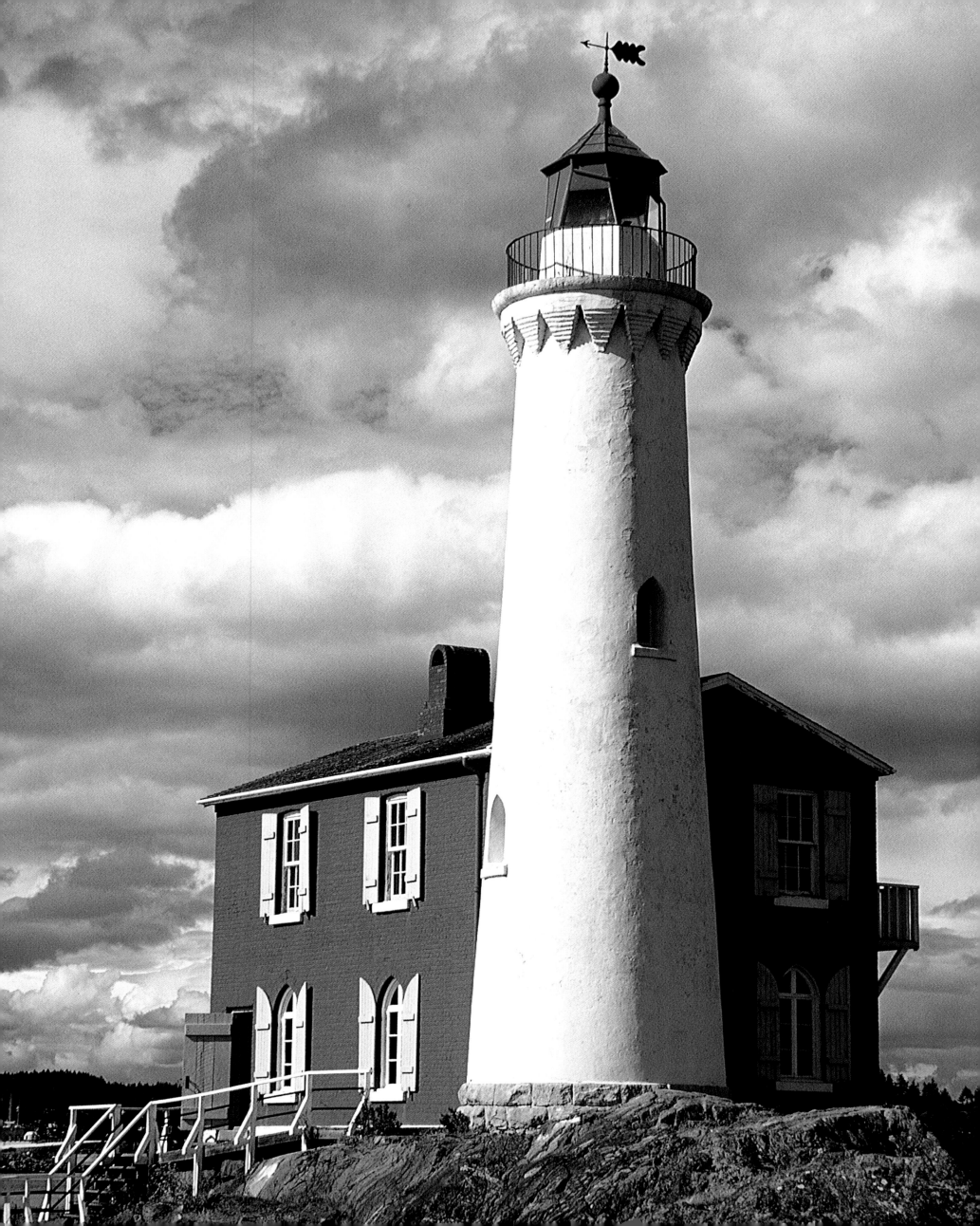

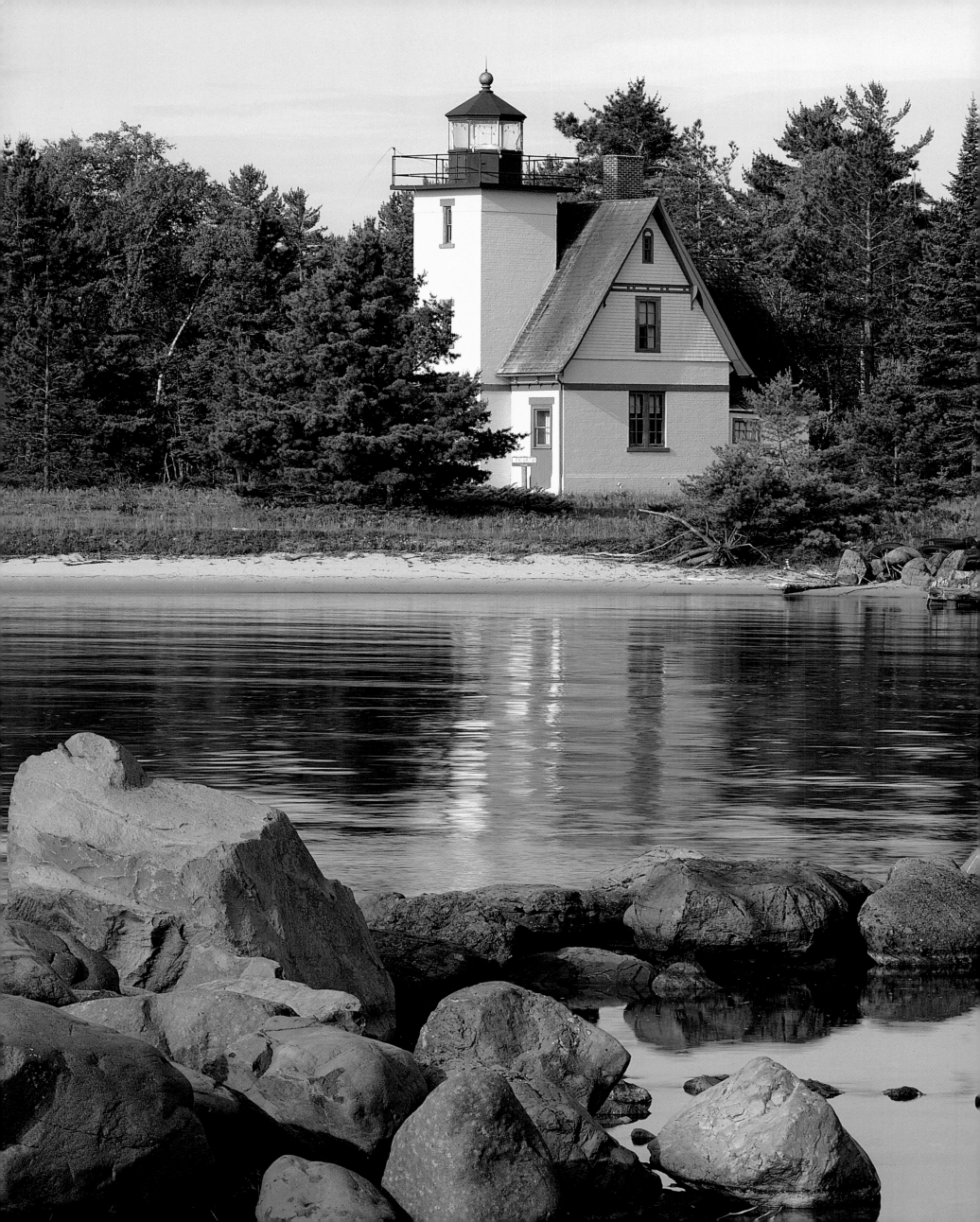

... *B*ut I—ah, patient men who fare by sea,

Ye would but smile to hear this empty speech,—

I have such beacon-lights to burn for me,

In that dear west so lovely, new, and free,

That evil league by day, by night, can teach

No spell whose harm my little bark can reach.

No towers of stone uphold those beacon-lights;

No distance hides them, and no storm can shake;

In valleys they light up the darkest nights,

They outshine sunny days on sunny heights;

They blaze from every house where sleep or wake

My own who love me for my own poor sake.

Each thought they think of me lights road of flame

Across the seas; no travel on it tires

My heart. I go if they but speak my name;

From Heaven I should come and go the same,

And find this glow forestalling my desires.

My darlings, do you hear me? Trim the fires!

Helen Hunt Jackson, *My Lighthouses*

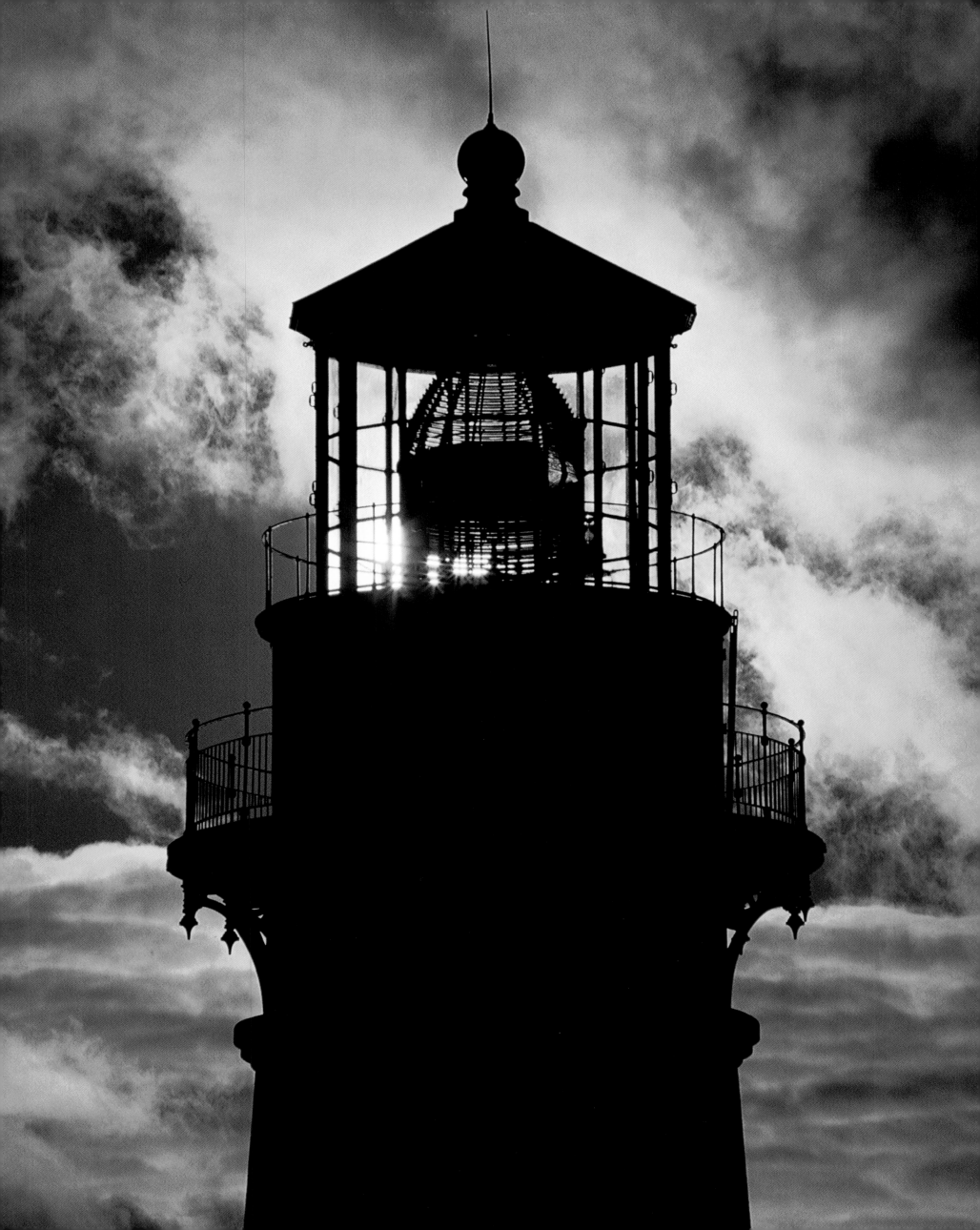

So tonight wandering sailors pale with fears
Wide o'er the watery waste a light appears,
Which on the far-seen mountain blazing high
Streams from lonely watchtower to the sky.

Homer

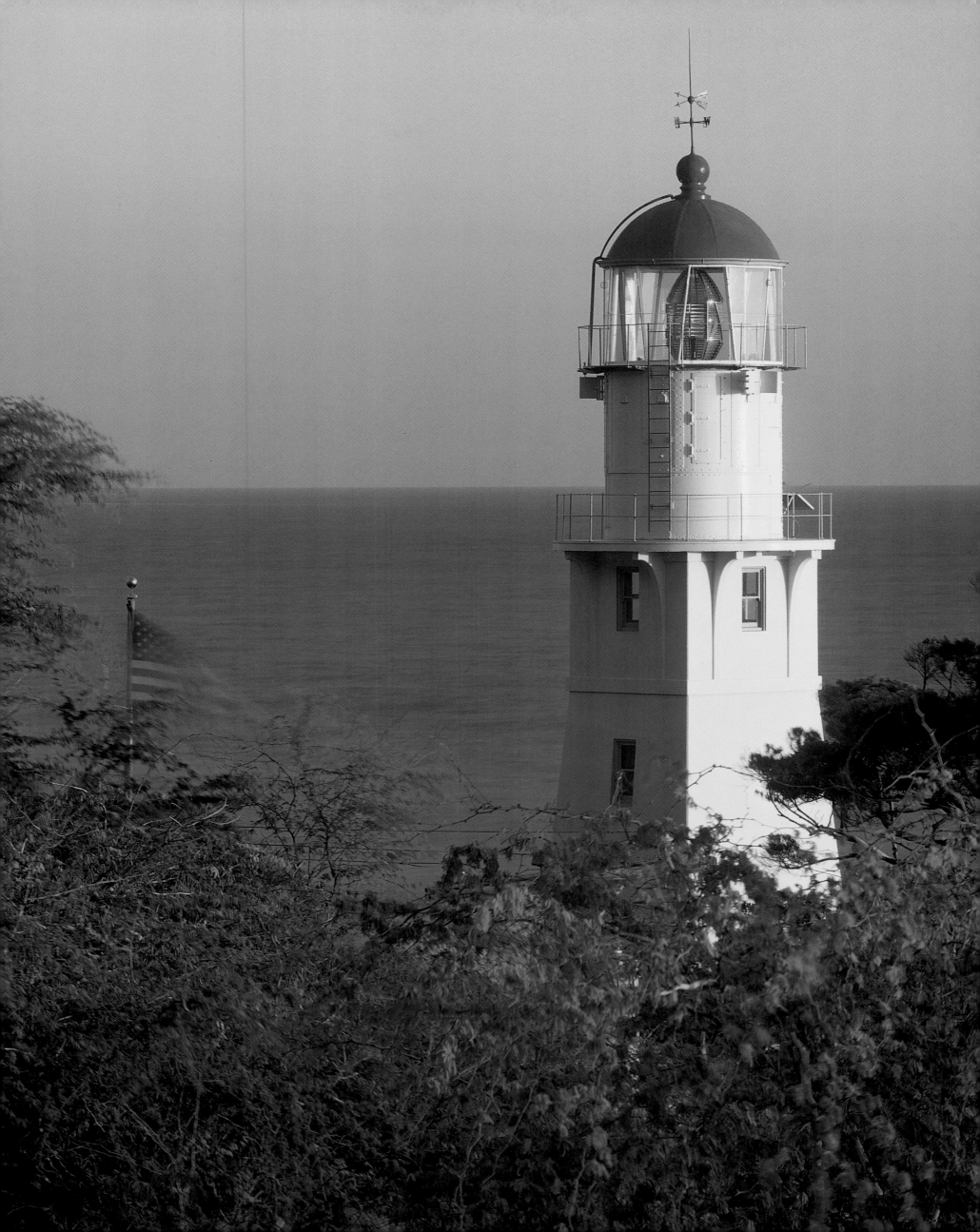

\mathcal{T}he sea without a stain on it...still standing and looking out over the bay. The sea stretched like silk across the bay. Distance had an extraordinary power; they had been swallowed up in it, she felt, they were gone for ever, they had become part of the nature of things. It was so calm; it was so quiet.

Virginia Woolf, from *To the Lighthouse*

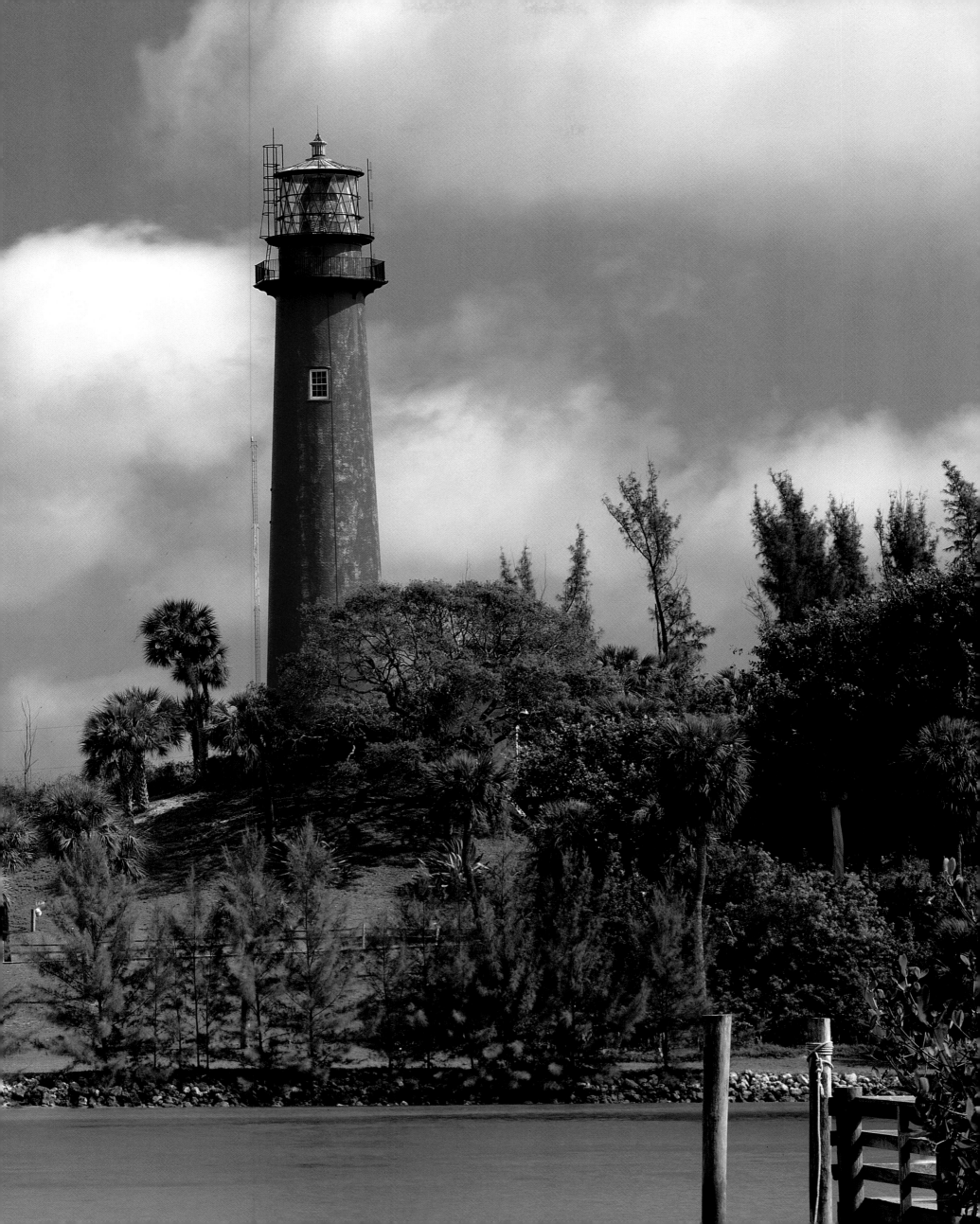

First light had drained away the darkening stars
And the icy moon, and now with dawning fire
Ocean was pregnant and the sea's expanse,
Revealed by the new sun, sank back to rest
Beneath the radiance of his panting steeds.

Statius, from *Thebaid*

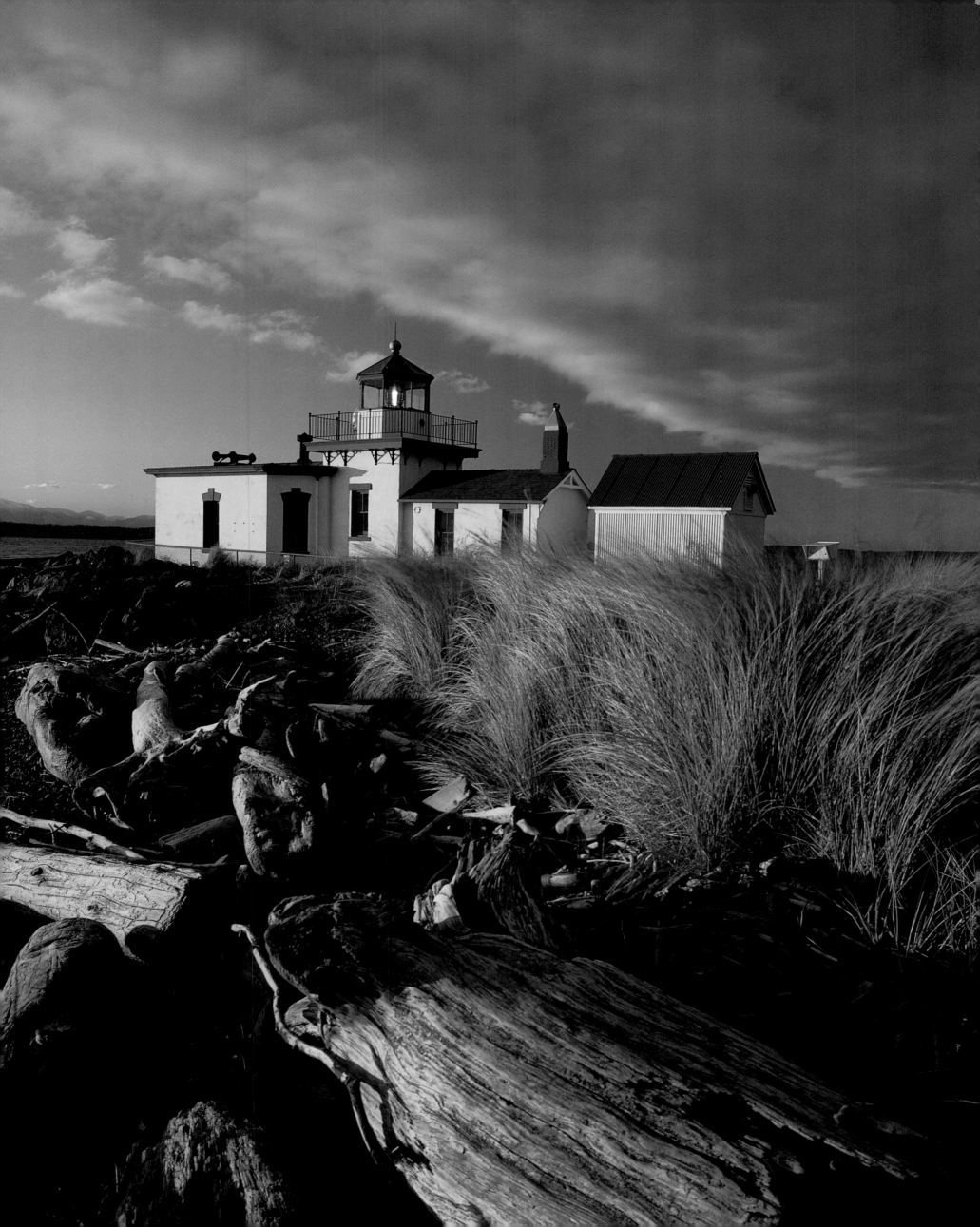

Sunset and evening star,
And one clear call for me!
And may there be no moaning of the bar,
When I put out to sea.

But such a tide as moving seems asleep,
Too full for sound and foam,
When that which drew from out the boundless deep
Turns again home.

Twilight and evening bell,
And after that the dark!
And may there be no sadness of farewell
When I embark.

For tho' from out our bourne of Time and Place
The flood may bear me far,
I hope to see my Pilot face to face
When I have crost the bar.

Alfred, Lord Tennyson, *Crossing the Bar*

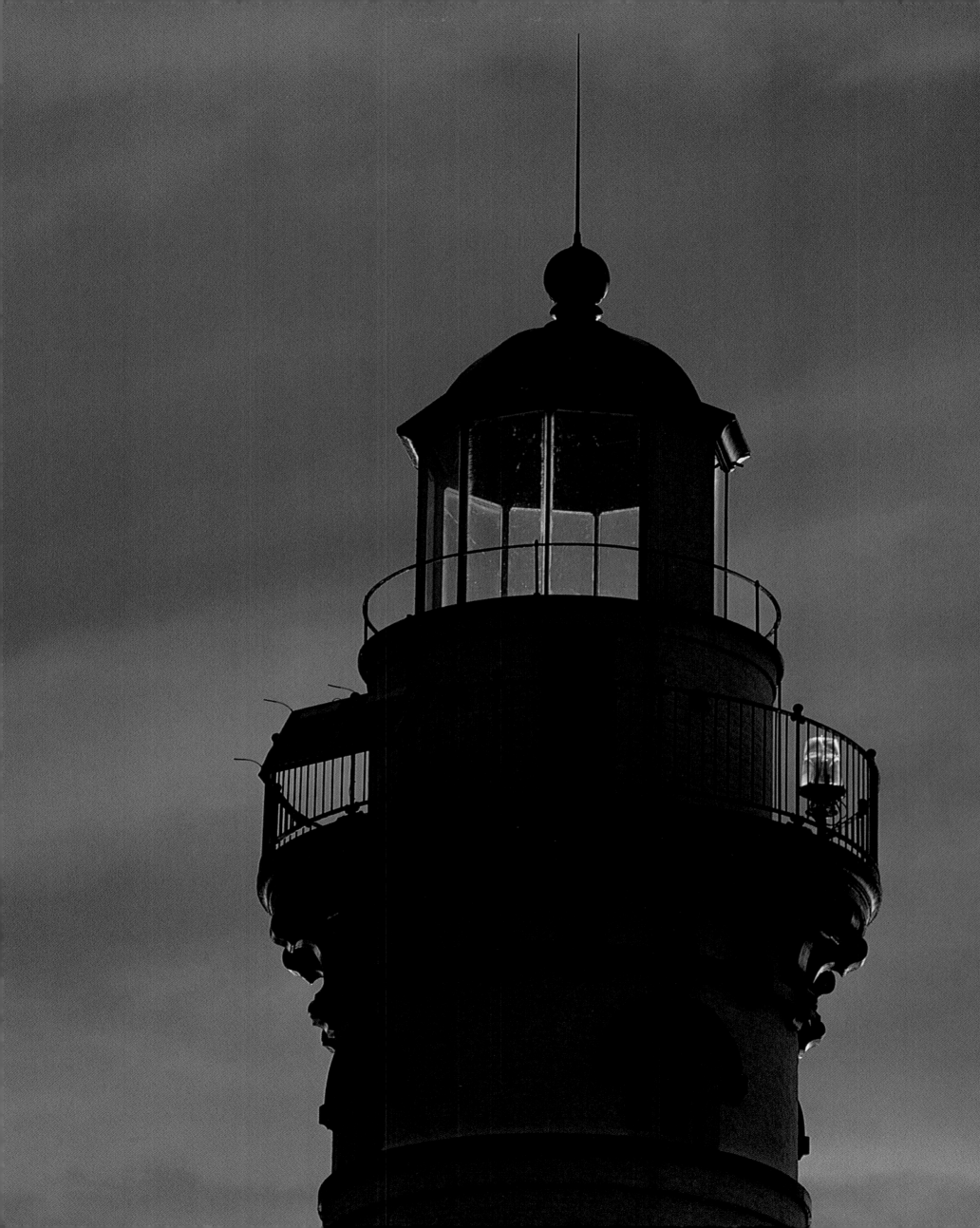

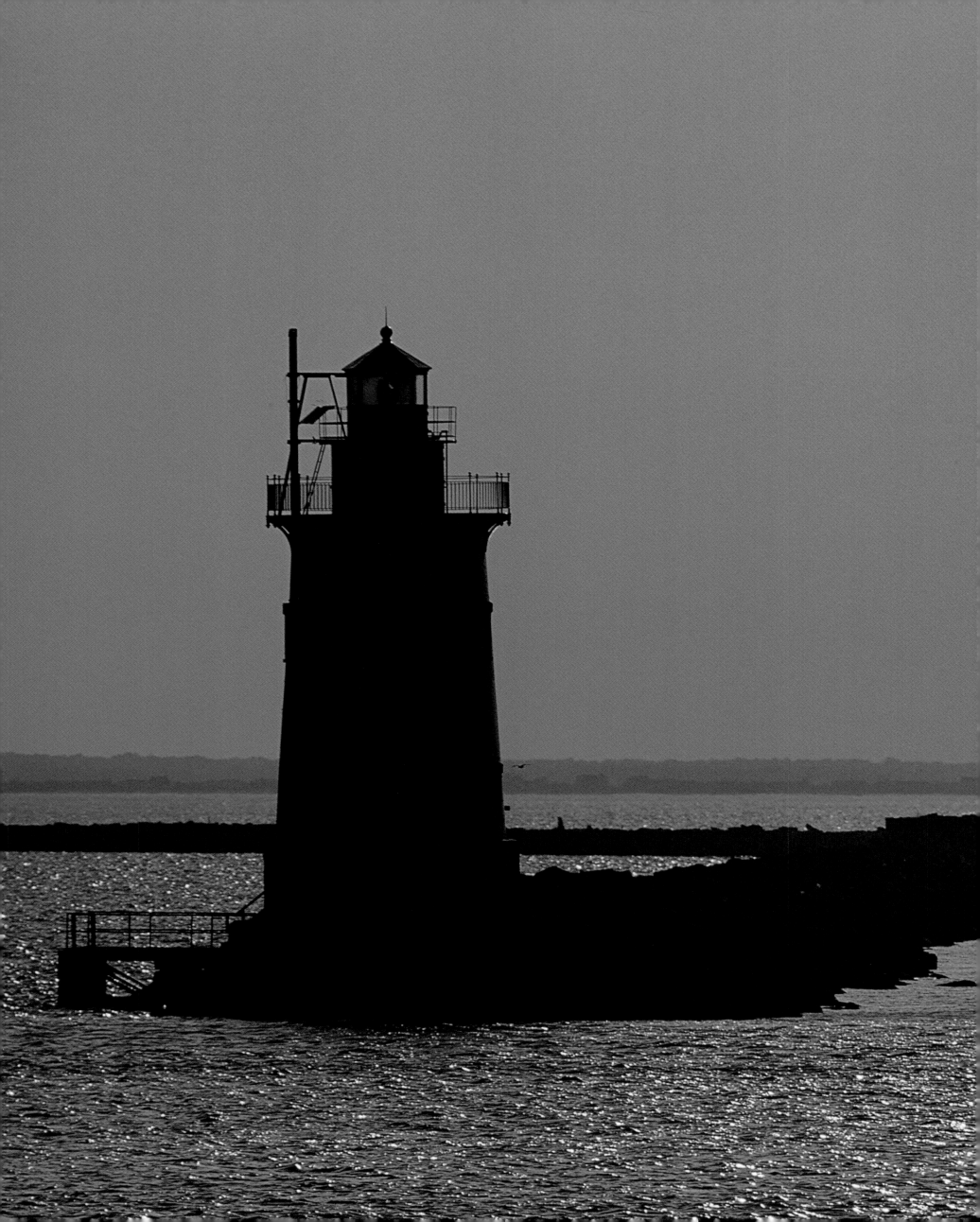

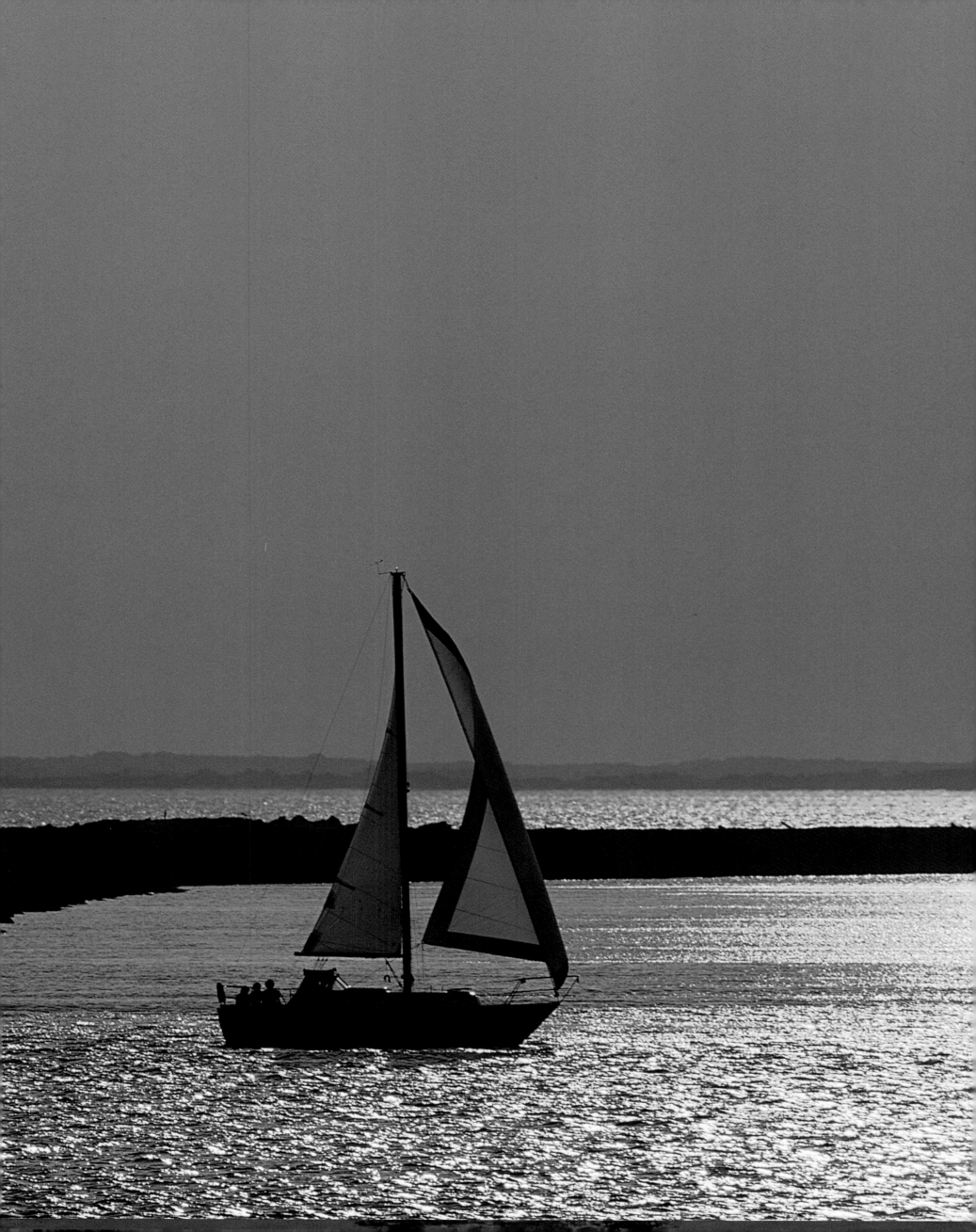

*E*very man should use his intellect, not as he uses his lamp in the study, only for his own seeing, but as the lighthouse uses its lamp, that those afar off on the sea may see the shining, and learn their way.

Henry Ward Beecher

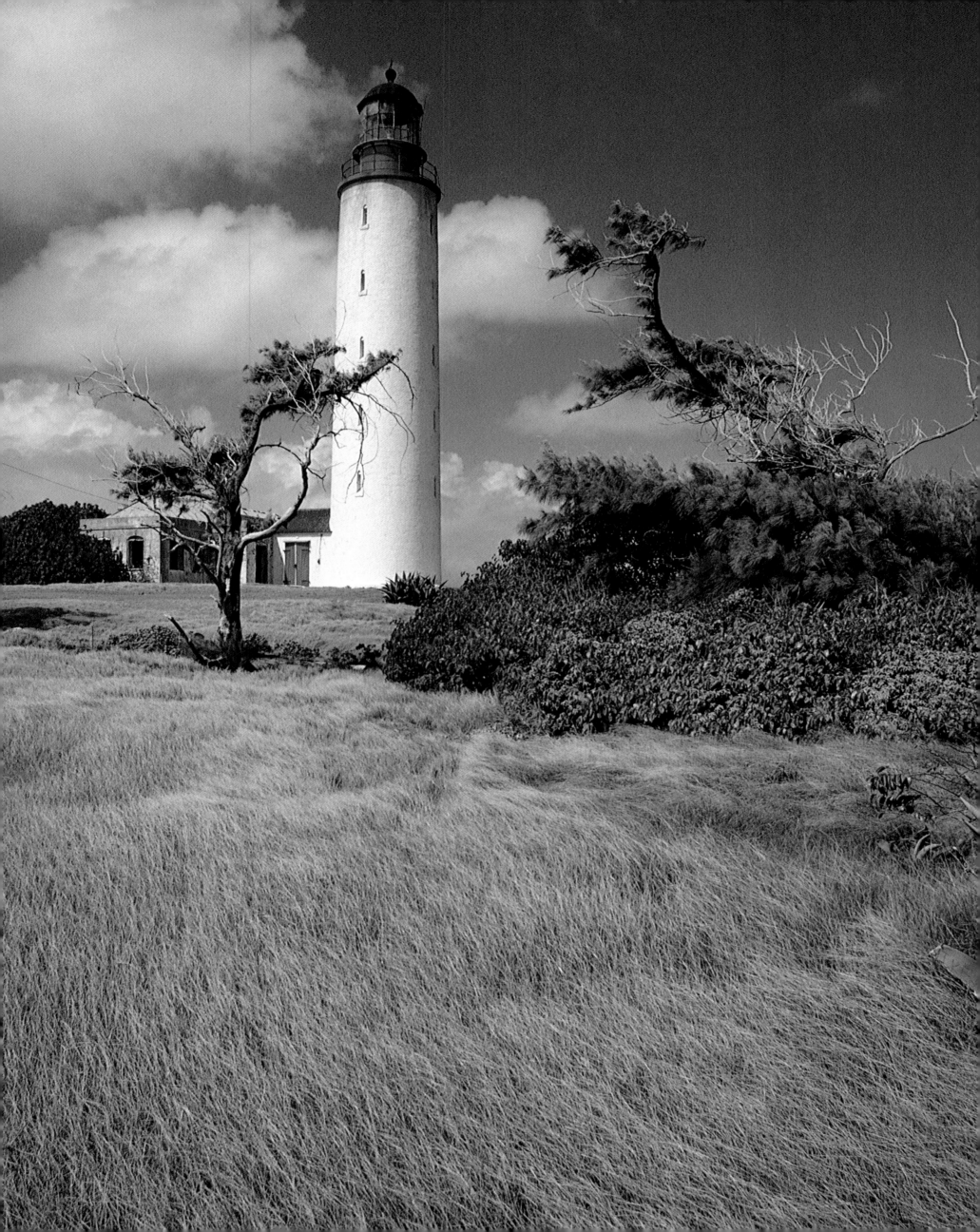

The rocky ledge runs far into the sea,
and on its outer point, some miles away,
the lighthouse lifts its massive masonry,
A pillar of fire by night, of cloud by day.

Henry Wadsworth Longfellow, from *The Lighthouse*

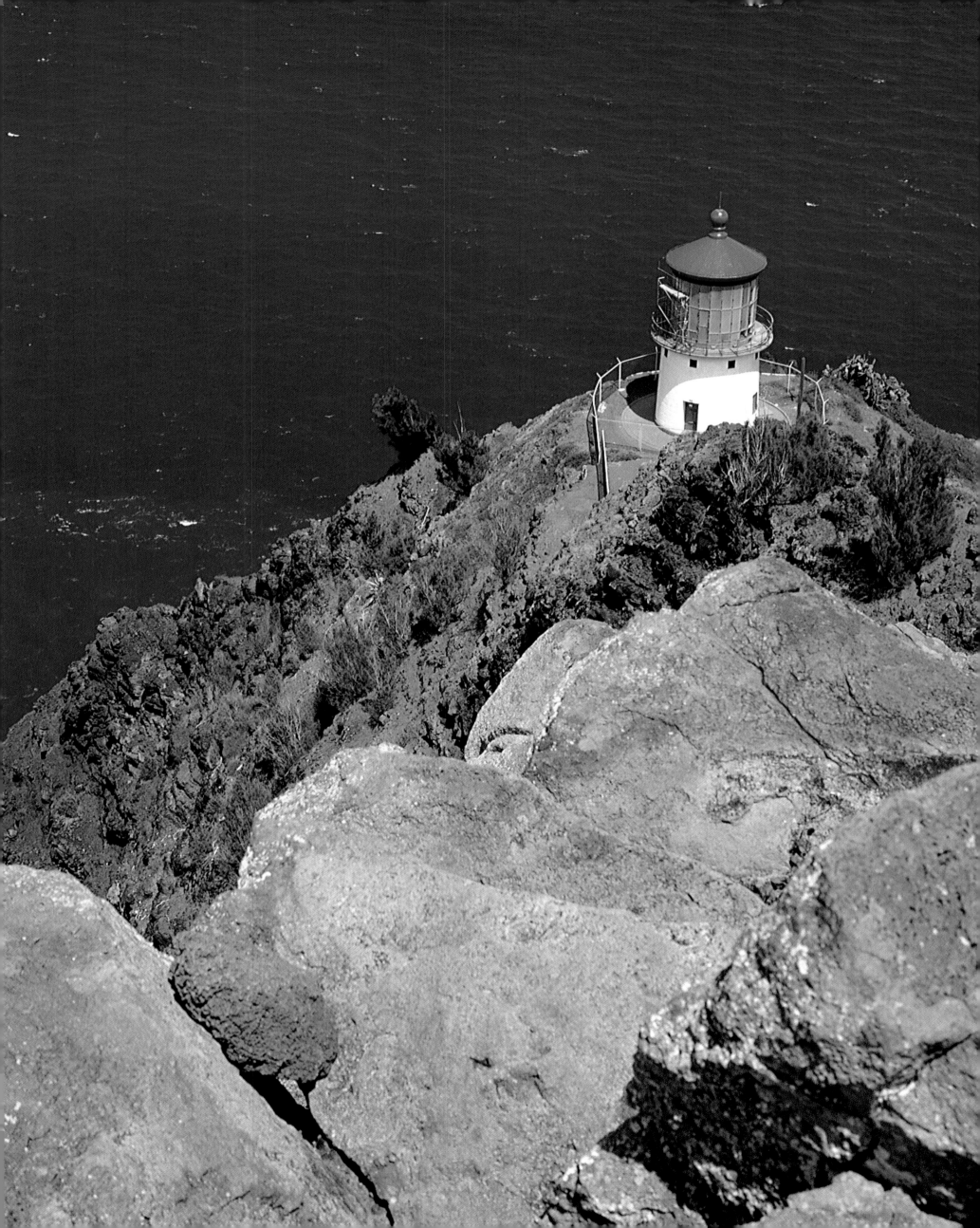

When from our better selves we have too long
Been parted by the hurrying world, and droop,
Sick of its business, of its pleasures tired,
How gracious, how benign, is Solitude;
How potent a mere image of her sway;
Most potent when impressed upon the mind
With an appropriate human centre-hermit,
Deep in the bosom of the wilderness;
Votary (in vast cathedral, where no foot
Is treading, where no other face is seen)
Kneeling at prayers; or watchman on the top
Of lighthouse, beaten by Atlantic waves;
Or as the soul of that great Power is met
Sometimes embodied on the public road,
When, for the night deserted, it assumes
A character of quiet more profound
Than pathless wastes.

William Wordsworth, from *The Prelude*, Book Fourth, Summer Vacation

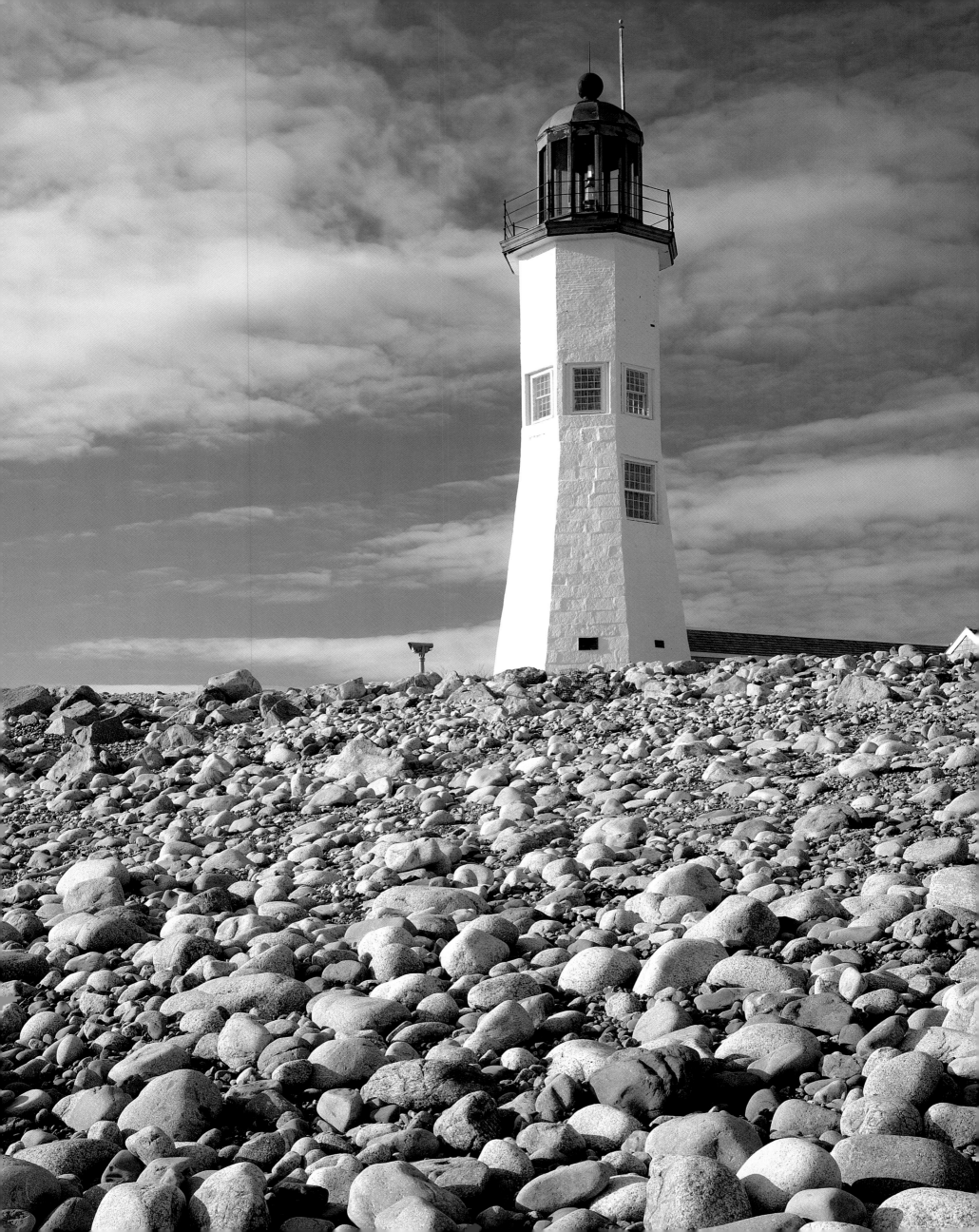

Nothing indicates the liberality, prosperity, or intelligence
of a nation more clearly than the facilities which it affords
for the safe approach of mariners to shore.

Anonymous

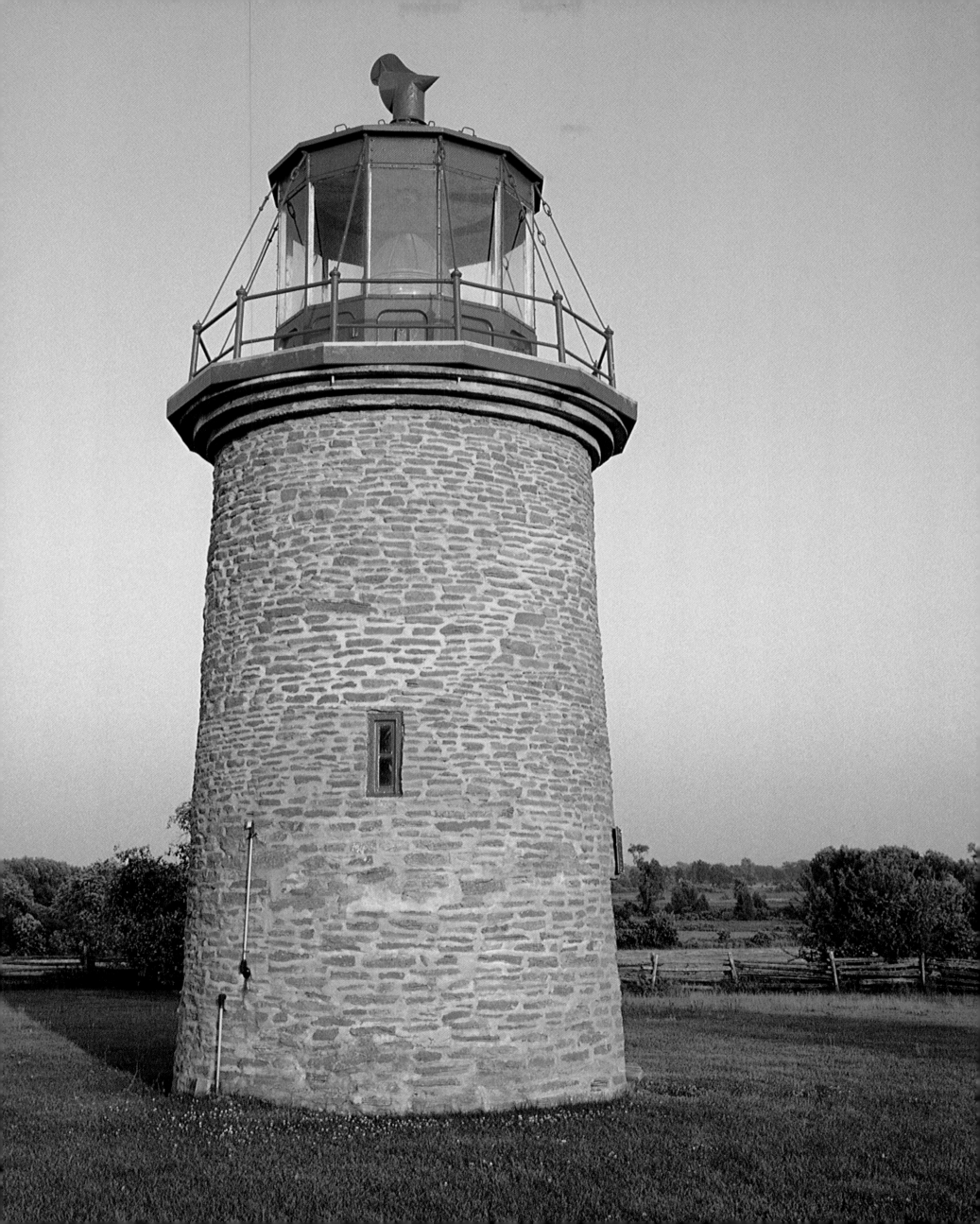

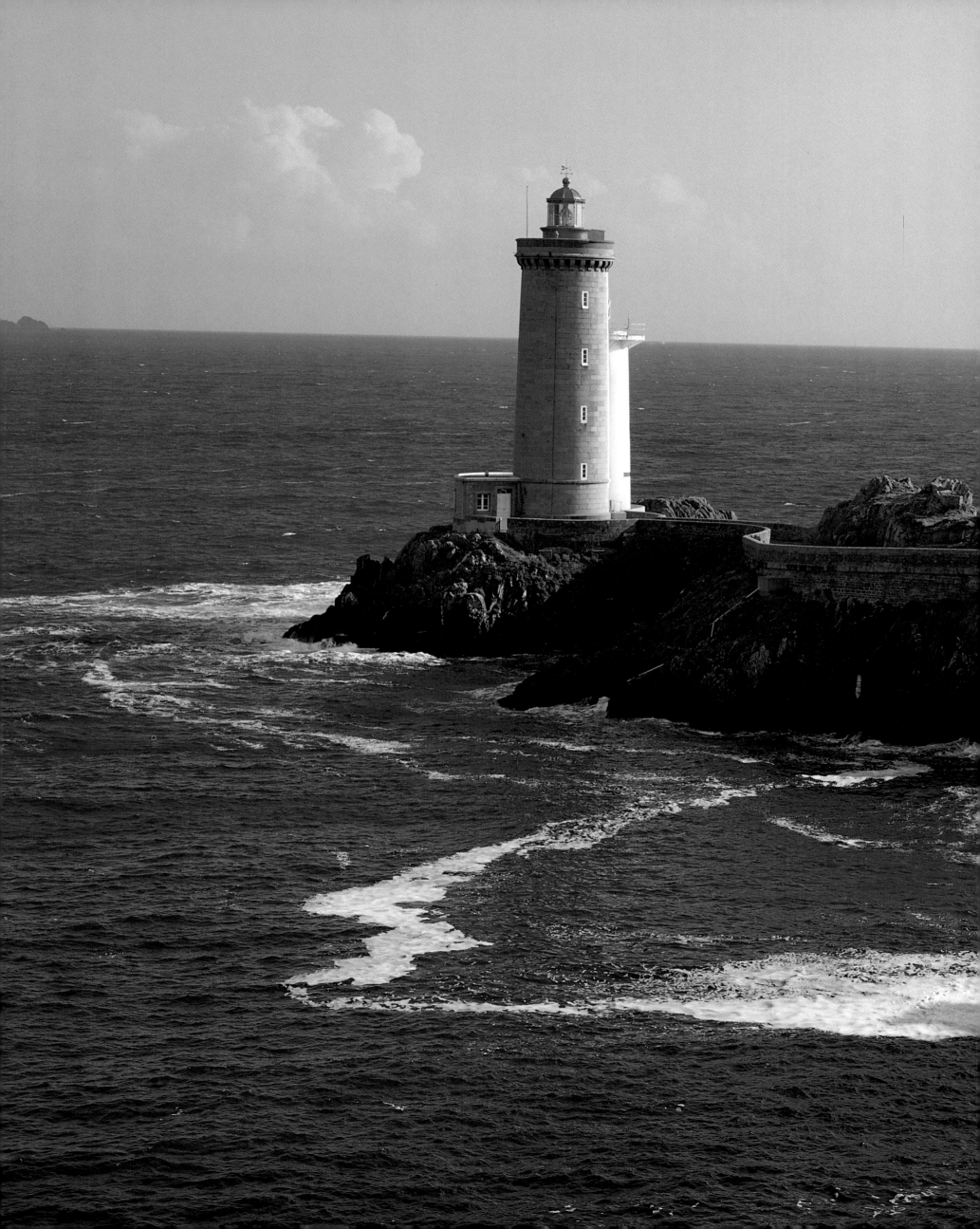

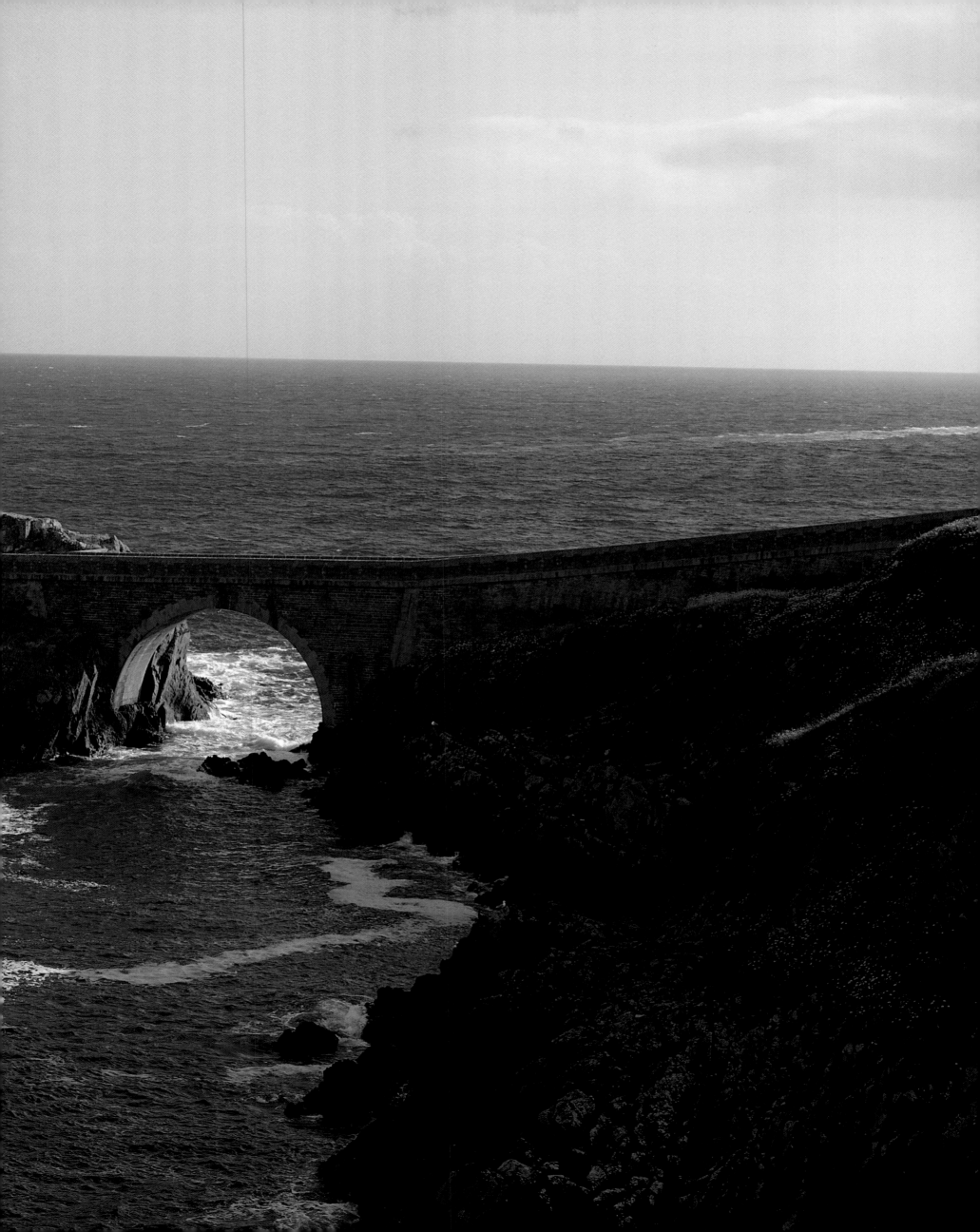

*L*ong may this structure (beacon of the land)

Guide erring vessels from both rocks and sand:

Long may this fabric tow'r towards the skies,

Its faithful watchman get their just supplies,

And Britain's genius e'er triumphant stand,

The immortal Pharos of a free-born land.

. .

The guide for seamen steering for the port,

Their faithful beacon and their best resort:

Above the sea—above the clouds it moves!

And brilliant shines! And happ'ly round revolves;

Alternately the dark and light appears,

By this sure guide the experienc'd pilot steers

But human works are destin'd to decay;

By storms destroy'd or burnt by fires away.

From *The Eddystone Lighthouse*, anonymous

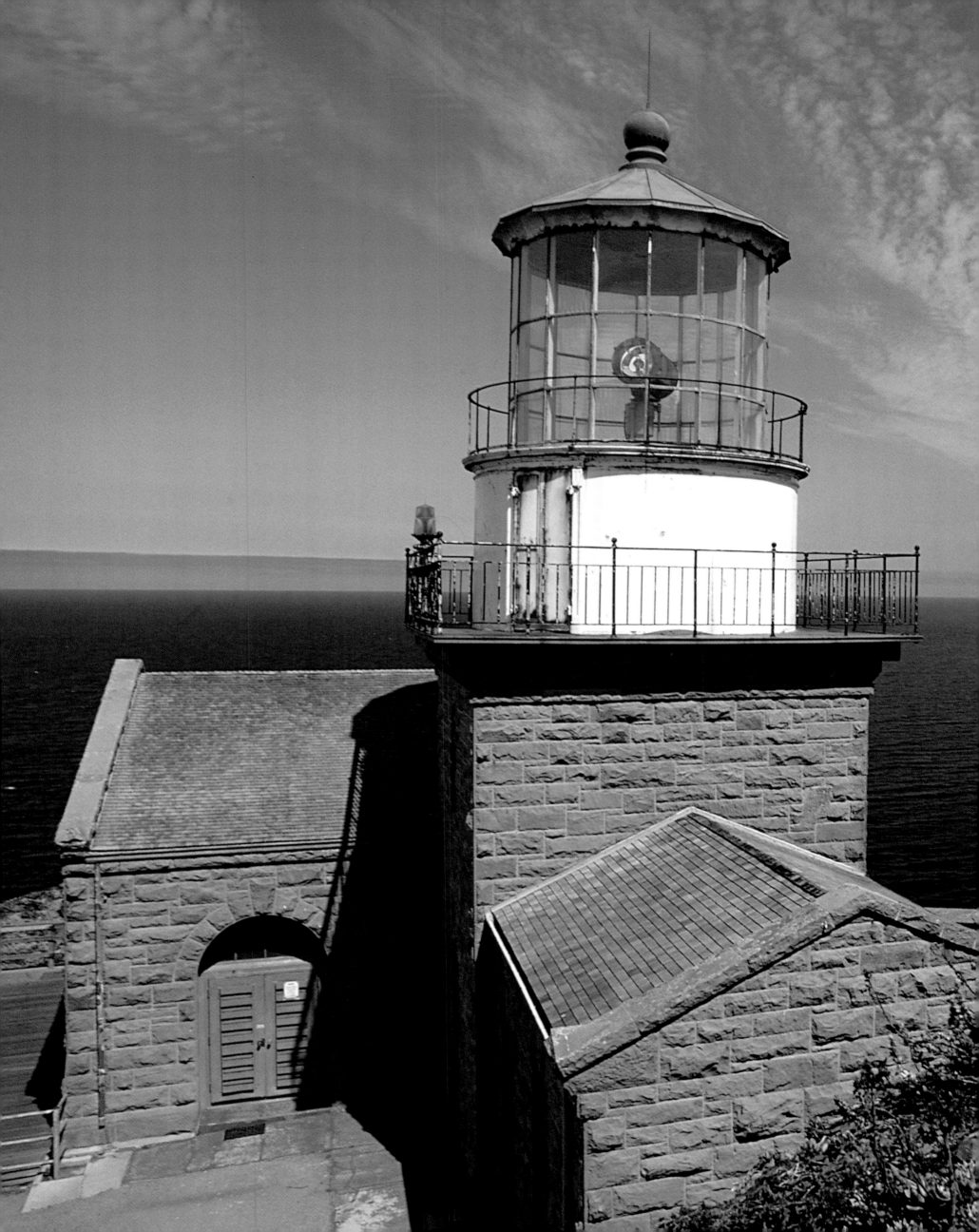

How like the leper, with his own sad cry
Enforcing its own solitude, it tolls!
That lonely bell set in the rushing shoals,
To warn us from the place of jeopardy!
O friend of man! Sore-vexed by Ocean's power,
The changing tides wash o'er thee day by day;
Thy trembling mouth is filled with bitter spray
Yet still thou ringest on from hour to hour;
High is thy mission, though thy lot is wild—
To be in danger's realm a guardian sound;
In seamen's dreams a pleasant part to bear,
And earn their blessing as the year goes round;
And strike the key-note of each grateful prayer
Breathed in their distant homes by wife and child.

Charles Tennyson Turner

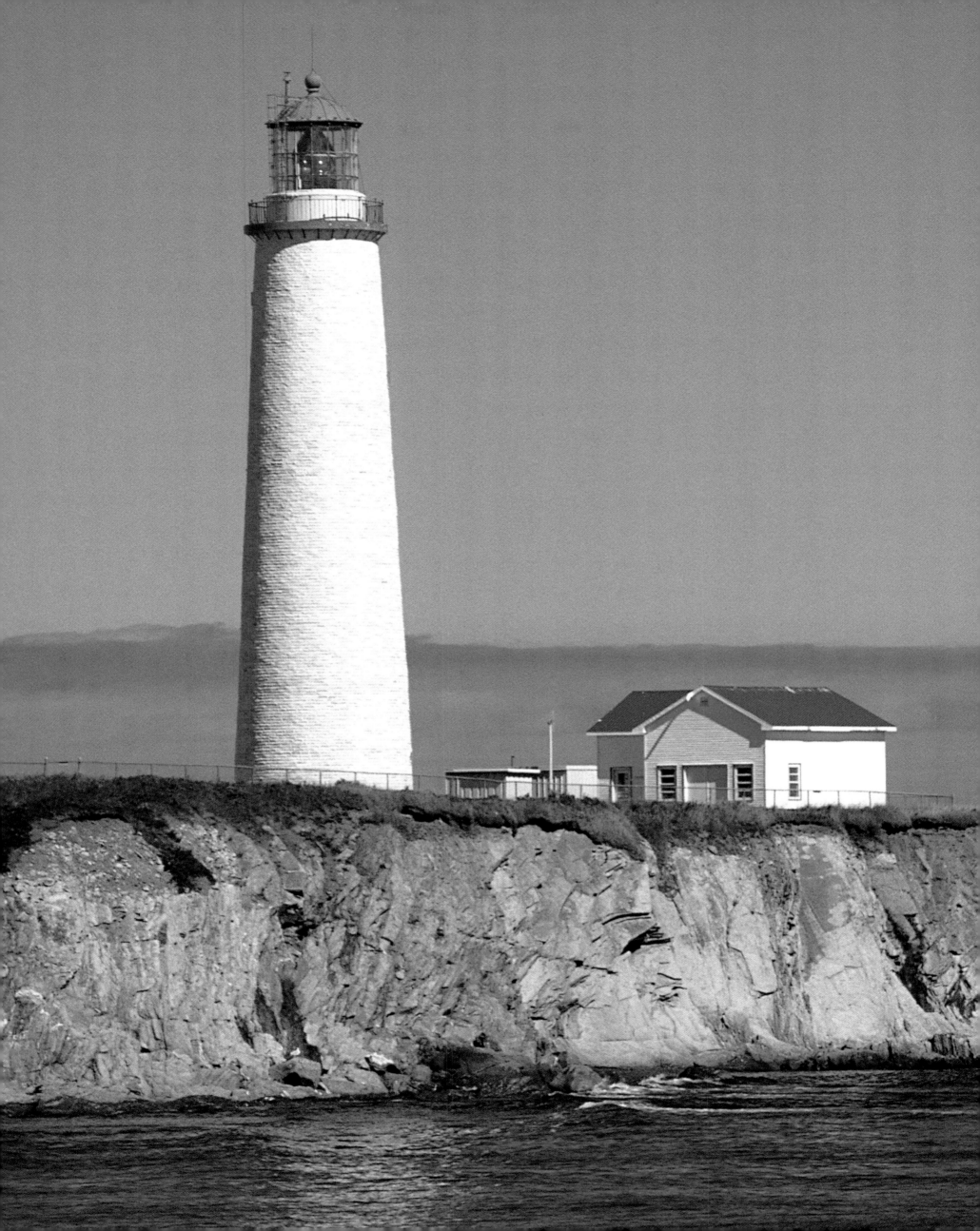

*O*h, what is the bane of the lightkeeper's life,
That causes him worry and struggles and strife,
That makes him use cuss words and beat up his wife?
It's Brasswork.

. .

The lamp in the tower, reflector and shade,
The tools and accessories pass in parade
As a matter of fact the whole outfit is made
Of Brasswork.

. .

I dig, scrub and polish, and work with a might,
And just when I get it all shining and bright,
In comes the fog like a thief in the night.
Goodbye Brasswork.

. .

And when I have polished until I am cold,
And I'm taken aloft to the Heavenly fold,
Will my harp and my crown be made of pure gold?
No, Brasswork.

Fred Morong, from *Brasswork, or The Lighthouse Keeper's Lament*

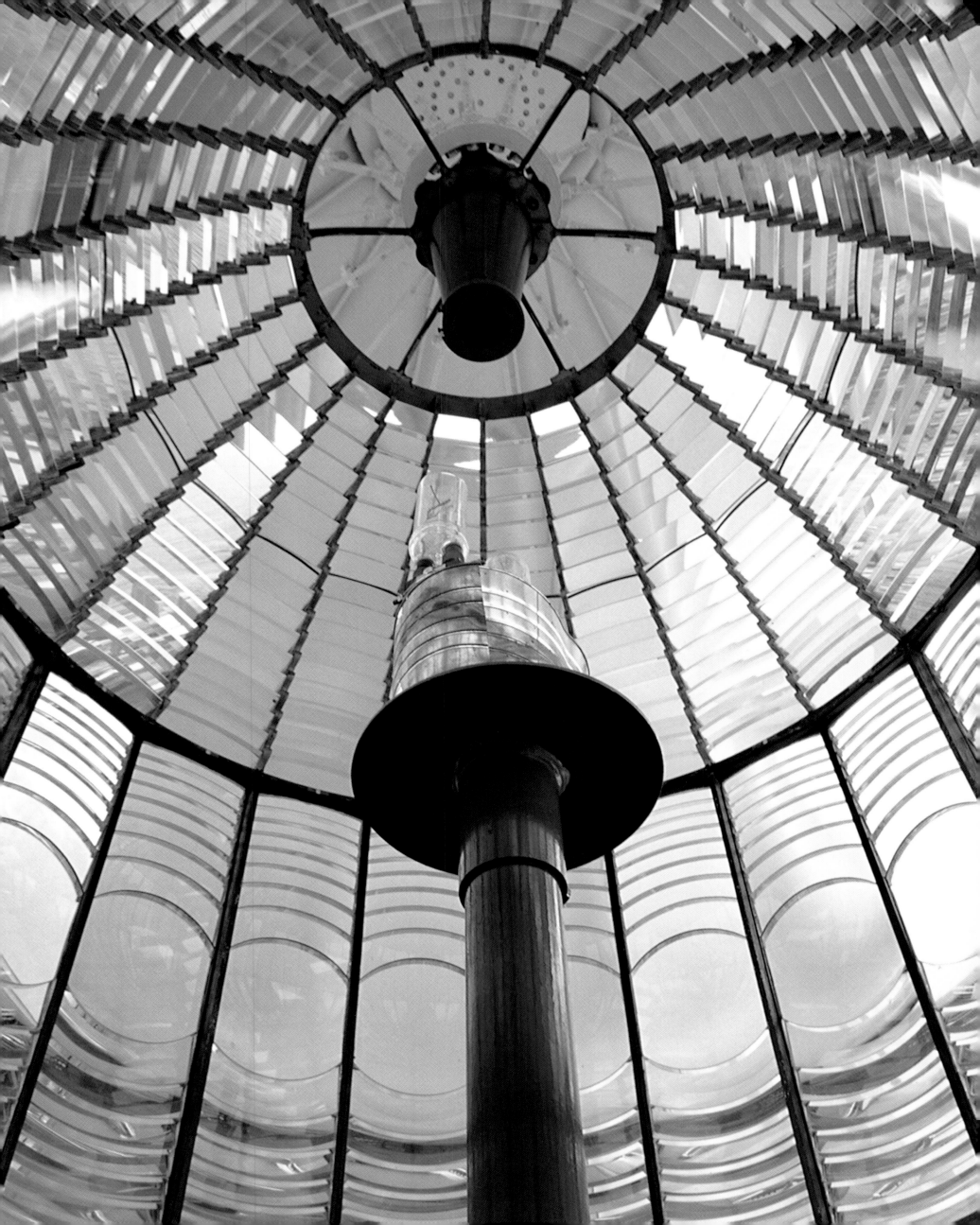

*A*nd o'er them the lighthouse looked as lovely as hope—
that star of life's tremulous ocean.

Paul Moon James

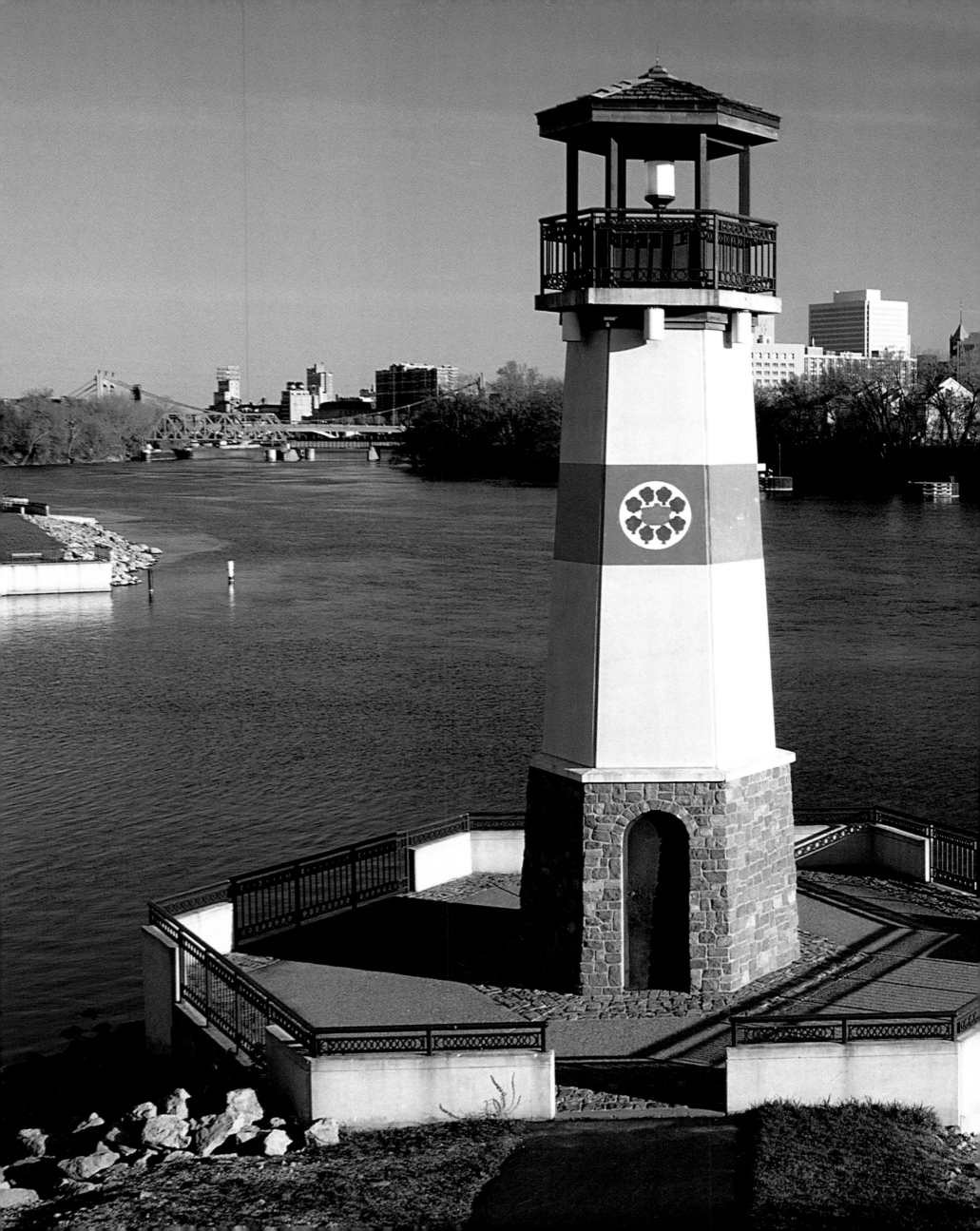

The Lighthouse was then a silvery, misty-looking tower with a yellow eye that opened suddenly and softly in the evening.

Virginia Woolf from *To the Lighthouse*

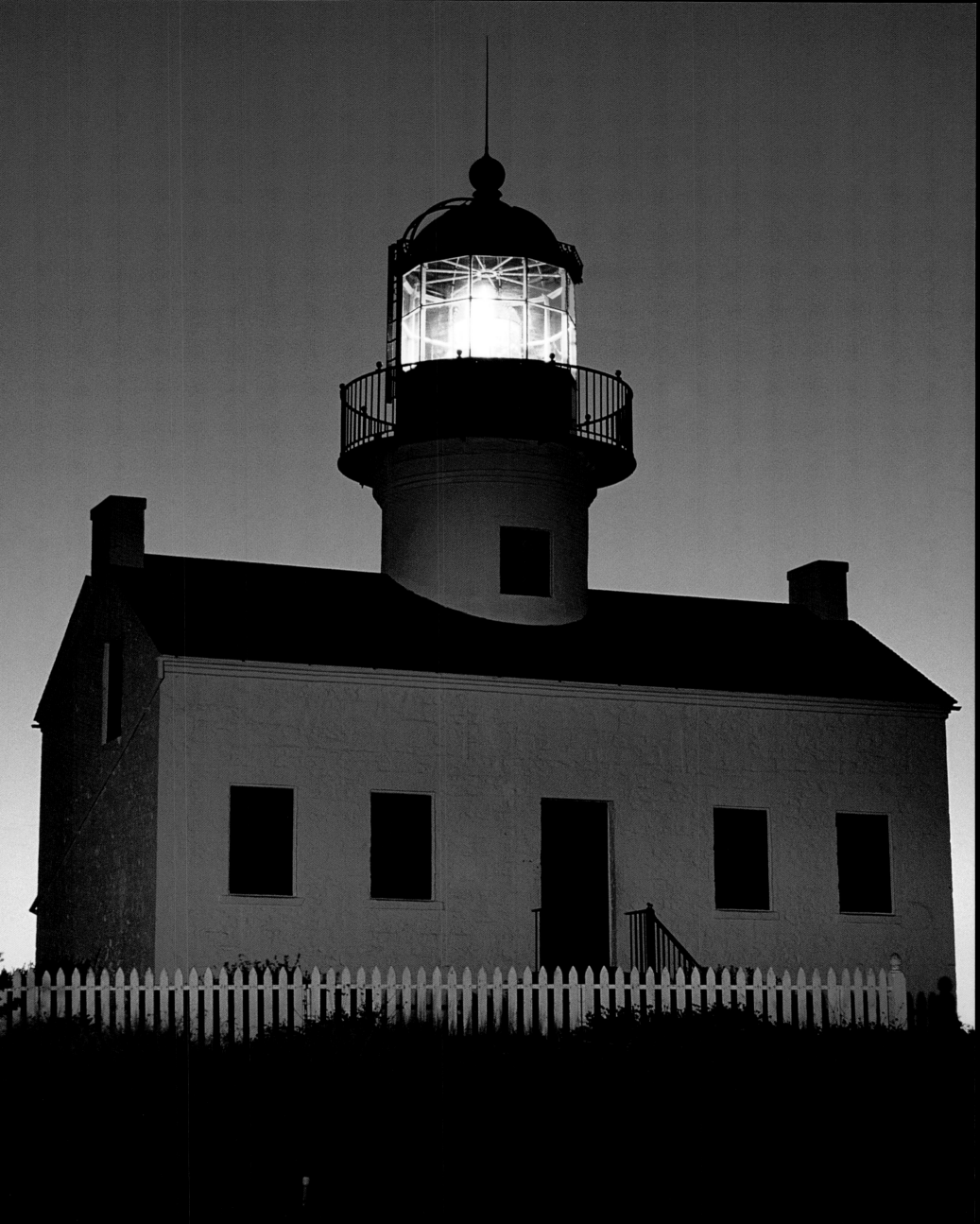

*H*ours, days, in my Long Island youth and early manhood, I haunted the shores of Rockaway or Coney Island, or away east to the Hamptons or Montauk. Once, at the latter place, (by the old lighthouse, nothing but sea-tossings in sight in every direction as far as the eye could reach,) I remember well, I felt that I must one day write a book expressing this liquid, mystic theme.

Walt Whitman, from *Specimen Days*

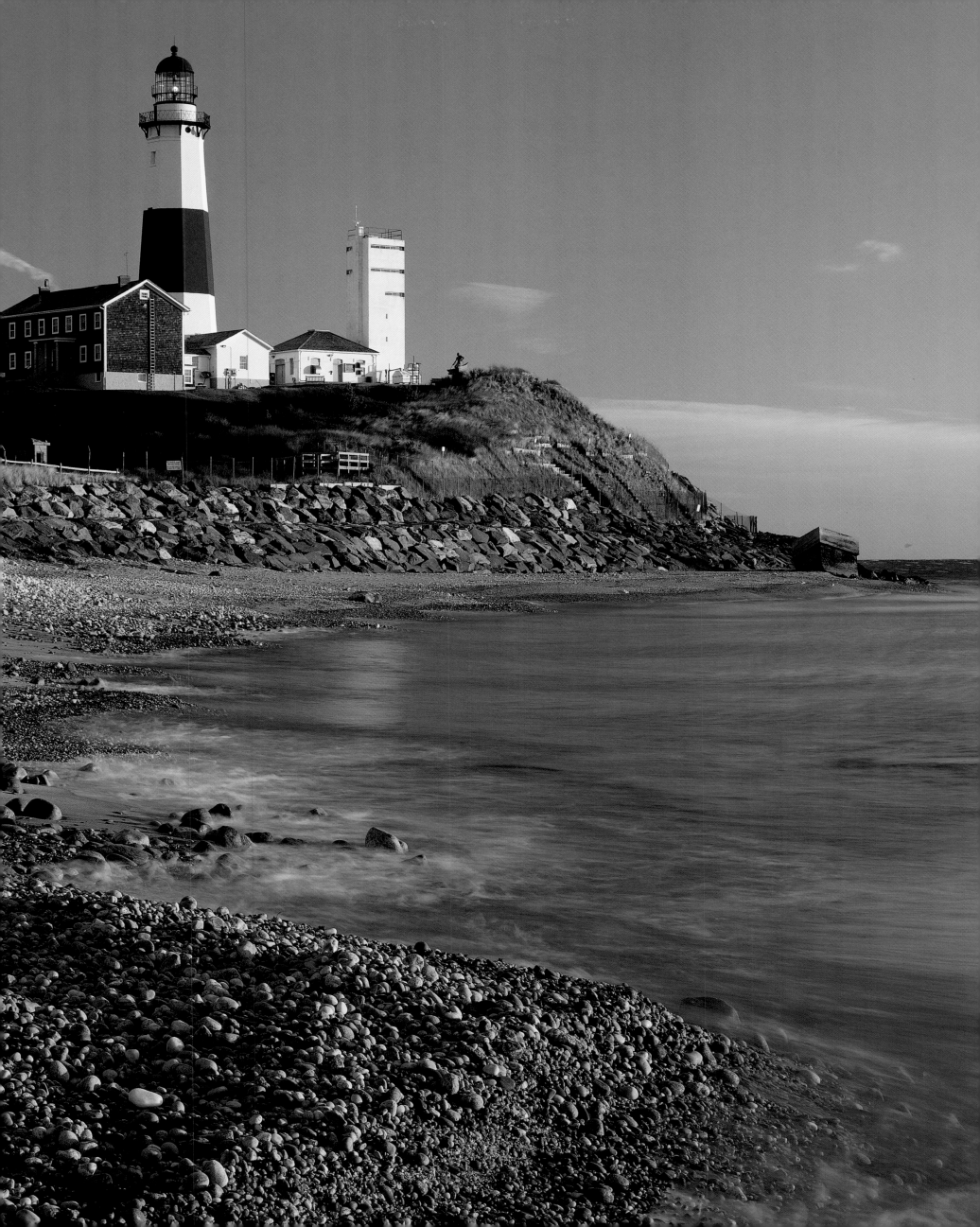

Lighthouses are marks and signs…being a matter of an high and precious nature, in respect of salvation of ships and lives, and a kind of starlight in that element.

Francis Bacon

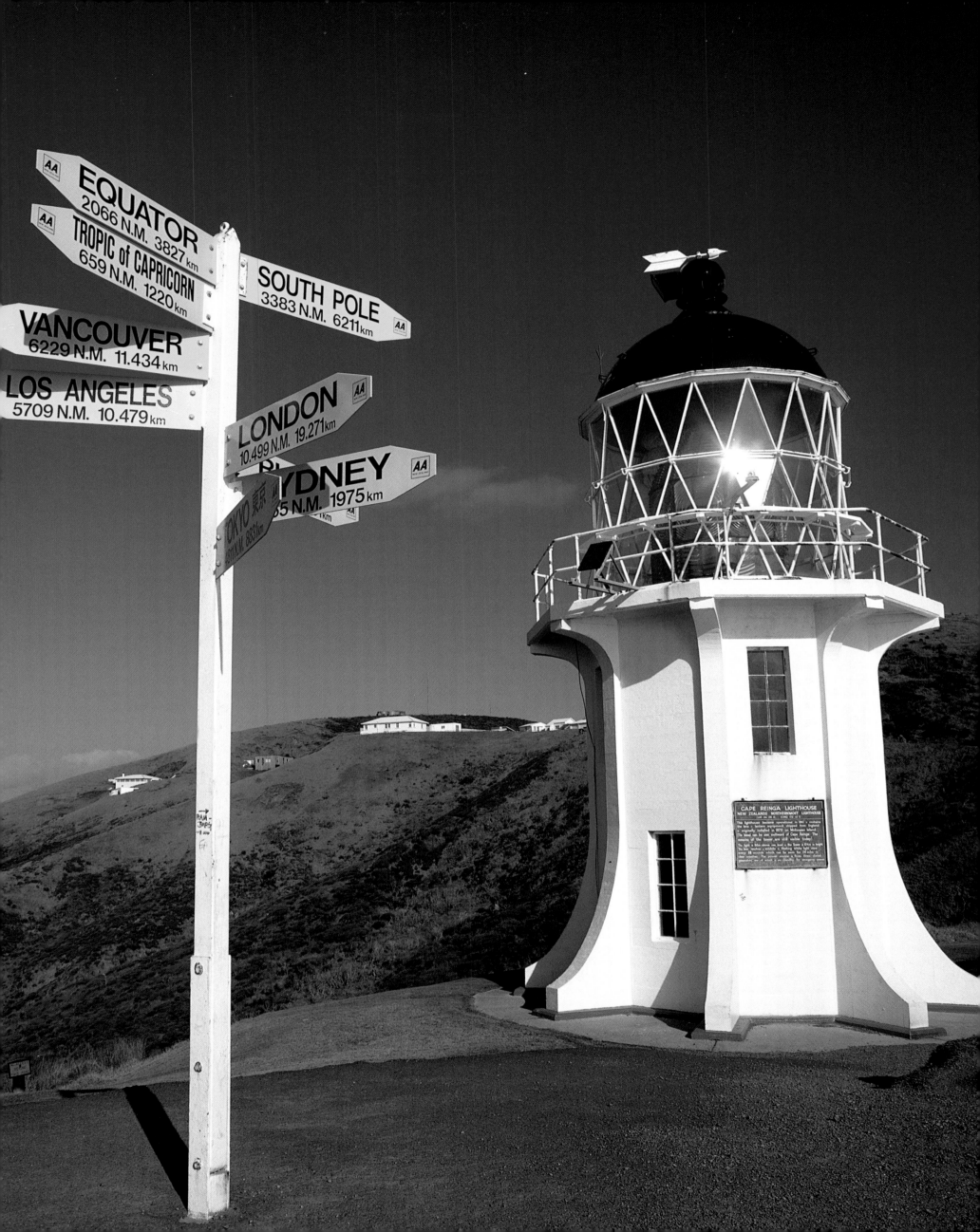

Three wives sat up in the lighthouse tower,
And they trimmed the lamps as the sun went down.
They looked at the squall and looked at the shower;
And the night-rack came rolling up ragged and brown.
But men must work, and women must weep,
Though storms be sudden and waters deep,
And the harbour bar be moaning.

Kingsley Amis

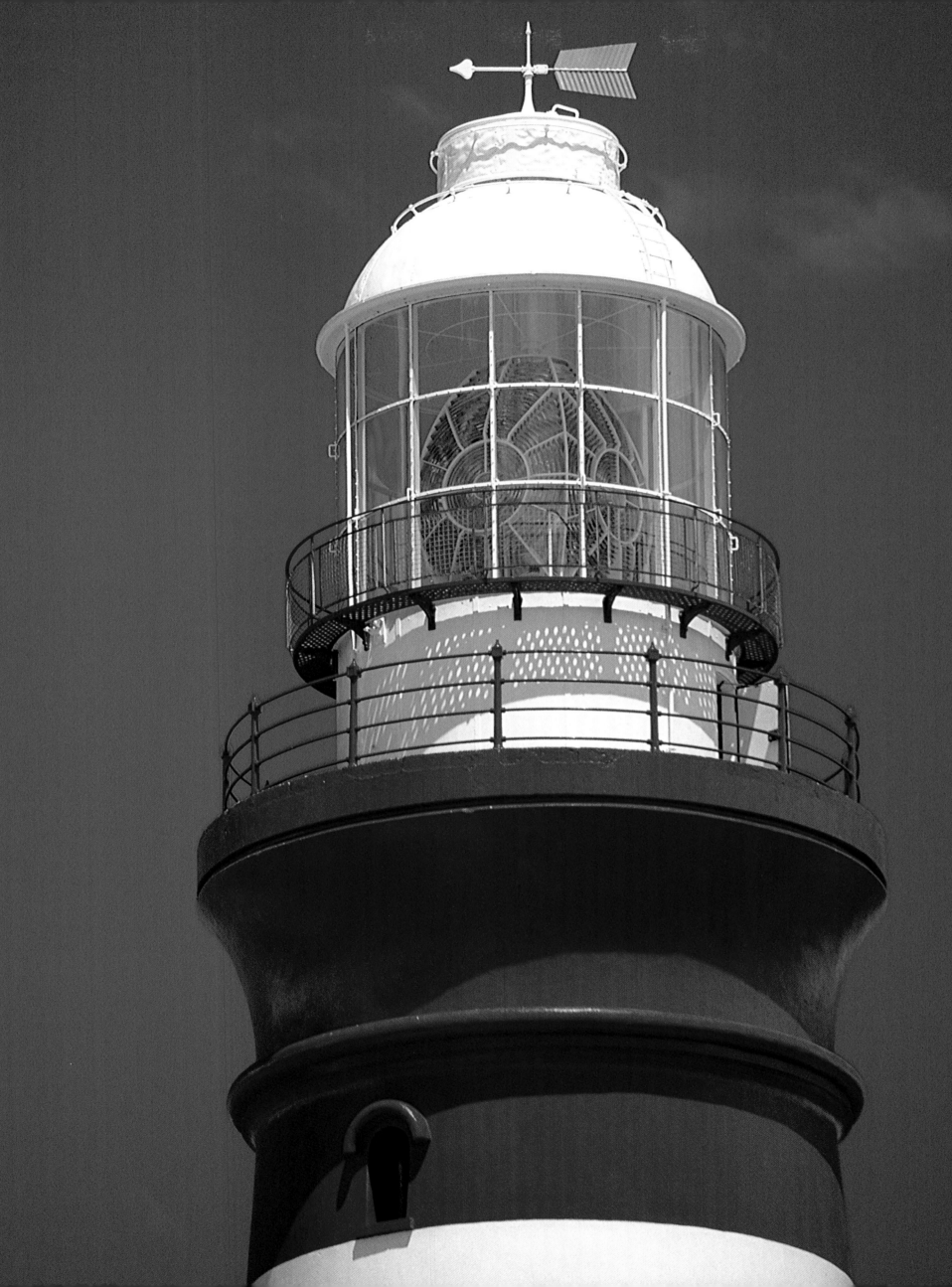

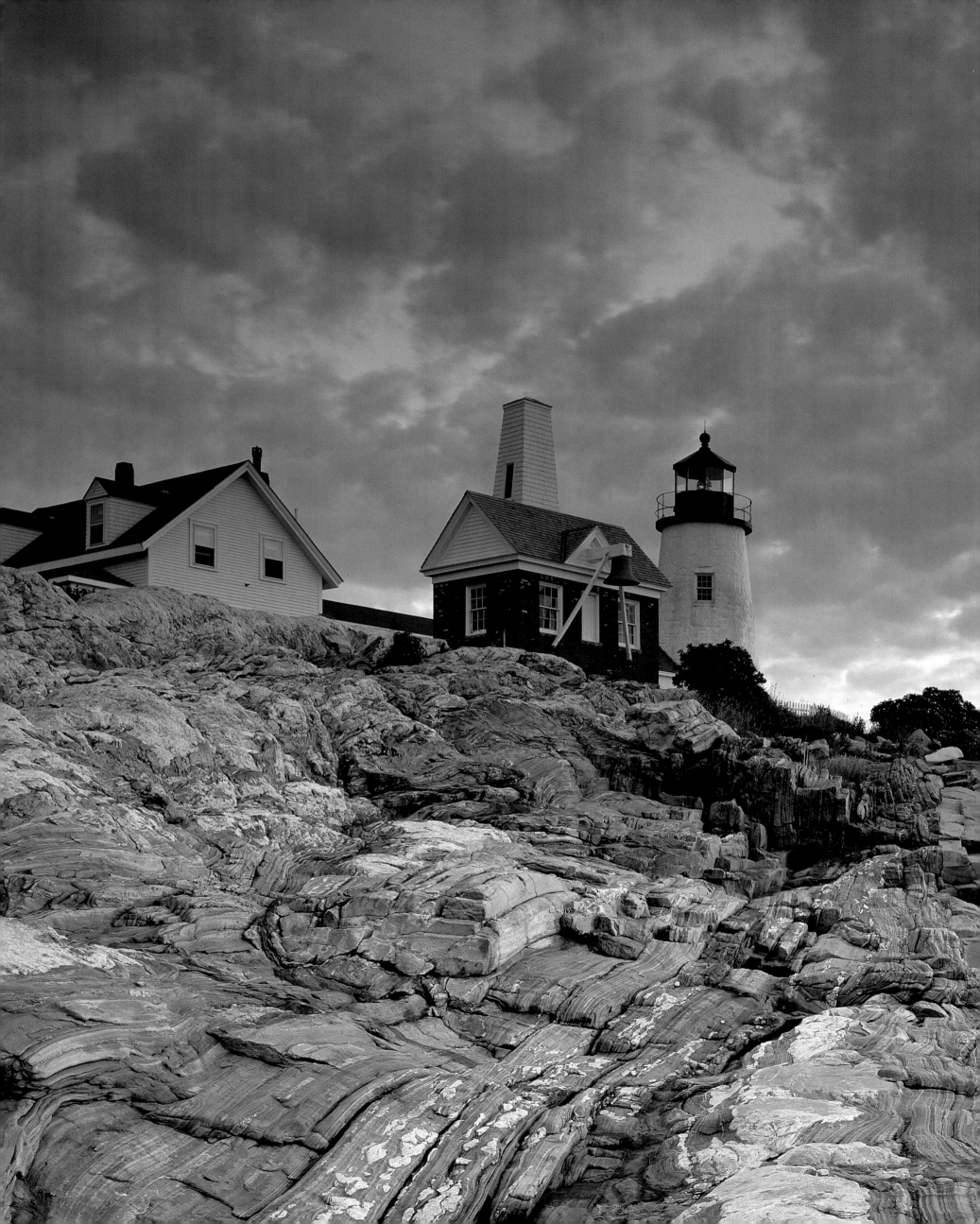

They set course for the coast of Africa. There is a haven there, at the end of a long sound, quite landlocked by an island in the shape of two breakwaters, which parts the waves entering from the open sea and draws them off into long channels. On each shore a frightening headland of rock towers massively into the sky; and the wide expanse of water which they overshadow is noiseless and secure.

Virgil, from *The Aeneid*

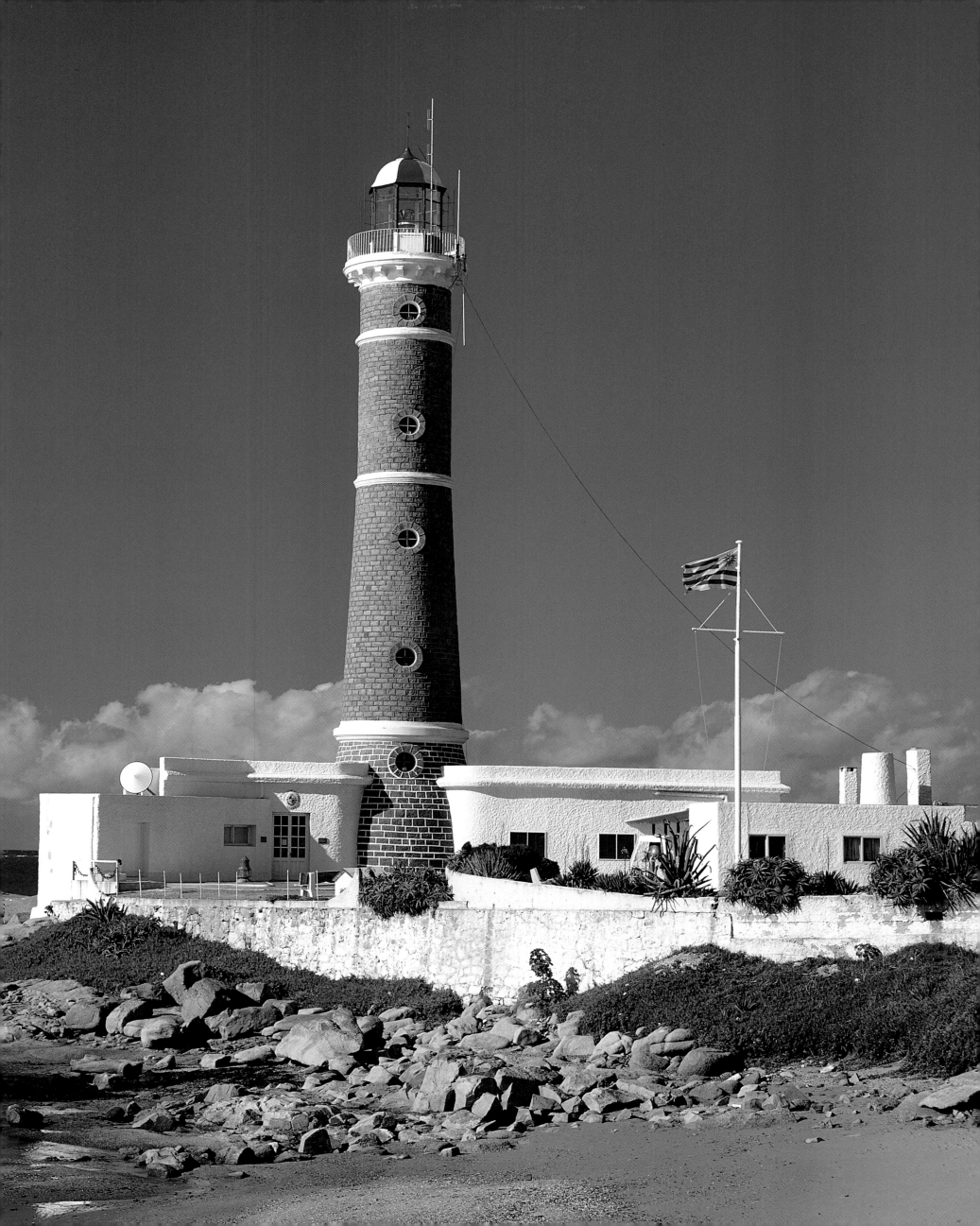

Break, break, break
On the cold gray stones, O Sea!
And I would that my tongue could utter
The thoughts that arise in me.

O, well for the fisherman's boy,
That he shouts with his sister at play!
O, well for the sailor lad,
That he sings in his boat on the bay!

And the stately ships go on
To their haven under the hill;
But O for the touch of a vanished hand,
And the sound of a voice that is still!

Break, break, break
At the foot of the crags, O Sea!
But the tender grace of a day that is dead
Will never come back to me.

Alfred, Lord Tennyson, *Break, Break, Break*

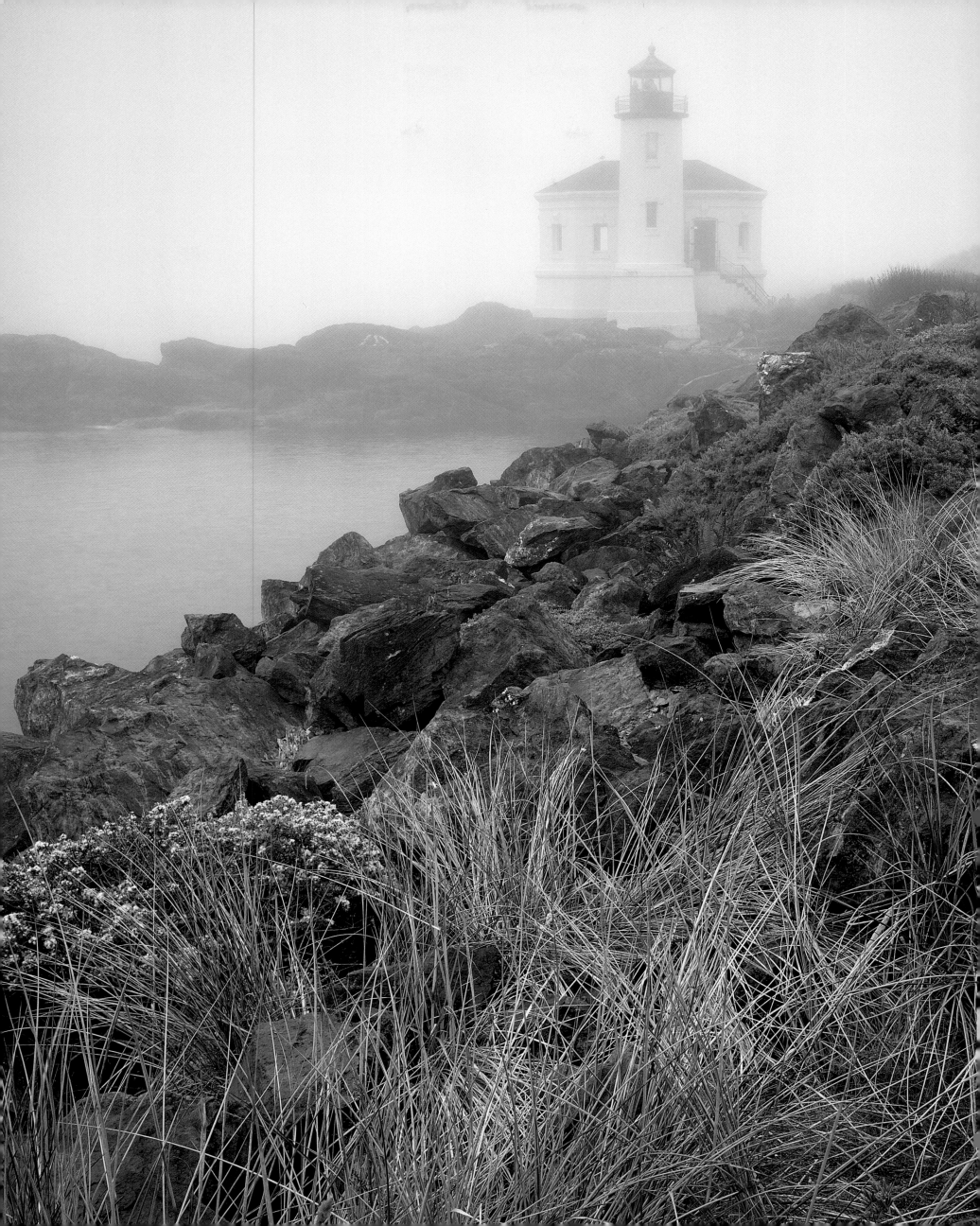

*I*t is now the middle of March, cold winds stream between earth and the serene assurance of the sun, winter retreats, and for a little season the whole vast world here seems as empty as a shell.

Henry Beston, from *The Outermost House*

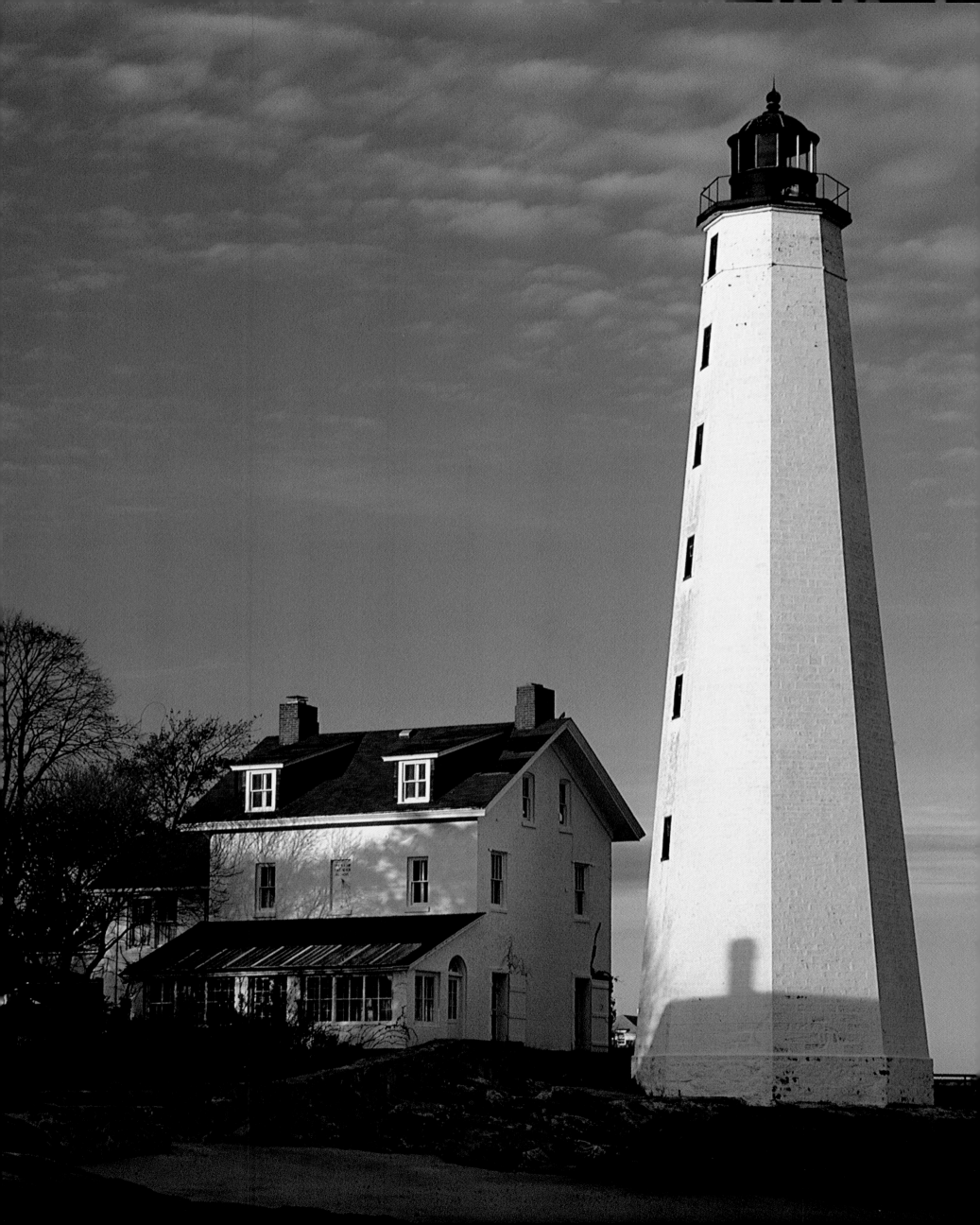

…*W*ithout either sign or sound of their shock,

The waves flowed over the Inchcape Rock;

So little they rose, so little they fell,

They did not move the Inchcape Bell.

..

They hear no sound; the swell is strong;

Though they wind has fallen they drift along,

Till the vessel strikes with a quivering shock…

..

The good old Abbot of Aberbrothock

Had placed the bell on the Inchcape Rock;

On a buoy in the storm it floated and swung,

And over the waves its warning rung.

Where the rock was hid by the surges' swell

The mariners heard the warning bell,

And then they knew the perilous rock

And blessed the Abbot of Aberbrothock.

Robert Southey, from *The Inchcape Rock*

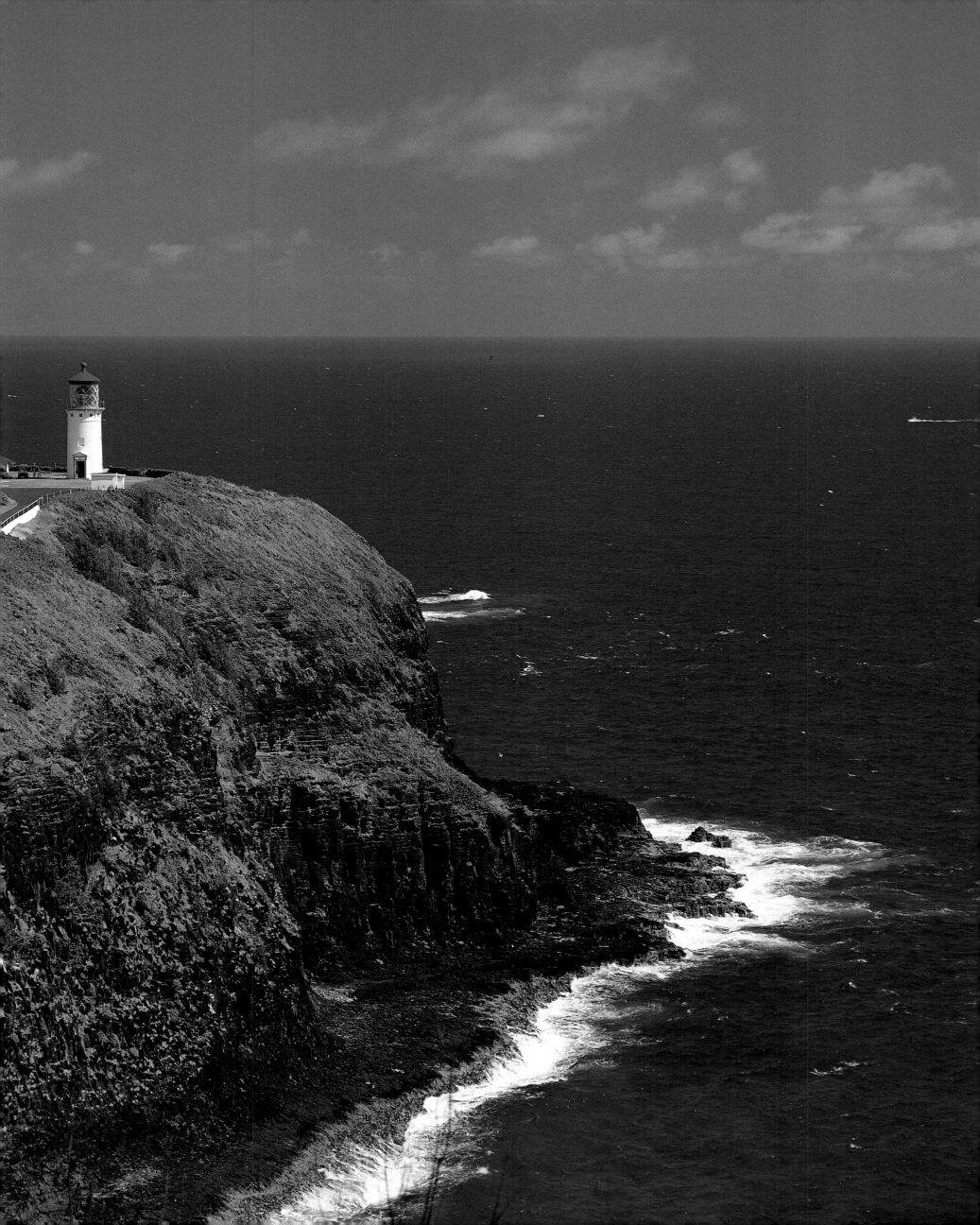

*L*ay down your head and close your eyes
and rest your weary soul,
For the lighthouse shines through fog, and rain,
and night as black as coal!

Though winds are lashing and waves are crashing
on coral reefs below,
The beacons calls and beckons all
with its majestic beam aglow.

When stars are out and seas are calm
and eventide draws nigh—
The seafarer rocks in a cradle of waves
to The Lighthouse Lullabye.

The Lighthouse Lullabye, anonymous

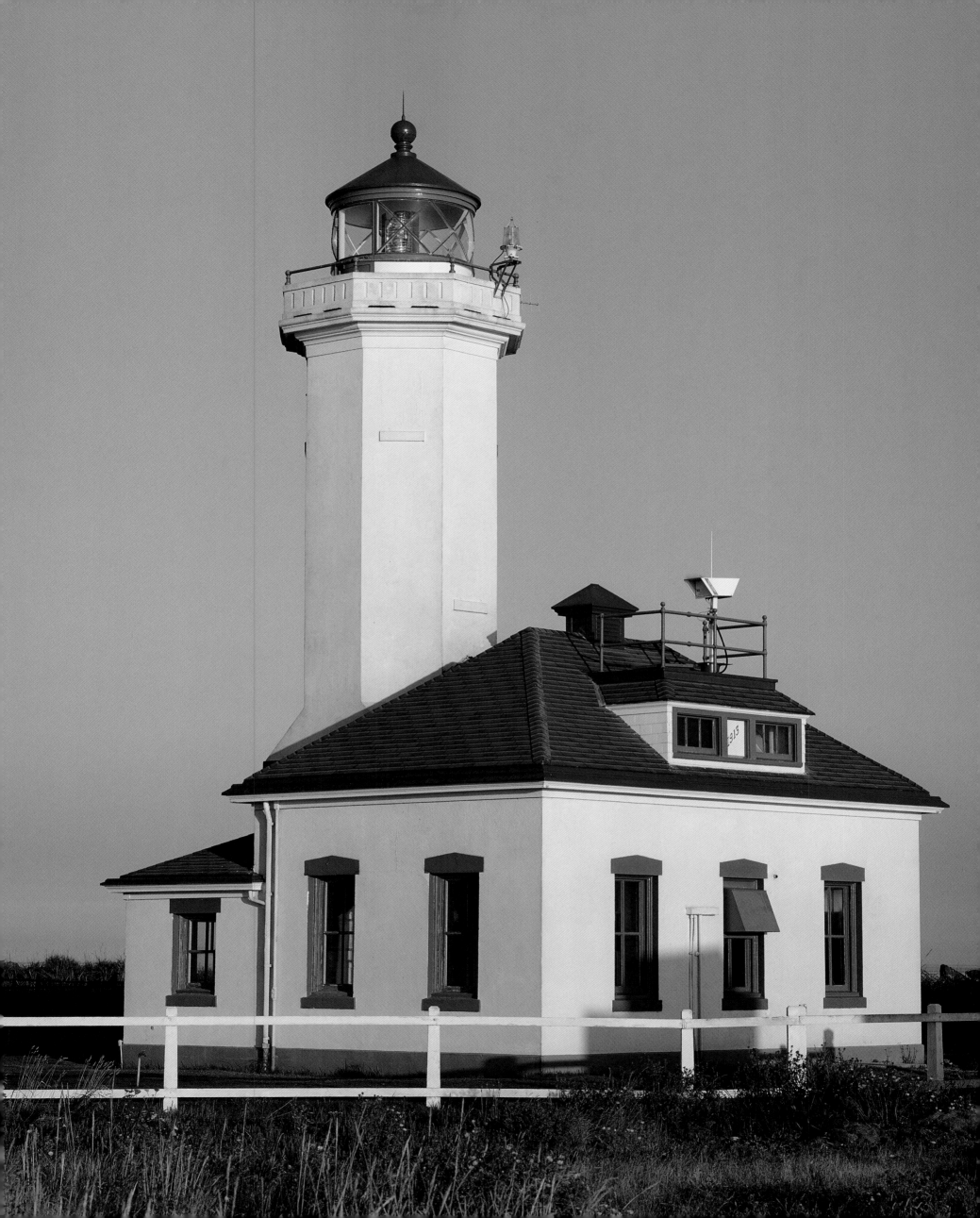

...*a* wicked reef of twenty-three rust-red rocks lying nine and one half miles south of Rame Head on the Devon mainland, great ragged stones around which the sea constantly eddies, a great danger to all ships hereabouts, for they sit astride the entrance to this harbour and are exposed to the full force of the westerly winds and must always be dreaded by mariners.

Captain's log, *Mayflower,* sailed from Plymouth on Sept. 6, 1620

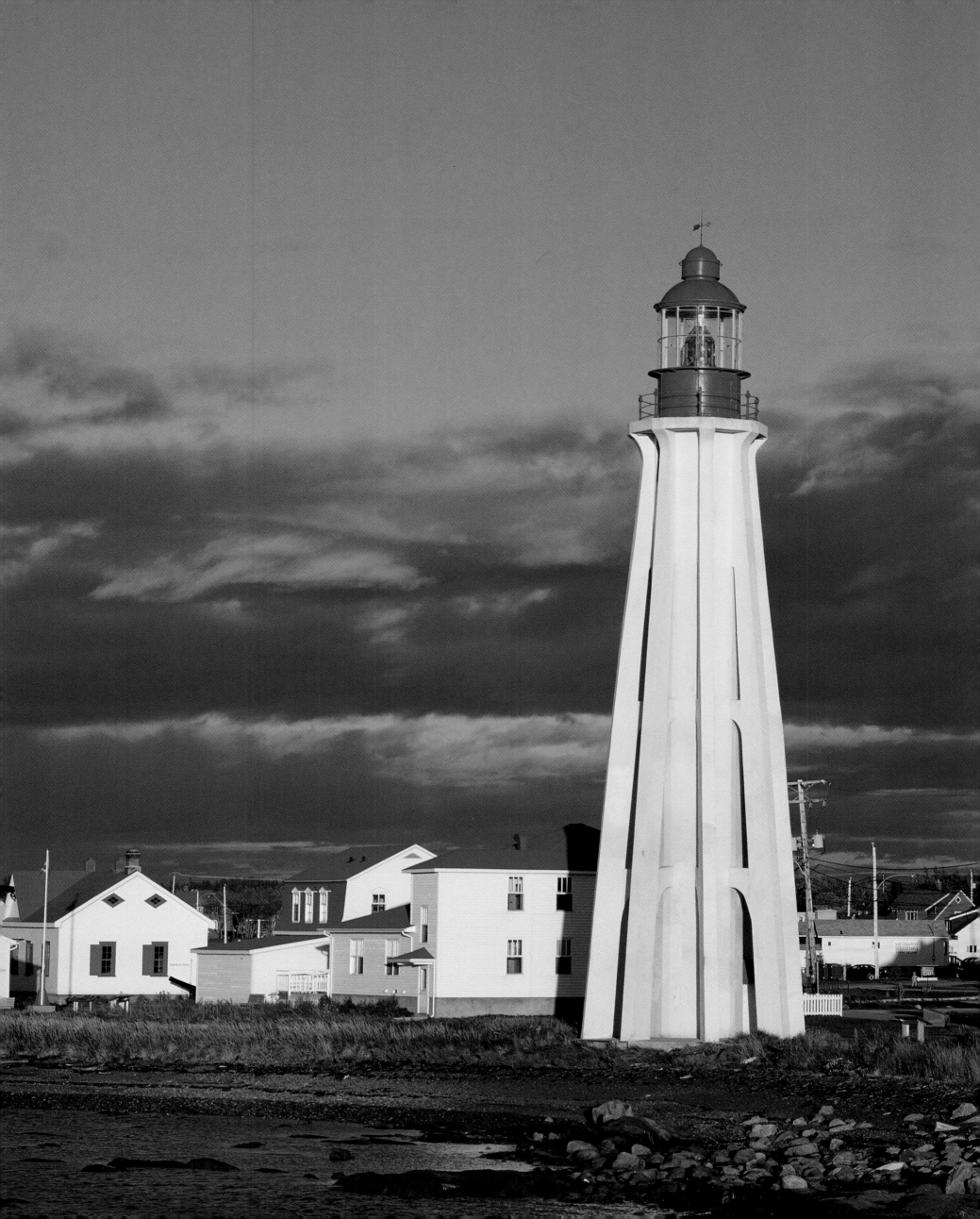

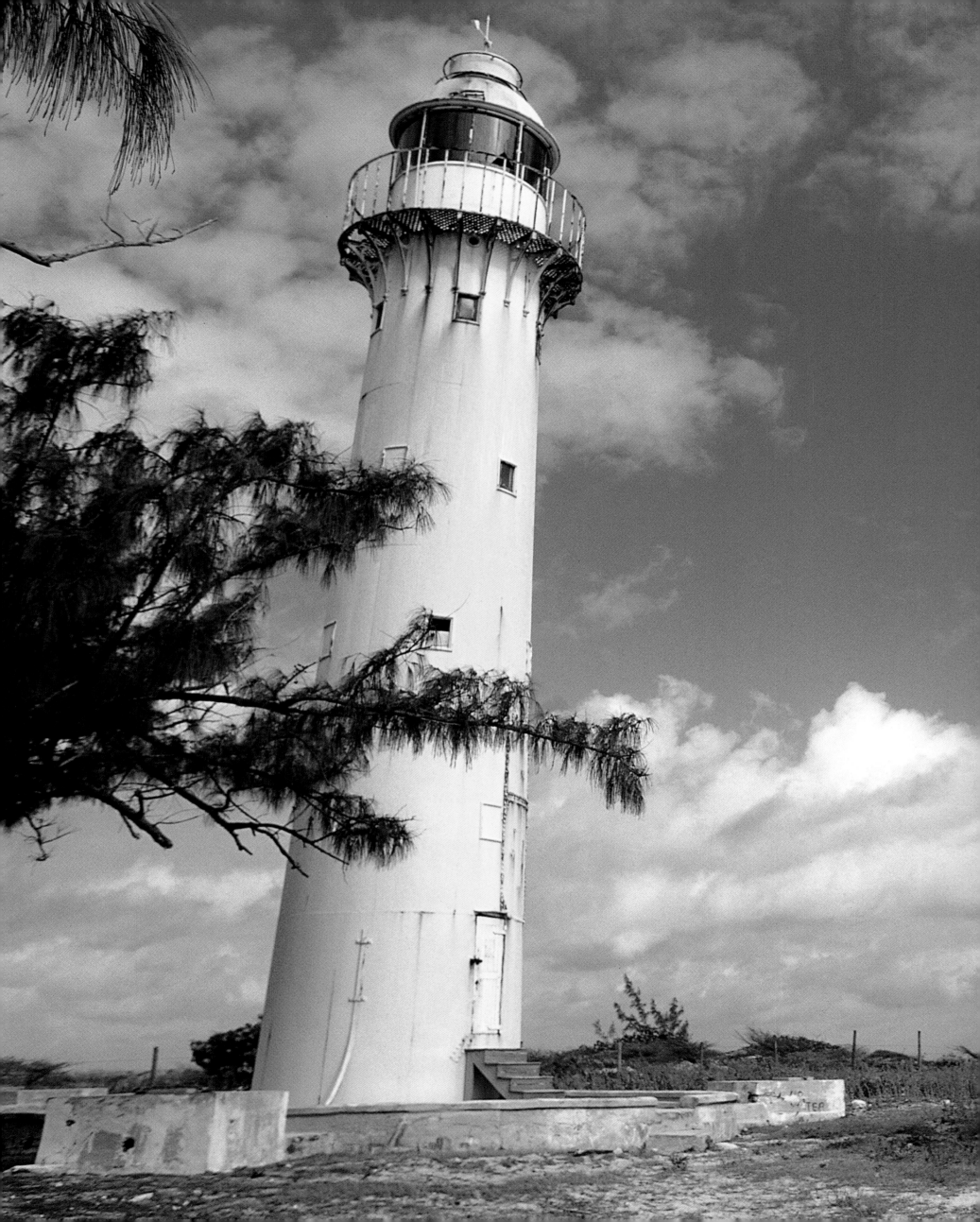

The Spanish light-house stands in haze:
The keeper trims his light;
No sail he sees through the long, long days,
No sail through the still, still night;

But ships that pass far out at sea,
Along the warm Gulf Stream,
From Cuba and tropic Carribee,
Keep watch for his distant gleam.

Constance Fenimore Woolson, from *The Florida Beach*

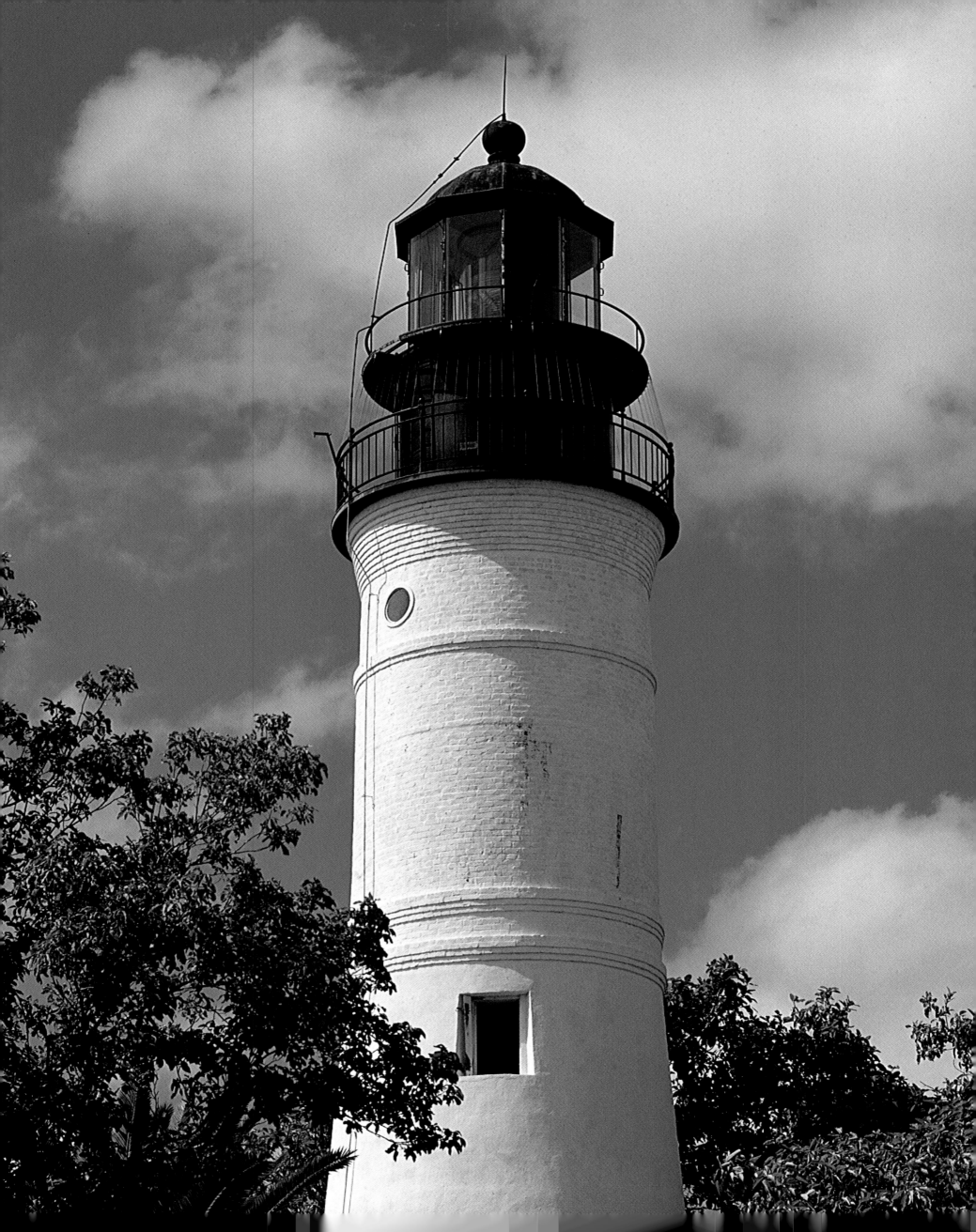

I observed, however, that Mr. Spenlow's Proctorial gown and stiff cravat took Peggotty down a little, and inspired her with a greater reverence for the man who was gradually becoming more and more etherealized in my eyes every day, and about whom a reflected radiance seemed to me to beam when he sat erect in Court among his papers, like a little lighthouse in a sea of stationery.

Charles Dickens, from *David Copperfield*

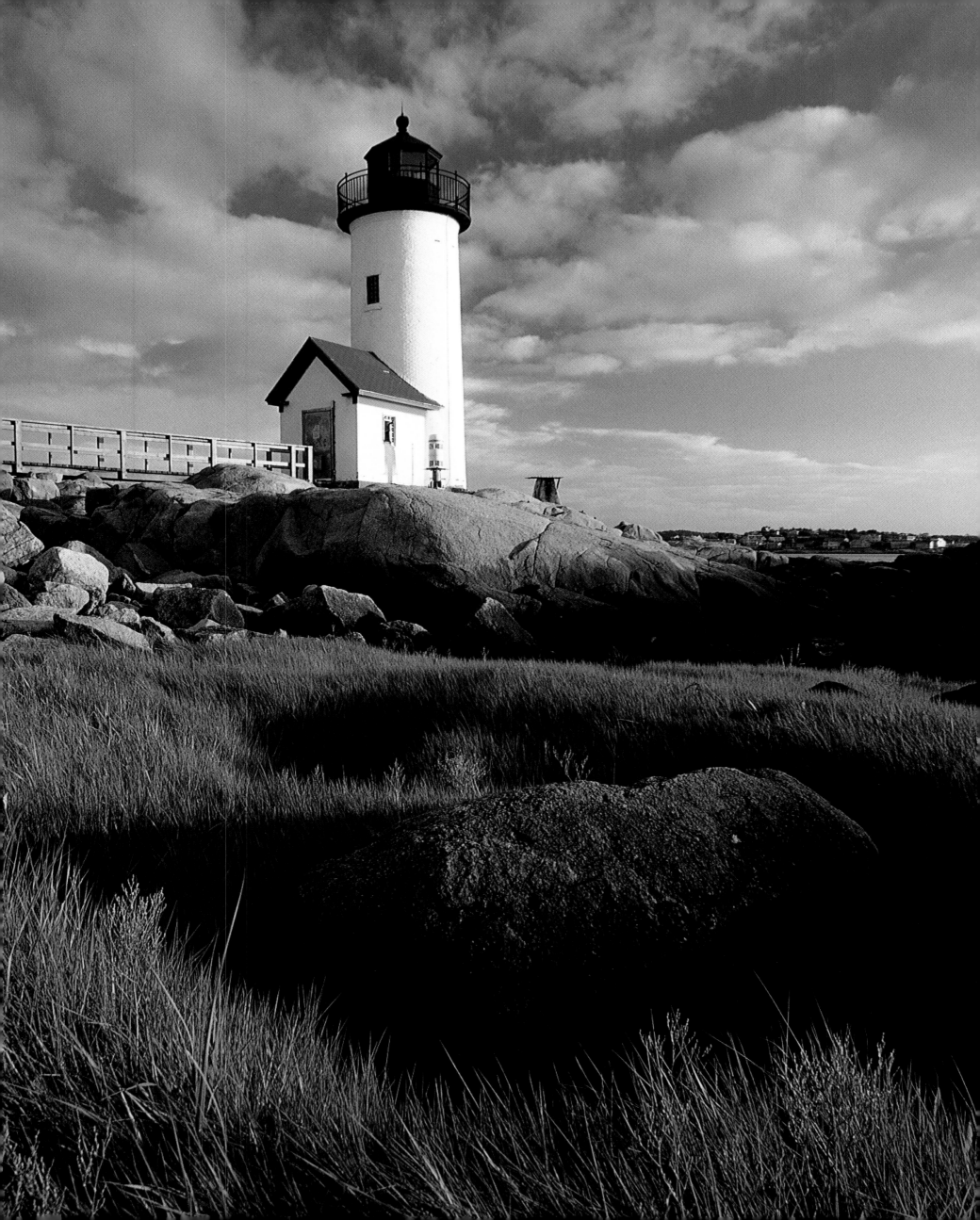

The light-house keeper said that when the wind blowed strong on the shore, the waves ate fast into the bank, but when it blowed off they took no sand away; for in the former case the wind heaped up the surface of the water next to the beach, and to preserve its equilibrium a strong undertow immediately set back again into the sea which carried with it the sand and whatever else was in the way, and left the beach hard to walk on...

Henry David Thoreau, from *Cape Cod*, The Highland Light

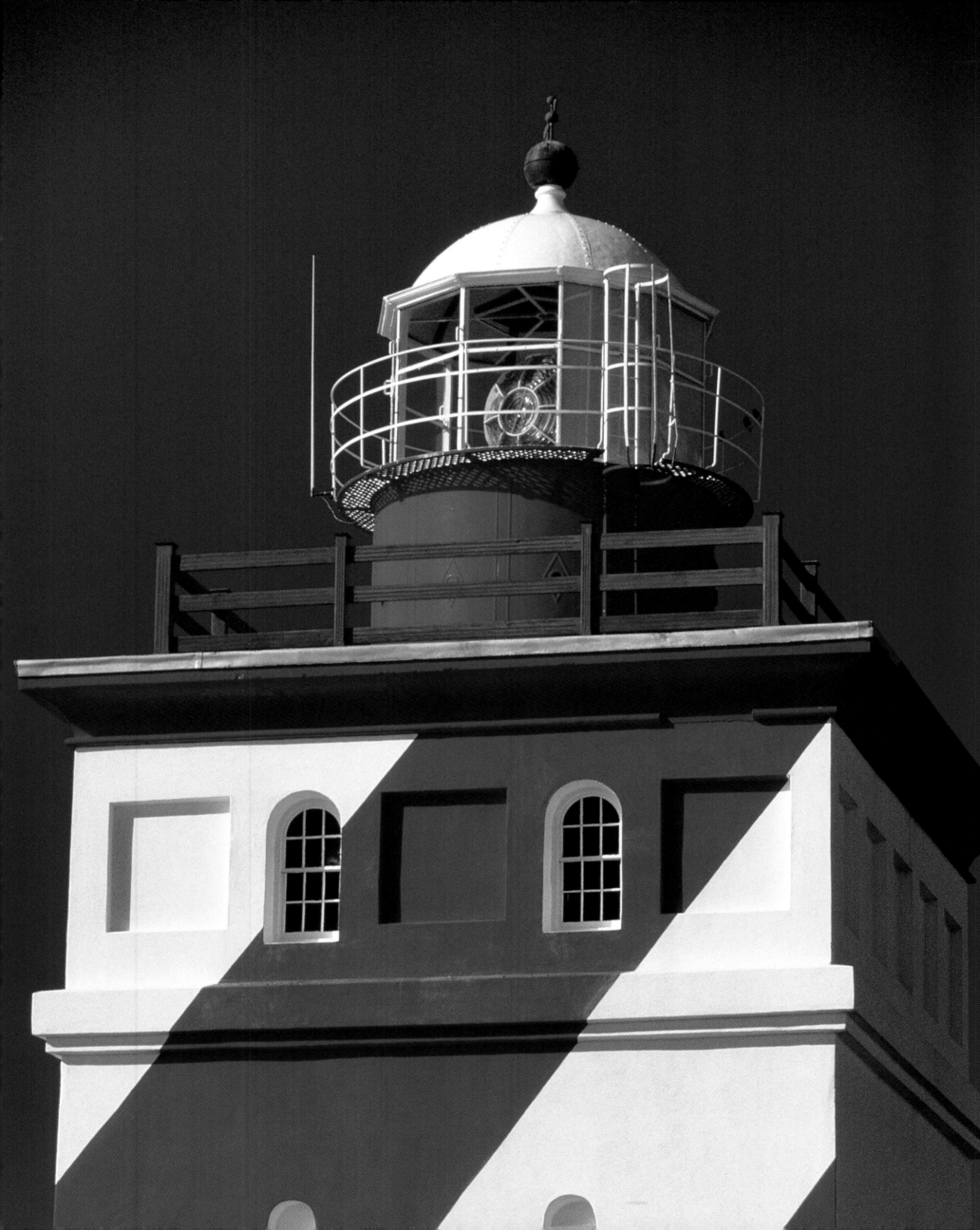

...A bright meteor shot athwart the sky, leaving a shining trail, and fell far out beyond the lighthouse. We watched it in silence. I know what my thoughts were. He knew his own. "Oh, well!" he said, with a half-sigh and arose, "So all things pass away. But they were beautiful days."

Jacob A. Riis, from *Theodore Roosevelt, the Citizen*

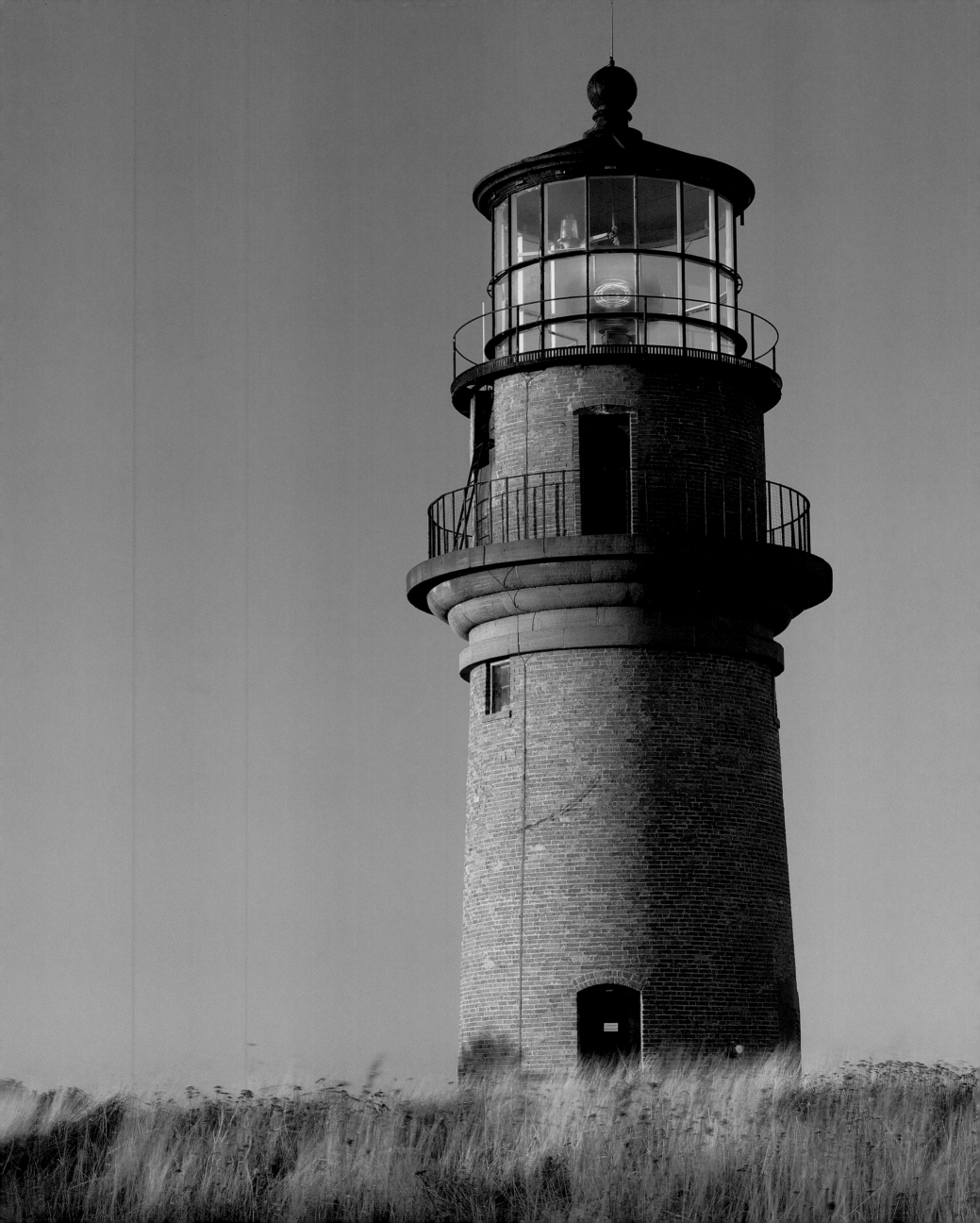

What through the murmur of the sea

Beats gently on the sandy lea,

And ever restless fills the ear

With sounds which it is sweet to hear on many a quiet shore.

Yet here it seems as if the wave

Were struggling with the sand to lave

The foot of yonder wooden cliff,

And then a barrier firm and stiff opposed the ocean's roar.

Matthew Arnold, from *Lines Written on the Seashore at Eaglehurst*

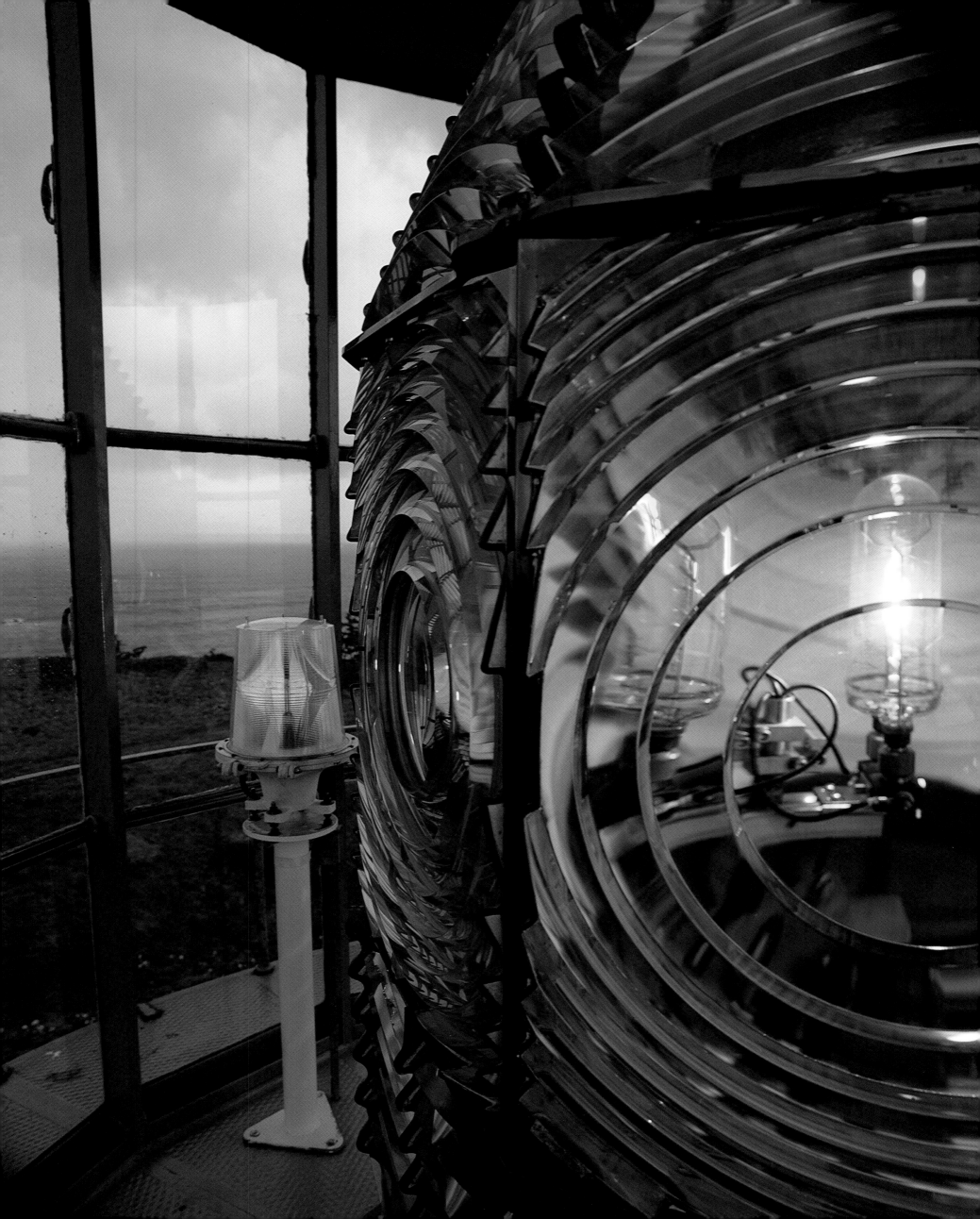

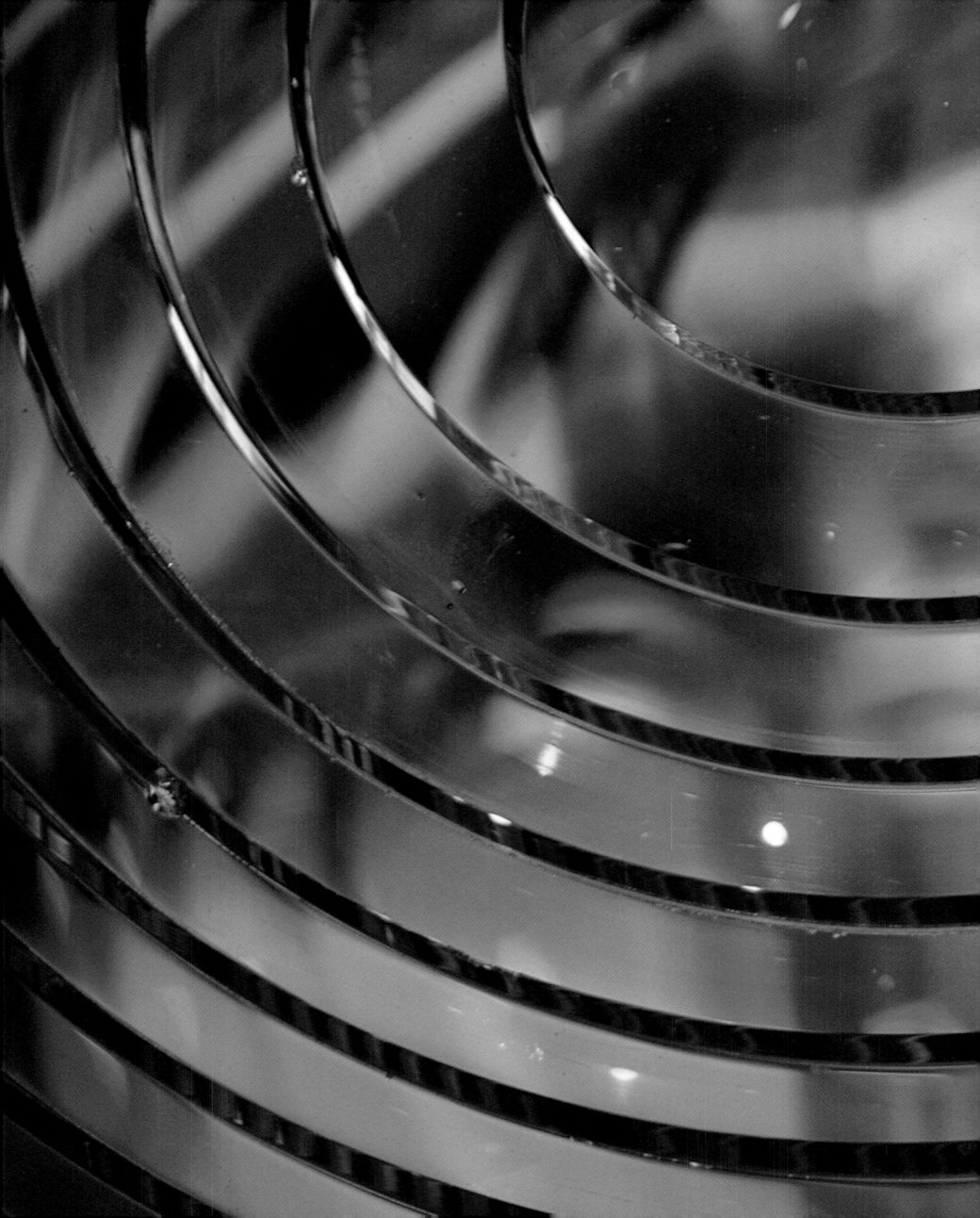

*L*ighthouse, n. A tall building on the seashore in which the government maintains a lamp and the friend of a politician.

Ambrose Bierce, from *The Devil's Dictionary*

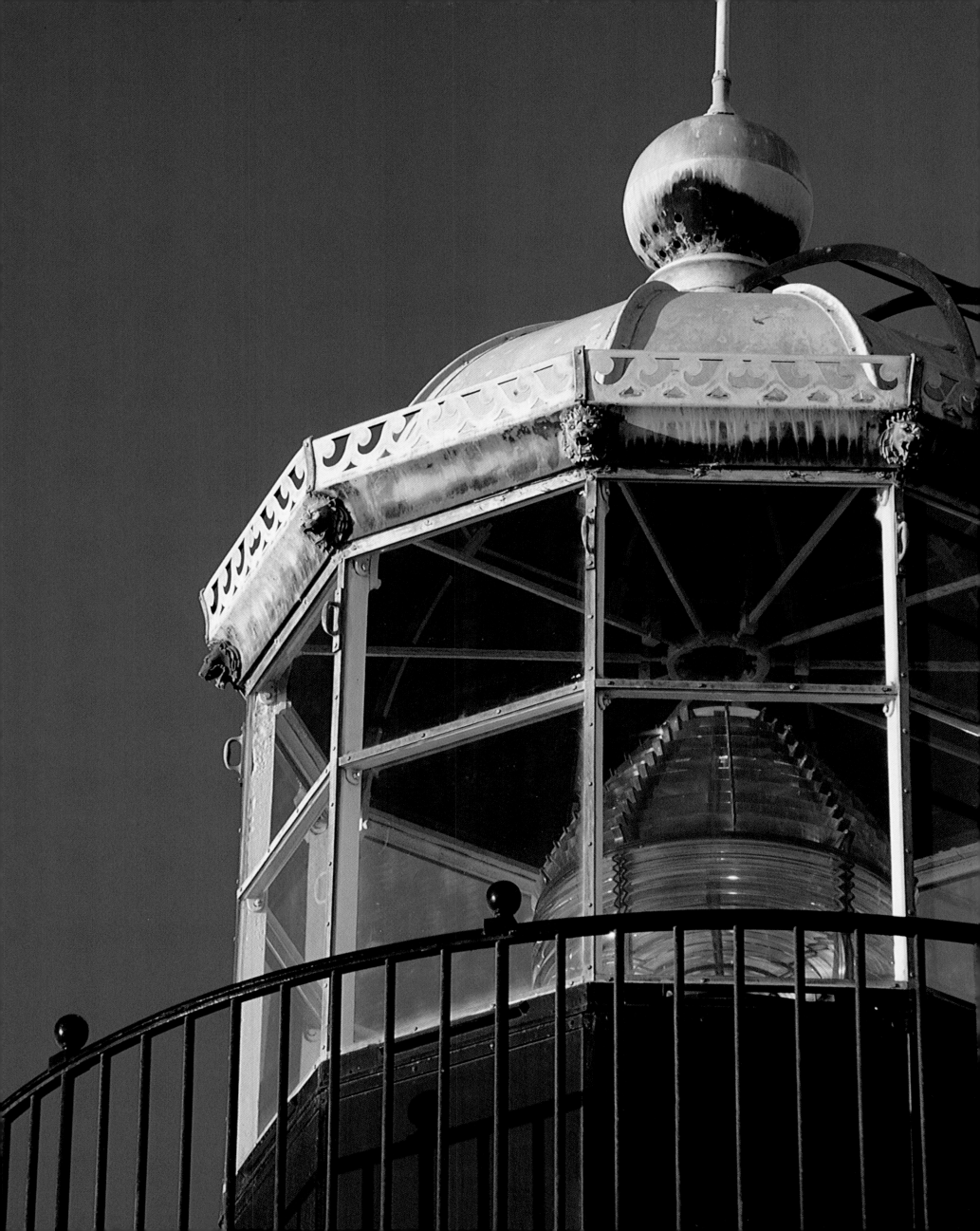

... *t*here is an easy harbor, with no need for a hawser nor anchor stones to be
thrown ashore nor cables to make fast; one could just run ashore and wait for the
time when the sailor's desire stirred them to go and the right winds were blow-
ing. Also at the head of the harbor there runs bright water, spring beneath rock,
and there are black poplars growing around it. There we sailed ashore, and there
was some god guiding us in through the gloom of the night, nothing showed to
look at, for there was only deep mist around the ships, nor was there any moon
showing in the sky, but she was under the clouds and hidden.

Homer, from the *Odyssey*

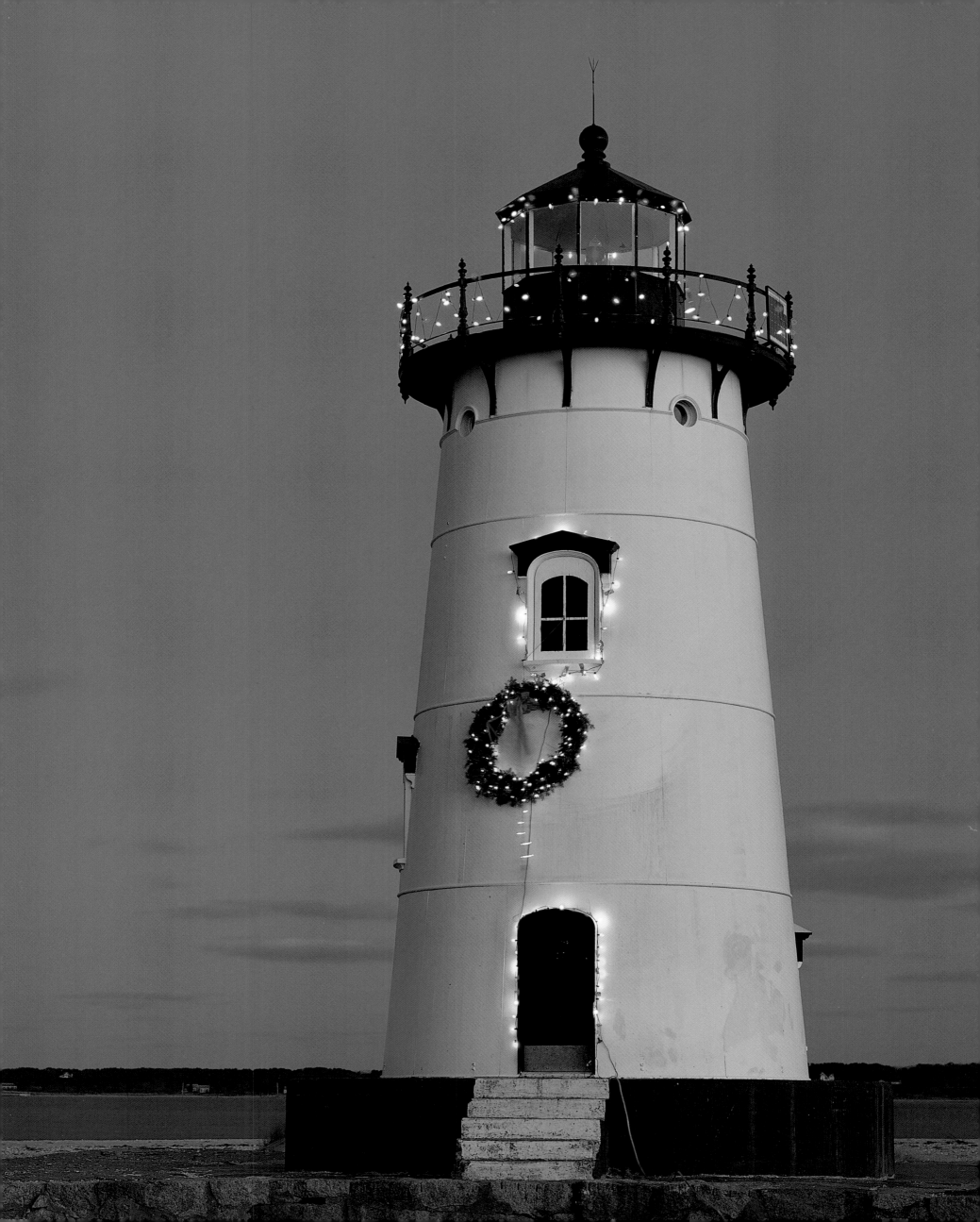

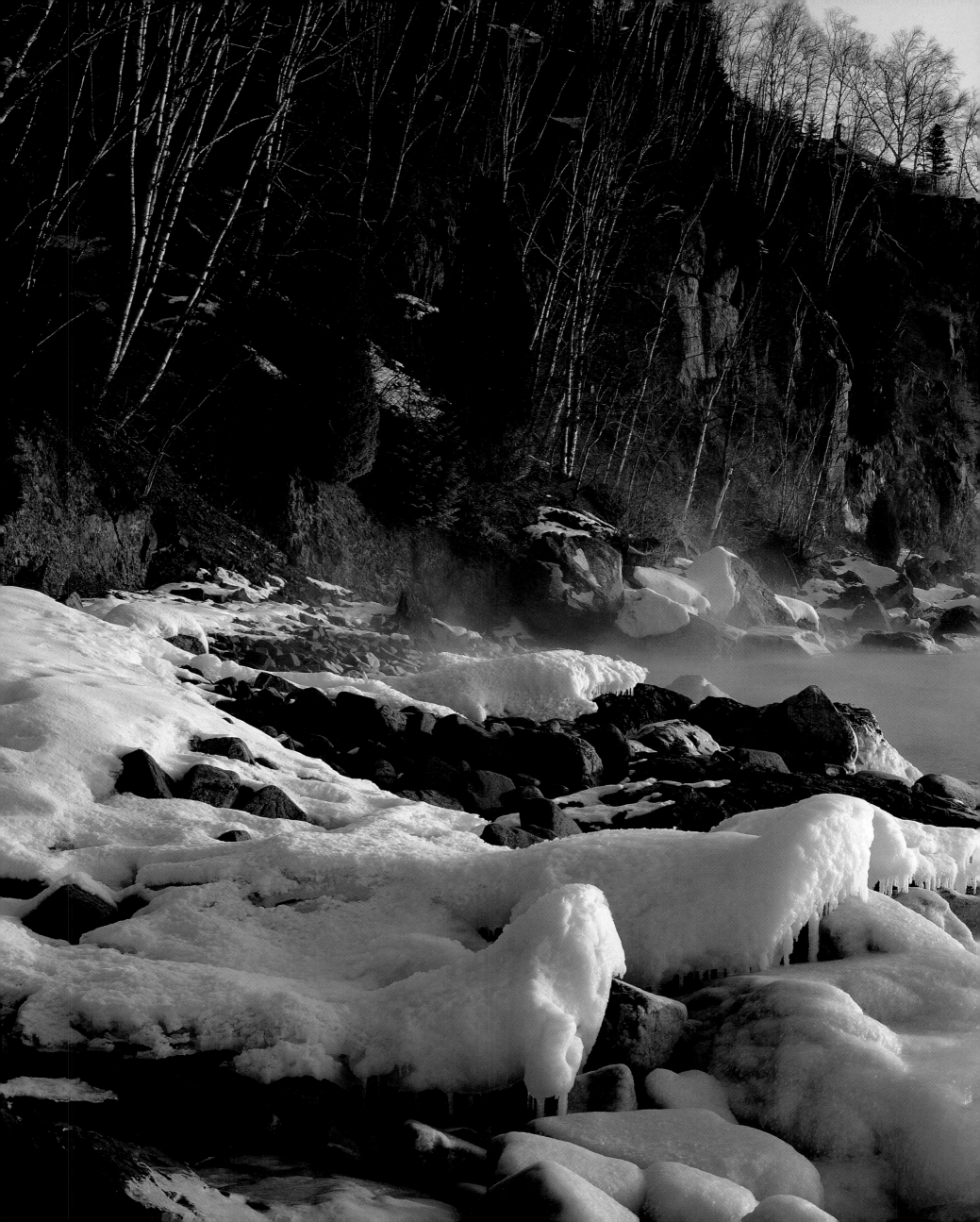

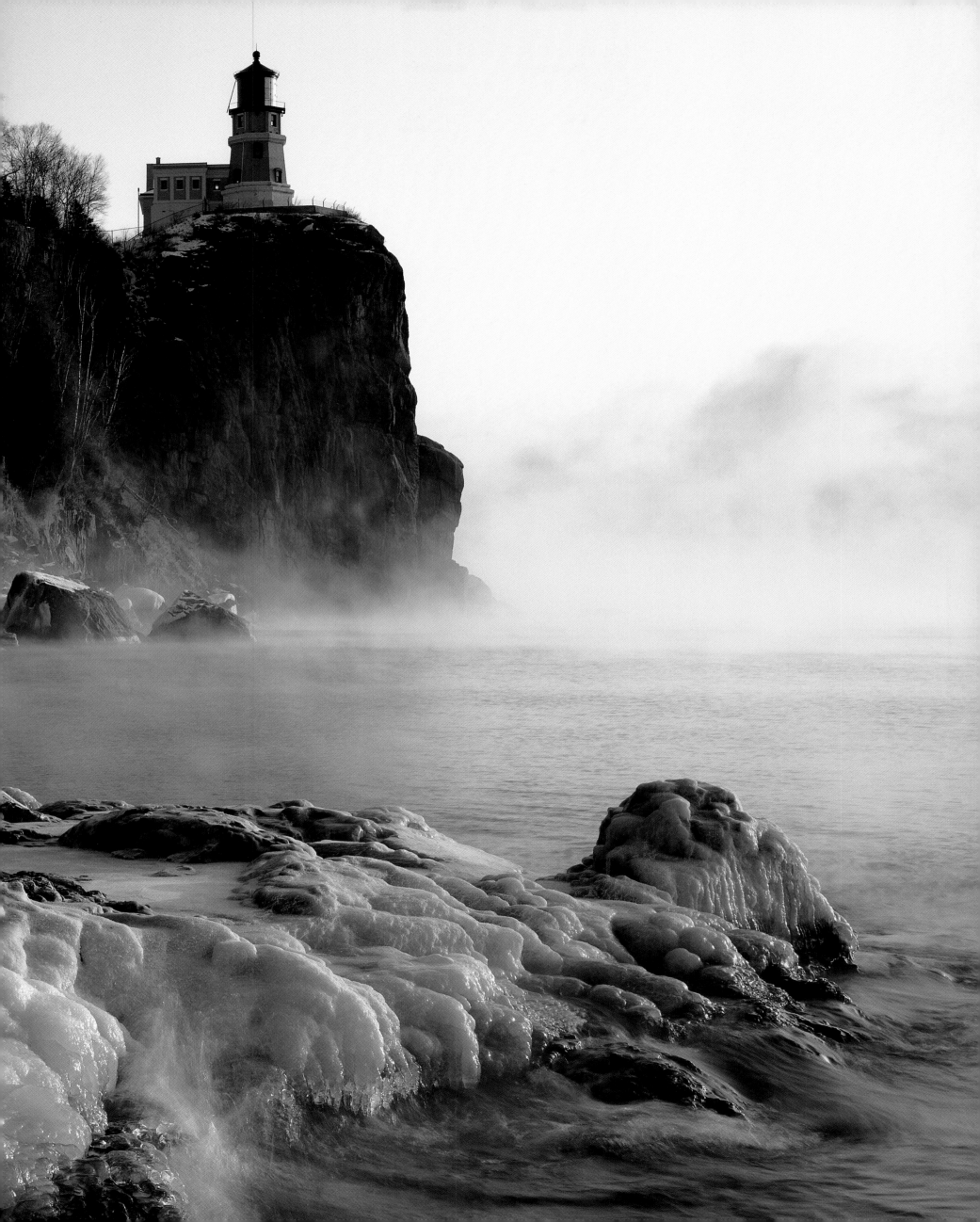

Identification Guide to the Lighthouses

Organizations

The local preservation societies devoted to lighthouses are too numerous to mention, but are wonderful sources of information about particular lighthouses. Find contact information for these in a local telephone book, through the region's tourism office, or on the internet. Listed here are associations with a broader presence, many of which offer newsletters or other publications of interest to lighthouse enthusiasts.

The Australian Lighthouse Association
14 Gurner Street
Saint Kilda, Victoria 3181 Australia
Publication: The Prism

The Great Lakes Lighthouse Keepers Association
PO Box 580
Allen Park, MI 48101-0580
Publication: The Beacon

The Lighthouse Preservation Society
4 Middle Street
Newburyport, MA 01950
Publication: Guide to Maine and New Hampshire Lights

The Lighthouse Society of Great Britain
Gravesend Cottage
Gravesend,
Torpoint, Cornwall, PL11 2LX, United Kingdom

National Lighthouse Center and Museum
One Lighthouse Plaza
Staten Island, NY 10301

The New England Lighthouse Foundation
PO Box 1690
Wells, ME 04090

The New Jersey Lighthouse Society
PO Box 4428
Brick, NJ 08723
Publication: The Beam

The Nova Scotia Lighthouse Preservation Society
c/o Maritime Museum of the Atlantic
1675 Lower Water Street
Halifax, Nova Scotia, Canada B3J 1S3

Outer Banks Lighthouse Society
210 Gallery Row
Nags Head, NC 27959

The United States Lighthouse Society
244 Kearney Street, Fifth Floor
San Francisco, CA 94108
Publications: The Keeper's Log, The US Lighthouse Society Bulletin